The Tolstoy of the Zulus

Also by Stephen Kessler

POETRY

Burning Daylight 2007
Tell It to the Rabbis 2001
After Modigliani 2000
Living Expenses 1980
Beauty Fatigue 1978
Thirteen Ways of Deranging an Angel 1977
Poem to Walt Disney 1976
Nostalgia of the Fortuneteller 1975

TRANSLATION

Desolation of the Chimera (poems by Luis Cernuda) 2009
Eyeseas (poems by Raymond Queneau, co-translated
 with Daniela Hurezanu) 2008
Written in Water (prose poems by Luis Cernuda) 2004
Aphorisms (prose by César Vallejo) 2002
Heights of Machu Picchu (poem by Pablo Neruda) 2001
Ode to Typography (poem by Pablo Neruda) 1998
Save Twilight (poems by Julio Cortázar) 1997
From Beirut (poem by Mahmoud Darwish) 1992
Akrílica (poems by Juan Felipe Herrera, co-translated
 with Sesshu Foster) 1989
The Funhouse (novel by Fernando Alegría) 1986
Changing Centuries (poems by Fernando Alegría) 1985
Widows (novel by Ariel Dorfman) 1983
Homage to Neruda (poems by eight Chilean poets) 1978
Destruction or Love (poems by Vicente Aleixandre) 1976

PROSE

The Mental Traveler (novel) 2009
Moving Targets: On Poets, Poetry & Translation (essays) 2008

EDITOR

The Sonnets by Jorge Luis Borges 2010

The Tolstoy of the Zulus
On Culture, Arts & Letters

STEPHEN KESSLER

El León Literary Arts
Berkeley, California

Most of these pieces (some in slightly different form) originally appeared in the following periodicals, whose editors are gratefully acknowledged: *Bachy, Coast Weekly, East Bay Express, Independent Coast Observer, The Mendonesian, Metro Santa Cruz, Metro Silicon Valley, North Bay Bohemian, Outlook, The Redwood Coast Review, San Francisco Review of Books, Santa Cruz Express, Santa Cruz Independent, Santa Cruz Weekly,* and *The Sun.*

The author also wishes to thank Dorothy Ruef for digital assistance and Kit Duane for her sharp eye and sure editorial hand.

Many editors, friends and colleagues have read, critiqued and encouraged these writings over the years. You know who you are. Thank you.

El León Literary Arts is a private foundation established to extend the array of voices essential to a democracy's arts and education.

El León Literary Arts books are distributed by Small Press Distribution, Inc., 800-869-7553 / www.spdbooks.org

El León books are also available on Amazon.com

El León web site: www.elleonliteraryarts.org

Publisher: Thomas Farber
Managing editor: Kit Duane
Cover designer: Andrea Young
Text designer: Sara Glaser

ISBN 978-0-9795285-8-3

Library of Congress Control Number: 2011923584

Contents

Preface / 1

Culture

Terror, Propaganda and Imagination 2001 / 7

Violins vs. Violence (The Madness of Art) 2002 / 17

Satanic Realism 1988 / 21

Literature, Unplugged 2004 / 26

Save the Letter 1997 / 33

In Praise of the Postcard 1999 / 38

Google's Library of Babel 2007 / 42

The Trouble with Publishing 2009 / 48

Writers on Strike? 2007 / 54

A Screen of One's Own 2004 / 59

Armageddon Will Be Televised 1983 / 63

Hollywood Wax Museum 1989 / 69

Disneyland Revisited 1985 / 74

Manson Demystified 1989 / 80

Not a Pretty Picture: *Esquire* in the Sixties 1995 / 85

Dylanography 1977, 1979, 1981, 1997, 2001 / 89

Beauty's Truths 2009 / 113

Arts

The Discreet Charm of Luis Buñuel 1983 / 123

Keats's Star Turn 2009 / 129

Grave New World 1983 / 132

A Whale of a Monster Movie 1999 / 136

Werewolves on Speed (The Movie) 1994 / 140

Mary Holmes, 1910–2002 2002 / 145

Museum Mysteries: A Self-guided Tour 2010 / 149

Bearden's Burden 2004 / 156

City Light: Edward Hopper in San Francisco 1982 / 161

Net Art Man: Stan Fullerton 1982 165

The Nutzle Enigma 2007 / 169

Vidstrand Is a Many-Stranded Thing 1995 / 181

Chips off the Old Watts 1985 / 185

Robert Gold, Bohemian Everyman 2006 / 191

Uneasy Listening 2000 / 197

Monk's Wake 1982 / 201

Exaltation at Zellerbach: Sonny Rollins Rising 2010 / 205

Sympathy for the Stones 1981 / 211

The Integrated Man: Harry Belafonte 2003 / 217

Lonesome Traveler: Bob Dylan at 60 2001 / 225

Letters

American Colossus: Henry Miller 1980, 2000, 2001 / 237

The Tolstoy of the Zulus: Saul Bellow 2005 / 252

Lost Illusions: Philip Roth 1998 / 262

Humanstein: Bellow and Roth 2000 / 267

Nonprophets: Roth and Dylan 2004 / 272

Three Bad Dudes: Jerome Washington,
 Pete Hamill, Marlon Brando 1994 / 281

Tough Guy Tells All: Charles Bukowski 1979, 1982 / 290

Salinger's Masterpiece: Fifty Years of Silence 2010 / 298

Beyond Good and Evil: Thomas Keneally 1993 / 304

Nietzsche's Headshrinker: Irvin Yalom 1993 / 308

Never Believe What You Think: Carlos Fuentes 1994 / 312

Marriage of True Minds: Page and Eloise Smith 1995 / 316

California Realist: James D. Houston 2009 / 322

An Amazing Man: Morton Marcus 2009 / 327

Bard under the Radar: Greg Hall 2009 / 332

An Unknown Writer: Richard P. Brickner 2006 / 335

George Hitchcock, Jorge-of-all-trades 2010 / 342

All the Fictions Fit to Print 2003 / 348

for Gary Young

Preface

Selected from more than 30 years of cultural and literary criticism, these essays record my personal engagement with an idiosyncratic assortment of artists, ideas and phenomena. Most were originally written for a variety of newsprint publications—alternative weeklies, mainly, and for my own quarterly *Redwood Coast Review*—whose ephemeral formats gave them a kind of disposable immediacy conducive to the discussion of timely topics.

Reading them again, arranged as they are here, not chronologically but thematically, I find that they amount to a fairly coherent and I hope durable argument about the central place of the arts in our social landscape, and the ways in which the creative imagination provokes and enriches our apprehension of reality. Movies, paintings, music, books and their creators contribute immensely to our understanding of the world we inhabit by their dynamic interaction with that world. In these writings I've tried to trace those interactions from an individual perspective anchored in my own experience.

When I abandoned academia for journalism in the early 1970s, it was partly in order not to have to prove I was right (as scholars are often expected to do) but rather to offer subjective

arguments based on an angle of vision informed by my own biases. This candid sense of subjectivity freed me to say what I thought without having to convince anyone of anything, while at the same time attempting to persuade by way of insight, intuition, informed perception and poetic association.

My hope and goal was to engage the reader who shared my interest in the subject but, like me, was not necessarily a specialist. In most cases I have written out of enthusiasm, astonishment, passion and excitement, but also with a sense of skepticism toward conventional wisdom and received ideas, and with fidelity to reason, irony and certain basic moral and political values. These pieces were intended to entertain and inform, to question and clarify in the moment they were composed. Taken together, they amount to an intellectual testament, words I am willing to stand by over time.

—*SK*

The Tolstoy of the Zulus

Who is the Tolstoy of the Zulus?
The Proust of the Papuans? I'd be glad to read him.

SAUL BELLOW to an interviewer

I have a great liking for polygraphs who cast
their fishing-poles in all directions...

JULIO CORTÁZAR, "What Is Polygraphy?"

Culture

Terror, Propaganda
and Imagination

[2001]

"You must make terror and moral horror your friend, or you will fear it," says Marlon Brando as the demented Colonel Kurtz to his assassin, Captain Willard (played by Martin Sheen), in Francis Ford Coppola's *Apocalypse Now Redux*. Watching this movie last September 24, less than two weeks after the World Trade Center holocaust, I was struck by its uncanny relevance to current events. By modeling his narrative on Joseph Conrad's 1902 novella *Heart of Darkness*—a journey upriver in search of a Westerner unhinged by his colonial encounter with a "primitive" culture—Coppola gave his 1979 film about the Vietnam War more lasting resonance, with its allegorical overtones, than he might have achieved with a more straightforward or strictly realistic account. Art, as Picasso famously observed, is a lie that can reveal the truth. Coppola's artistic imagination enabled him to make a creative statement that spoke not only to its historical moment but also to our present predicament.

The parallels between the war on terrorism and Vietnam are inexact at best—the moral obscenity and murderous destruction

of the September 11 attacks are infinitely more threatening to our security than some vague communist menace on the other side of the world—but even George W. Bush admits that the assault on Afghanistan and the hunt for Osama bin Laden are (or were) only the beginning of a struggle with no end in sight. Terrorism, in some ways even more than communism, is a phantom enemy whose whereabouts and identity are maddeningly elusive. The guys who hijacked those planes hung out in California, Florida and New Jersey, and their presumed associates are scattered across the globe. While the military mission in Afghanistan may or may not prove to be a Vietnam-style quagmire, the more ambitious campaign "to rid the world of the evildoers" promises to be an even vaster morass.

Yet the criminal atrocities that provoked this war, and the scope of their repercussions, make any pacifist antiwar critique seem dangerously reductive. (Almost as simpleminded as the notion of ridding the world of evildoers.) Under these circumstances it's easy to see why even the smartest people are confused.

The diabolical brilliance of the September 11 attacks—the fiendishly ingenious use not only of commercial airliners but of television as an instrument of terror—requires a comparably creative response. The impact of the physical obliteration of the twin towers and thousands of people within was exponentially increased in the psyches of millions more who were helpless to tear themselves away from their TV sets, witnessing again and again the endless replays of an incredible spectacle as compelling as it was horrendous. Exploiting with amazing efficiency an electronic medium they profess to abhor as a carrier of cultural corruption, the holy warriors performed a

consummate act of medieval postmodernism, a pornographic spectacle on an unprecedented scale: mass murder as performance art.

Pearl Harbor, to which the attack has been compared, was not in the same league. The more precise analogy is Hiroshima, whose nuclear annihilation changed forever the psychic and historic landscape of humanity.

Simply bombing or arresting all the bad guys, even if it were possible, is hardly a sufficient strategy for dealing with such a consciousness-shaking experience. While the state with its legal and military machinery lurches mightily toward some version of justice, individual artists and ordinary people must find their own ways of responding to the unspeakable. To expect any political or spiritual resolution or "closure" to what we're going through is unrealistic. There's little consolation for the victims of these events, but while history's tragic drama plays out around us we need some kind of creative transformation, some antidote to despair.

Although in the immediate aftermath of September 11 mere art seemed utterly inadequate if not irrelevant, the months since have seen an explosion of activity in creative communities across the country. New York is of course the epicenter of this eruption of artistic energy, but writers and artists and musicians everywhere, grief-struck and perplexed as they may be, have begun to register their questionings. Perhaps the most moving and remarkable works thus far have been the spontaneous shrines that sprang up all over Manhattan in honor of the dead and missing, collective assemblages of photos and flowers and poems and other tokens of respect and sorrow.

While visiting the city in late October, I was stopped in my

tracks one night on Seventh Avenue by the Wall of Hope and Remembrance outside St. Vincent's Hospital: a collage some 60 feet long and six feet high composed primarily of home-made "missing" fliers posted near the hospital by friends and families of the lost. Hospital workers had evidently removed these pieces of paper from their original locations and brought them together in a sheltered area under a protective plastic covering where they would be preserved; at the base of the wall passersby had left an assortment of candles, dried flowers, little toy firefighter helmets and other poignant artifacts. Memorials of this kind are still up in various parts of the city, and their humble beauty is in its way as powerful as any masterpiece in the Metropolitan Museum.

Even the American flags I saw displayed in New York had a touchingly personal and individual aura lacking in the more generic flags I've seen flying from cars and hanging outside homes and businesses in California. Context is everything: what appears in one place a cliché or a ritual gesture of patriotism, in another—the actual location of the carnage—takes on an elegiac sincerity. Slogans like "God Bless America" and "United We Stand"—which can be translated as "Shut up and get in line behind the government" as well as whatever else they're supposed to mean—not to mention the opportunistic blather of politicians and the president's John Wayne rhetoric—are examples of official language rendered meaningless by abuse. Even the word *terrorist* is debased by the fact that it's only used to describe our alleged enemies—never, for example, the US-funded Nicaraguan contras of the 1980s, who terrorized their own country in the name of anticommunism, or Augusto Pinochet's Chilean military which, on September 11, 1973, overthrew

Chile's elected government in a US-sponsored coup.

Still feeling the emotional aftershocks of an unimaginable tragedy, most people can be forgiven for falling back on familiar phrases and images, but artists must find new ways of expressing the inexpressible. Even when it can't completely transform tragedy, creative language and imagery can be an antidote to platitude.

As far as propaganda goes, the strongest examples I've see of public art since September 11 appear on buildings in busy neighborhoods of San Francisco and Los Angeles, respectively. One is a 12-story-tall mural on the side of Westwood Medical Plaza on Wilshire Boulevard in West LA. It shows, in the foreground, a racially ambiguous female US marine in full combat gear toting an M-16—and a sexy marine she is—with the Statue of Liberty, the twin towers, a stealth bomber tucked under the wing of a diving bald eagle above her and a wall of flames in the background; below are the words LIBERTY AND, and in much larger letters, JUSTICE, and in the lower right corner the numbers 9-11. The monumental scale of this image, its awesome visual impact, its message of patriotism and military power combined with feminism and ethnic diversity, give it a forcefulness and nuance absent from all the other war-cheerleading I've seen.

This may be because—as the artist, Mike McNeilly, explained to me—the mural was conceived less as a belligerent statement than as "a salute to the men and women in the armed forces, the 19- and 20-year-old kids who are out there putting their lives on the line." Like the New York firefighters to whom McNeilly devoted a previous mural, such soldiers as the one depicted are heroic, almost mythic figures in the popular imagination who

transcend politics even as they represent "politics by other means": war.

Given the slickness of his technique, it was no surprise to learn that McNeilly's more commercial projects include billboards and murals for movie studios and other entities of the entertainment-industrial complex. Hollywood, which for a while feared a direct attack by terrorists, appears more pathetic than ever in the face of the reality show that has eclipsed the most extravagant creations of its leading minds. Why use special effects and make-believe mayhem, the attackers demonstrated, when the real thing is so much more impressive. McNeilly's mural, in its skyscraper size and swaggering attitude, is infinitely more persuasive of American strength and resolve than any number of lousy movies or TV shows or flags or firm-jawed anchormen.

The other first-rate piece of public art I've seen, with a very different political message, is on five banners hanging from the roof of City Lights Books on Columbus Avenue in North Beach. On each of the banners (created by the San Francisco Print Collective) is a face with an American flag wrapped around its mouth, and above each face, one word at a time, is printed DISSENT…IS…NOT…UN…AMERICAN. The boldness and simplicity of this statement is a most refreshing counterpoint to the thought-stopping Ashcroftian imperative to accept without question anything the president decrees. Dissent—political debate—is in fact more American than rhubarb pie; it is the Dr Pepper of our democracy. What distinguishes the United States from, say, Saudi Arabia or Cuba is that contention with (and within) the government is not just permitted but encouraged by the Constitution. The enforced unanimity

of totalitarian regimes like the Taliban or fundamentalist religious or political orthodoxies is not our model. The message displayed on the City Lights building is at least as "patriotic" as any call to unity could be.

It's only fitting that the cofounder and co-proprietor of City Lights, Lawrence Ferlinghetti, has long been one of the country's leading dissidents. As a poet, publisher, bookseller, painter and political activist, Ferlinghetti has been on the front lines of resistance to conformity for half a century. Language, he has shown through his own writing and the books he's published, is one of the most powerful instruments we possess to question received ideas. The poet, more than anyone else, is charged with keeping language clear and precise, free of banality, Buck-knife sharp and fresh as just-baked bread. Poetry at its best reveals with the intimacy of an inner voice feelings and thoughts we're scarcely aware of otherwise.

It was surprising to hear US Poet Laureate Billy Collins declare on NPR that he would not be writing anything about September 11—not because any writer is obliged to address a particular topic but because that day now permeates our private as well as public lives, and one expects our "national" poet to look for ways to explore such a subject, however indirectly.

But given the stupefying horror of the disaster, and the tendency of most commentators to belabor conventional wisdoms rather than say anything original, a certain reticence may be in order. Who can presume in good faith to find words remotely sufficient to the occasion? It's just too big to get one's mind around.

And yet, in my recent travels, I've been asked by friends and strangers countless times if I have any poems on the subject

and been told that it's up to me and members of my profession to articulate what others can't express. In the absence of an all-American Subcommander Marcos—the Zapatista philosopher/poet/polemicist/propagandist who has so effectively verbalized the political aspirations of Mexico's indigenous outcasts—to counter with witty and brilliant rhetoric the jihad-mongering videos of bin Laden, it's up to many individual creative writers to subvert the propaganda of the ideologues, whatever world order they're trying to impose. Artists, in the "heightened state of awareness" they tend to cultivate with or without terrorism as a motivator, are ideally equipped to convert historic chaos into some inspiring or consoling or harmonious or illuminating form.

When, during my recent stay in New York, I made the pilgrimage to ground zero to see and feel and smell for myself the immediacy of the site, the glimpse I got of the four-story section of wall of the World Trade Center still sticking up from the rubble like some terrible piece of post-apocalyptic sculpture, and the stench of smoldering synthetics still belching out of the huge tomb of the pile, and the grave and reverent expressions of my fellow tourists as they tried, like me, to absorb the reality of what still was not quite believable, that staggering sense of devastation—all these disorienting fragments of impressions drove home both the impossibility and the necessity of bearing witness to what we're living through.

New Yorkers have taken tons of photographs during and after the catastrophe that are now exhibited in various venues around the city, an instant record of what they've been experiencing. Those of us geographically removed from the zone of greatest misery are not exempt from the psychic damage done to anyone

who's been paying attention. For people inclined to think things through and search for some rational understanding, this is an especially vexatious time, for no neat explanations or resolutions are available. And as I write, the killing continues.

John Keats, in his letters (1817), speaks of what he calls "*Negative Capability*, that is when man is capable of being in uncertainties, Mysteries, doubts, without any irritable reaching after fact and reason," suggesting that the artist must possess this quality ("which Shakespeare possessed so enormously") in order to accomplish anything truly meaningful. Now more than ever, it seems to me, negative capability is called for in our attempts to deal creatively with the ongoing process of extreme destruction that History is inflicting on the world. We have to question not only the propaganda of officialdom and the glib and morally obtuse pronouncements of the we-had-it-coming crowd, but our own beliefs and assumptions.

As Colonel Kurtz, via Brando, in his twisted way implies, we need to face with honesty the "evil" within ourselves before we can begin to fathom whatever may be loose out there. The terror and moral horror of the moment is a philosophical opportunity to learn, for better or worse, some of the darker truths of the human soul. Writers, artists, musicians, creative workers of all kinds are on the front lines of this urgent investigation, proposing hopefully humane alternatives to hatred, violence and self-righteousness.

The president and the secretary of defense and the attorney general and the homeland security czar have all warned us that there's no light at the end of this tunnel because there is no tunnel. Or perhaps more accurately, as in Afghanistan, there is an endlessly interconnected network of caves from

which there is no sure exit. We must, like Keats, learn to live in uncertainty and use that darkness and doubt and skepticism as spurs to imagination, instruments of discovery, vaccinations against hopelessness and blind obedience, passageways toward beauty.

As Colonel Kilgore (Robert Duvall), another deranged combatant in *Apocalypse Now*, mutters to no one in particular after the bizarre scene where he has ordered a couple of his men to go surfing while their comrades cover them by engaging the Vietcong in a ferocious firefight: "Someday this war's gonna end."

Violins vs. Violence
(The Madness of Art)

[2002]

We work in the dark, we do what we can,
we give what we have, our doubt is our passion, and our
passion is our task. The rest is the madness of art.

HENRY JAMES

Anyone who's been paying attention can't fail to have noticed that the geopolitical "outside world" appears to be careening further out of control these days than at any time in memory. The horrors of last September brought home to Americans brutal realities that in the past always seemed to happen somewhere else. The hot pursuit of bad guys in and around Afghanistan, the ongoing Palestinian–Israeli bloodbath, guerrilla and paramilitary atrocities in Colombia and the Philippines, our own domestic jitters and official panic in reaction to future moves in Al Qaeda's campaign to rid the world of infidels, and perhaps most pungent of all, the borderline nuclear showdown between India and Pakistan, have combined to make our sense of personal, let alone national, security extremely shaky at best. Just beyond the boundaries or beneath the surfaces of everyday life lurks the scariest kind of chaos.

Maybe it's always been like this, and it's only the increased efficiencies of electronic communications and the technological "advances" in murderous weaponry that have made us more aware of the violence driving history. Surely the vulnerability of the United States to the sort of cataclysm to which it previously seemed immune calls into question all previous assumptions about American separateness from planetary anarchy. Marshall McLuhan's benevolent global village turns out to be more like the disputed territories of the West Bank or Kashmir, where various kinds of religious and political fundamentalism are battling it out for absolute supremacy. Moderation, tolerance, coexistence, liberalism, democracy—such wimpy principles are no match for ideological righteousness backed by firepower. Rational discourse can't be heard over the sound of explosions.

In such bleak historical surroundings, cultural life may seem almost beside the point. If diplomats skilled in delicate negotiations are helpless to defuse the most urgent crises, what role could the arts have in fixing a world out of whack? Music, theater, dance, painting, poetry, film, literary fiction—all vital forms of individual and collective cultural expression so often considered frills or luxuries compared with the more serious business of sheer survival (whether by earning money or killing the enemy)—are surely marginal pursuits, at best.

But not to artists. And not to people who recognize the universal languages of story and song and imagery and drama and form and movement that reveal our common humanity. If any force holds out hope of correcting the insane course of current events—or at least consoling us with islands of sanity, oases of relief, what Primo Levi writing of Auschwitz called "moments of reprieve"—it is the force of art.

Totalitarian orthodoxies tend to consider art disruptive. The Taliban, an admittedly extreme example, tried to abolish music in Afghanistan as a dangerous deviation from piety. In a sense, you could say they were right. While there's a long and distinguished record of art in the service of religion, and art as a way of praising the Creator, some art can stir up feelings and ideas at odds with any controlling authority. The unbound imagination makes connections that rigid minds may find deeply threatening, unsettling, unseemly, "obscene."

Yet even the Nazis knew enough to spare musicians in the death camps who could improve the atmosphere of those infernos by performing selections from the classical repertory. And in the barracks those same musicians redeemed with healing sound some trace of their fellow prisoners' doomed humanity.

Consider the violin. West European highbrows, East European itinerant Gypsies, Appalachian illiterates, Delta blues singers, and Chinese concert musicians among many others can use this elegant instrument to communicate across cultural barriers. Isaac Stern traveled the world giving workshops to children whose mere exposure to such music might lead them to respect the dignity of people and cultures far from their own. Next to food, clothing, shelter and medicine, music is probably the most valuable humanitarian export any country can send abroad, either by way of live ambassadors performing in person or recordings brought to life via the technical magic of electronics.

If heads of government had any sense, they would settle international conflicts by means of dueling bands. Multilingual poetry slams could prove more conducive to peace than any amount of United Nations speechifying. Transcultural

art festivals would reveal to anyone with an open heart that beauty and love and suffering and joy and fear, and even hate, in all their variations, are fundamentals of human experience everywhere and give us more in common than petty political differences have any right to eradicate.

Yet paradoxically, all culture is also local. It is rooted in specific traditions of places in time, whether here and now or in some expired historic locale and people whose creative memory has been carried forward by others who've taken the trouble to learn the old techniques. The subsequent embellishment of those licks through encounters with other traditions, as is happening worldwide now that borders barely exist and emigrants are crossing paths in unexpected countries on an increasingly globalized planet, is a hybridization that breeds strength, as in agriculture, and holds out some promise, however faint, for eventual harmony among peoples.

True, it's an endless road from here to there. But even if we get blown up in the meantime, it's intrinsically worth the effort to create and honor cultural works as exchanges of wonder and understanding, acts of kindness, gestures of encouragement, gardens of revelation, and votes of confidence that the prevailing madness can be overcome.

Satanic Realism

[1988]

Like almost everybody else, including those most scandalized by it, I haven't read *The Satanic Verses*. Nor do I claim to know much about Islam except for what I've gathered via the media, which consistently misrepresents most foreign cultures. Nevertheless the unprecedented furor over Salman Rushdie's novel fascinates me as a student of literature and has set me thinking about the powerful connections between religion, politics and art this incident illustrates. The scale on which the drama of the book's publication is being played out has given its protagonists a mythic dimension even as the story is still "news." Rushdie's 15 minutes of fame and all its ramifications are likely to outlast and overshadow the artistry of his creation, whatever its literary value.

According to Rushdie, who was born a Muslim, the prophet Mohammed is not accorded divine status by Islam but his book, the Koran, is. Muslims, then, presumably worship a text they believe to be the Word of God. Like fundamentalist Christians and even some Jews who take the Bible literally, devout followers of the Muslim faith ascribe inordinate power

and authority to a book. Anybody who takes one book that seriously is bound to be a little unhinged by a tome, authored by a mere mortal, which calls into question the official version of a venerated myth. Last year's upheaval in the US over the movie *The Last Temptation of Christ* is a variation on the taboo against humanizing an allegedly historical figure invested with the power of divinity.

But there's a fine line between fundamentalism and fanaticism, between belief in some particular religious dogma and righteous intolerance of unbelief, and it's clear from Ayatollah Khomeini's thuggish pronunciation of a death sentence against Rushdie that the Iranian Imam has long since crossed that line. It's religious-cum-political demagogues like Khomeini who are living proof that their gods must be crazy, and deserve to have their deities deconstructed, debunked and ridiculed to the fullest extent of the skeptical imagination. There is a noble tradition of heretical art, from pre-Dostoyevsky to post-Buñuel, to which Rushdie can claim proud allegiance. Ironically, *The New York Times* reports that while *The Satanic Verses* is one of the hottest-selling books in the country, "the controversy has generated so much interest in the Islamic religion" that sales of the Koran are also up.

One obvious option for people upset by Rushdie's novel is not to read it—or to read it and respond in writing with a defense of their faith. But since *Verses* is a work of imagination, not a theological treatise, rebuttal is a trickier proposition. Nearly all crusaders need an enemy, however, a scapegoat or evil empire or Great Satan on which to project their hates and fears, and the book has provided Khomeini with the instrument he needs to whip his true believers into a violent froth.

Independent of the ayatollah, Muslims in Pakistan and India have also rioted over this largely unread text, and according to the *Times*, Pakistani Prime Minister Benazir Bhutto may find her young government threatened by the religious backlash the novel has occasioned. To a secular western mind like mine, such political fallout from a work of fiction is hard to comprehend.

But the crafty old ayatollah is no dummy, and his demonic death sentence cuts at least two ways: It reinforces the notion of the West and all its works as the major menace to Islam (thus distracting from Iran's internal political and economic problems—one of which, curiously enough, is its estrangement from the rest of the international community), and it hangs a sword of Damocles over Rushdie's pen and person for the rest of his life. Even if nobody claims the millions in prize money for bumping him off, Rushdie will be hard pressed to get a good night's sleep any time in the foreseeable future. This kind of psychological jihad against one unsuspecting novelist (and his publishers) is a fiendishly cruel and clever form of censorship.

Of course there are plenty of precedents for violent suppression of writers and their works, especially journalists and poets, who often have a way of directly challenging the authority of those in power. What distinguishes Khomeini's recent pronouncements is that here we have a religious leader, who's also a head of state, who has unilaterally put the whammy on a citizen of another country. As a slap in the face to both international law and freedom of expression, the ayatollah's call for vengeance should have clerics, statesmen, writers, publishers, booksellers and readers worldwide loudly reaffirming some fundamental human liberties rather than running scared

from Khomeini's hit squads. The pope conveniently avoided the issue in the Vatican by ignoring the Iranian ambassador's offer to murder Rushdie himself. And the craven response of Waldenbooks, B. Dalton and Barnes & Noble, all of whom have pulled the novel from their shelves, proves these operations are corporate philistines with no commitment to culture.

Everybody knows that truth is stranger than fiction, and that fiction in turn can be a form of truth. But Rushdie obviously had no idea his book—which reportedly employs a surrealistic style of storytelling—would be taken so seriously. The author, like many artists, subscribes to what could be called a religion of the imagination. "Literature," he recently wrote in the *New York Review of Books*, "is where I go to explore the highest and lowest places in human society and in the human spirit, where I hope to find not absolute truth but the truth of the tale, of the imagination and of the heart." His biculturalism as an Indian-born Englishman undoubtedly accentuates his sense of relativity, his multiple perspectives as a crossover soul—an inside-outsider in at least two worlds. Writing fiction, for Rushdie as for many others, is a way of investigating and reconciling his own intellectual and spiritual contradictions.

The ironies of his dilemma are compounded by the fact that this whole incredible affair is likely to make him a sensationally wealthy man if he lives to enjoy the profits from the sales of his famous novel. One writer friend of mine suggested that Rushdie is getting so rich off the free publicity that if he were really a surrealist he would counter Khomeini's bounty with an offer of his own: an extra million or two to anyone who *doesn't* kill him. In any event it's easy enough to envision a rush of writers eager to jump on the bestseller bandwagon creating a boomlet

in a new literary genre, the anti-Islamic novel.

In a perverse and disturbingly exciting way, the commotion over *The Satanic Verses*, whatever its merits or defects as art, is a healthy shock for literature—a form of human expression lately fighting for its life against more newfangled modes of creation and entertainment. Writers and readers alike should be strangely grateful that the hysterical intolerance of certain zealots has given such an air of importance to a work of fiction. The novel has been revived as a carrier of news whose fallout is felt in the real world, which any artist knows is the most amazing text of all. The repercussions of Rushdie's book are awesome in what they suggest about the truly dynamic and inspiring relation between imagination and reality.

Literature, Unplugged

[2004]

According to a recent study by the National Endowment for the Arts, the reading of serious literature in the United States has declined sharply over the last 20 years. At the same time, more books than ever are being published, even though the only ones that seem to sell are celebrity memoirs, self-help guides, political diatribes and the occasional novel endorsed by the distinguished critic Oprah Winfrey. To compound the ironies and further confound understanding, a glance at *Poets & Writers* magazine—a bimonthly journal for publishing or aspiring authors—reveals an unprecedented proliferation of literary prizes, creative writing programs, writers' conferences, writers' retreats and related professional services, suggesting that somehow the writing business is booming.

The simultaneous decline of reading and increase of writing seems paradoxical at best and at worst perverse, but these contradictory trends may stem, to a great extent, from the growing power of the computer and the Internet to shape the processing not just of information but of narrative and intelligence itself. People continue to read, but more and more their

reading occurs on computer screens and less and less in books. This may in some ways be more natural—the brain's electronic circuitry has more in common with that of a computer than with sheets of printed paper—but along with the other forces conspiring to speed up our cultural metabolism, it signals serious changes in the ways we think.

Marshall McLuhan's optimistic vision of a postliterate, electronically interconnected "global village" was prophetic but half-baked. McLuhan's paradigmatic medium was television, through which he foresaw a greater and more harmonious network of worldwide communication. The zillions of channels now available via cable and satellite technologies, combined with the infinite multiplicity of the Internet—not to mention the nonstop squawking of talk radio—have created much less a united global village than an endlessly cacophonous tower of universal babble. The volume—in both quantity and noise—of so-called information assaulting us constantly has created an epidemic of attention-deficit hyperactivity and unreliable intelligence.

Unlike a television or computer screen with myriad channels and news crawls and links and pop-ups and commercial digressions, a work of literature in book form requires the kind of sustained involvement that ideally draws its reader deeper into the theater of his or her own imagination rather than outward into the world of a thousand optional distractions. Reading a literary novel or poem means engaging with its author's creation at a level of intimacy akin to private conversation—a refuge from the clamor of public discourse. The personal voice of a lyric poet or the revealed inner life of a novelist's fictional character is both a window into the world of another individual

and a mirror of our own humanity. Those who still relish this kind of reading, and who make time for it amid the cultural coercion to rush off to the next self-unraveling activity, value the old-fashioned book as a brake on mindless "progress," use it as a way of slowing down.

It is in such moments of slowness that we can reflect, consider, think, regain our balance or be carried into an imaginary zone of restorative enchantment that both stimulates and calms the mind. A good read for its own sake—rather than for some urgent exterior purpose—can be an oasis of meaning amid the pointlessness of so much worldly blather and agitation. People who still read seriously do so to reclaim a realm of sanity in a social universe that feels increasingly deranged. The technological juggernaut can't be stopped, globalization is a fact of postmodern life and political history may be careening beyond the control of anyone, but a great writer can console us by engaging us in the adventure of consciousness.

Perhaps that's why so many people—according to all the evidence, more than ever—aspire to be writers in these technopostliterate times. The industrialization of "creative writing" in a time of decreased reading appears to defy the law of supply and demand, but there's a perverse logic to this phenomenon: If most writers can't make a living through sales of their books, teaching may be a convenient safety net for the otherwise unemployable. There was a time when writers taught literature—many still do—but more and more they're employed by creative writing programs, which manufacture new lines of freshly minted "masters" every year. Beyond the academy there are countless conferences where, with the right combination of creative talent, social skills and luck, would-be authors can

workshop, shmooze and network their way to publication.

But why would anyone want to be a writer when nobody's buying books? One reason might be the affirmation of one's unique existence that's evident in a work of one's own creation. I write, therefore I am. My personal story distinguishes me not only from the mass of humanity—the nameless multitudes that may or may not ever pick up my book—but from the impersonal dehumanization of a technocentric society. Updating Thoreau: Machines are in the driver's seat and drive mankind. Faced with an increasingly computerized if not robotic reality, aspiring writers may simply be trying to rescue a sense of pre-electronic identity.

What's doubly or triply ironic about this trend is the fact that computers themselves—those ingenious extensions of the human brain—facilitate people's ability to compose and even publish their own works. How curious that the very machines that have contributed so much to the decline of reading books have at the same time made it so much easier for anyone with half an idea in their head or an inclination to tell a story to get that story down in recorded and possibly publishable form. The computer has further democratized writing as neither the pen nor the typewriter ever could. Like teenage rockers with electric guitars forming bands in their garages, legions of writers have launched careers thanks, at least in part, to an instrument practically anyone can play.

As one still timewarped in the 20th century who has resisted the imperative to upgrade his equipment—I'm writing this with pen and paper before typing it on my 1974 Adler manual portable—I've heard from hundreds of well-meaning techno-evangelists how much easier my work would be for me if I'd

just convert to the church of the computer. That may be so, but who says writing should be easy? The very ease with which virtually anyone can crank out text may have something to do with the proliferation of books that nobody reads. *You can move things around,* I've been told a thousand times, as if that's really a great thing. My preference when writing is to think each sentence through and permit the composition to proceed organically from one paragraph to the next. The technologically abetted ability to spill out sentences or partial thoughts in any order and then go back and rearrange them into something resembling coherence strikes me as a diversion from the discipline of thinking. But then of course I am, like, totally retro.

Yet isn't writing, and literature itself, hopelessly behind the cultural curve? Even libraries, those bastions of literacy, have increasingly in recent years (with help from Bill Gates) replaced books with computers as tools for research. People I know who teach report that students almost universally exploit the Internet instead of books as a source of scholarly information, as if a quote pulled out of cyberspace (and out of context) automatically carried the same weight as one gleaned from the more deeply invested reading of entire books or articles. The credulousness of many Internet users, their lack of critical discrimination about the sources of their so-called information, makes one wonder about consequences for truly informed understanding.

The rambling blabbery of bloggers is one more symptom of creeping Internet aliteracy. For every online magazine written in real prose of considered purpose there are thousands of self-made self-absorbed commentators—many of them otherwise intelligent people—whose style amounts to nothing more than

high-speed logorrhea, as if they had taken some verbal laxative before they sat down to type. Such freewheeling virtual conversation, or journalism, or whatever it is, may further democratize public dialogue, but like the jabber of cellphone users who insist on narrating their most banal accomplishments ("I just got off the plane…"), it also debases language. The thoughtfulness required to compose an old-fashioned letter or essay is in danger of going the way of the fountain pen—an instrument reserved for the elegantly eccentric.

So it's no wonder that the literary novel is an endangered species. Who has time to read real sentences carefully constructed by a conscientious stylist for the sake of some nonexistent reader with the patience and inclination to savor their shades of meaning? Who knows how to sit still for a spell without electronic assistance and surrender to the power of a great storyteller? Who can slow down their psyche enough to engage the subtlety and nuance of poetry that's more than slam-bang entertainment? Plenty of people, surely—the same kind who take time to read such pages as these, a few of whom will always be around to keep the novel alive long after its latest demise has been officially declared. And it's those kinds of readers who are most likely to write whatever future literature we can hope for. Because, contrary to current trends (of people who write but don't read), reading great books is a precondition of writing them.

There's no going back to some imagined golden age when books were the primary carriers of knowledge and wisdom and pleasure and entertainment—they've been eclipsed by too many flashier means of data transmission—but for those to whom they continue to matter, real books, however margin-

al to the currents of popular culture, remain an irreplaceable source of spiritual and intellectual nutrition. There's nothing else quite like the excitement of discovering a great writer, dead or alive, and exploring his or her work, unplugged, as far as it leads the mind. In a world of unlimited dissonance and stupidity, good books remain the most faithful allies of creative reason and awareness, and reading them, in these stupefying times, can be an act of resistance.

Save the Letter

[1997]

Last November I was in New York for the 50th-birthday celebration of a childhood friend with whom I've stayed in touch for the past 20 years through correspondence. My friend, a veteran journalist, was posted during this period in such exotic locales as Washington DC, New Delhi and Tokyo, while I remained mostly in California, but we managed to keep each other informed of our respective lives and adventures via the time-tested medium of the mail. Occasionally we found ourselves in the same place—Manhattan, Monterey—and relished the chance to shmooze in the flesh over a slow meal, that most civilized of conversational settings: but bridging these rare and treasured encounters our letters have been instrumental in keeping alive a closeness we've enjoyed since kindergarten.

As it happened, the weekend I visited New York the Public Library had on display "The Hand of the Poet," a splendid exhibit of original manuscripts and related memorabilia—letters, notebooks, photographs—of some of the century's all-star bards. On the afternoon of the evening in which I was to join a party of distinguished mediati in honoring my old friend's

birthday I managed to take a couple of hours to browse the cases containing these original documents. I found the letters especially touching in the casual eccentricities of individual expression, most notably for me not just the expected uniquenesses of ink and paper and handwriting styles but the remarkable variation in the distinctive signatures of much-used manual typewriters—the way the alignment of type, the impression of the letters, the density of inking due to ribbon or carbon condition, the margins, the typos, the handwritten corrections, the grades of paper represented an amazing range of visual designs, revealing as much about the writers' personalities as the more formal configurations of their published verse.

I confess to an archaic attachment to the manual typewriter. While virtually every other writer I know has long since converted to the computer, I remain devoted to my 1974 Adler manual portable, a machine which no less an authority than "Mr. Typewriter," the legendary Martin Tytell of Fulton Street, once told me would last forever "if you don't drop it." For going on 23 years my trusty Adler has been the instrument on which I've banged out some dozen books of poetry and translation, one novel and thousands of pages of journalistic and literary essays, not to mention countless letters. For most of my informal correspondence lately I use a vintage Olivetti Lettera 32 I nabbed for seven dollars at a garage sale, but in either case I'm in love with the old technology—its tactile resistance to the dancing fingers, its neo-primitive letterpress texture, its patient silence between sentences, its unplugged screenless esthetic and, not least important on the stormy ridge where I live, its ability to operate in a power outage.

Sitting down at home in what I call the Caffè Olivetti to

strike up a slow-motion conversation with some absent-at-present friend is one of the most satisfying rituals of my day. I write a lot of letters because, apart from the writerly pleasure of stringing sentences together without the self-consciousness of composing for publication, just letting fly with whatever thoughts or news or gossip may suit the recipient, improvising on recurrent themes developed over time with a particular correspondent or simply enjoying the sculptural clatter of steel type against the platen—apart from these intrinsic pleasures, I live to receive mail. The shapes and styles of my correspondents' envelopes, the images on their postcards, the commemorative stamps they select, the laser-printed or hand-scrawled or (more rarely, these days) typed addresses—these signs of personal life are a welcome antidote to most of the other junk cluttering my mailbox. Since many of my correspondents are also writers, I often sense in their letters a similar delight in the process of unraveling a line and riding it into the mind of a congenial reader.

And the contents of these privileged communications! The confessions of anguish and discontent, domestic or professional melodrama, romantic agony or bliss, soul-searchings, political arguments, confidences concerning mutual acquaintances, big-ideas-in-the-making, little narrative anecdotes of a day's otherwise unnoted events, declarations of affection, off-the-cuff commentary on happenings in the news—the letters that arrive in each day's mail are infinitely more interesting and informative than almost anything likely to light up the television screen (an appliance which, like the computer, I voluntarily live without).

What astonishes and saddens me about letter writing in

the current culture at large is how few people seem to do it anymore. Overworked, utterly victimized by time, driven by a pathological collective compulsion for instantaneity, tyrannized by techno-dictatorial imperatives, an increasing number of otherwise thoughtful and literate individuals have surrendered the leisurely elegance of the letter to the fast-forward "conveniences" of the telephone, the fax machine and, most insidious of all, email. Surely each of these media has its uses, and even its practical advantages in the world of commerce, but considered discourse and sensitive dialogue are not among them. As intimate as a telephone conversation can be, as efficiently business-expeditious a fax and as snappily hip and immediate a volley of email, their pleasures are far more ephemeral and less esthetically satisfying than the savored text sent in a stamped envelope.

"The Hand of the Poet" exhibit moved me in many ways, mostly having to do with the traces of the writers' lives revealed, but a pervasive subtext in this collection of singular documents was that these forms of intimate and idiosyncratic personal communication are becoming as antiquated as their media— the pencils and pens and typewriters these poets employed as their tools. I beheld the glass-encased artifacts with the combination of awe, nostalgia and estrangement one might experience in the presence of ancient papyrus or medieval illuminated manuscripts, remnants of a lost age superseded by the omnipotent hegemony of electronics. By far the least interesting or beautiful items in the show were the immaculately laserized pieces of some of the younger contemporaries. These printouts, compared to their hoarier companions, displayed a typographic soullessness that made me wonder what they were

doing there at all. Unless perhaps it was a stratagem devised by some subversive curator to expose the vacuity of the computer. One can't help wondering if cybermuseums of the future will display the email messages of neo-postmodernist literary-geniuses-in-a-hurry, complete with the interactive option of virtual dialogue with the dead.

Due to the demands of his profession, my journalist friend has advanced to the high-tech, top-of-the-print-chain technology that enables him to encode his copy directly into the system of his employer. And no doubt most if not all of the luminaries who toasted him that birthday night compose their important, up-to-the-minute articles and books on equally advanced devices. But the bumpily typed letters my friend once sent me from India remain in my files as one-of-a-kind evidence of the texture of his times abroad, and I know the rambling, irreverently affectionate reports I've scribbled or typed and filed with him over the years physically embody our bond in a way no other medium could. That epistolary intimacy, permanently cast in ink, is the next best thing to (and sometimes better than) being with the one who sent it.

"Letters," as John Donne once said on an 8-cent first-class postage stamp in 1972, "mingle soules." The decline of this tradition means the loss of something vital to both the literary record and our lives. If wolves and condors and pelicans, among other endangered species, can be rescued from the brink of extinction by crusading biologists, surely a guerrilla force of postally committed fighter-writers, armed with the various instruments of their trade, can be mobilized to save the threatened letter.

In Praise of the Postcard

[1999]

As one who has successfully avoided or ignored most of the recent technological advances in communications, I come to sing the praises of the humble postcard. Contentedly disconnected from the World Wide Web and the commercial plague of rampant dot-communism, I still like to maintain ties with far-flung friends, and so make frequent use of the US Postal Service. Writing a letter is like making love or engaging in a leisurely conversation, and these activities take a certain commitment and sufficient time to savor the exchange—time that, curiously, the electronic lifestyle seems to have eroded rather than enhanced. Even those of us who remain unplugged suffer from the general epidemic of being rushed. That's why the postcard is the perfect antidote to virtual hyperactivity: with a few strokes of the pen you can slow down time and make concrete contact with a faraway or nearby correspondent, offering the gift of a unique document whose other, graphic side is also an expressive image.

Like the haiku, the sonnet and other short verse forms, the art of the postcard demands concision and a certain lucid

simplicity. When I was a student traveling in Europe my first summer abroad, I remember cramming elaborate accounts of my adventures in tiny script on the backs of picture postcards of the places I was visiting, amazing my parents with the amount of detail I managed to compress into so small a space. Now that I'm older and more domesticated, my postcards tend to be more succinct but hopefully just as pungent, responding pithily to a correspondent's note or reporting on some personal event. Unlike email, which is famously quick and efficient but also sort of sterile and impersonally promiscuous in the ease with which one can zap out multiple messages, the postcard is an intimate medium, each one singular and original, the visual image on the other side specifically selected to speak to its intended recipient.

Every postcarder has favorite sources for the kinds of cards he or she most enjoys sending—museum shops, drugstore racks, flea markets, stationery stores, not to mention the occasional collectors' show. I look for postcards at rummage sales, junk stores, yard sales, art shows, wherever serendipity might present them. There's a shop in SoHo in New York City called Untitled, which has bins and bins of art and photography postcards organized by artist or category—a visit to this store requires at least a couple of hours for leisurely browsing. But my favorite postcard venue is a little paper-goods shop in the Bay Area (whose name and exact location I can't reveal) where, in the back corner, racks and racks of staggeringly various postcards are set up in no particular order, at a price of four for a dollar, for the exploratory pleasure of the investigative postcard hunter. Photos of wild animals or exotic landscapes; Ansel Adams or Walker Evans prints; kitschy touristic images and

silly jokes; portraits of legendary movie stars, authors, musicians, artists and athletes; reproductions of modern paintings, Japanese prints, European masterpieces, Persian miniatures or details of Chinese scrolls; antique travel or advertising posters; paperback book or magazine covers; historic photographs of urban architecture or international landmarks—these are just some of the irresistible images I've discovered in that wondrous corner—each of them to be savored as an art object and eventually destined for a particular individual on the occasion of some brief communiqué.

Selecting the card with the recipient in mind, spontaneously composing the economical message, affixing the stamp and sending it off via butterfly mail—that deliciously slow and delicate journey which, on arrival, may set off storms of psychic delight or simple gratitude for information conveyed or thoughtfulness expressed—this old-fashioned, timeless, intimate process, a seemingly small gesture in the flux of high-speed distraction to which we're all subjected, is a corrective to all the little everyday alienations: the junk mail, recorded messages, have-a-nice-days, telemarketing harassments, press-the-keypad options, ads of all kinds, Internet spam and generic crap bombarding us nonstop. Someone has taken time to inscribe a personal note on the back of a picture that carries its own esthetic or emotional kick, and the day is somehow made more real by this infusion of actual reality. To receive the postcard is to feel physically—in the texture of the ink, the shape of the script, the wit of the image selected—the presence and personality of the person who sent it. That feeling of connection, for me, is far more profound and soulfully satisfying than digitized bits of information zinging their way through fiber-

optic cables to appear on a screen or be spit from a printer.

A birthday or holiday greeting, a taste of tourism, a gentle reminder, a pointed retort, a light flirtation, a long-time-no-see note, a definitive kiss-off, a friendly inquiry, a bulletin of personal news, a note of condolence, an invitation, a confirmation of plans, a thank-you note, a conversational afterthought, an image sent for the sake of its own eloquence—the postcard is a remarkably versatile means of getting one's message across. Next to the letter itself, that voluptuous yet tragically endangered medium, the postcard endures as the classic low-tech way of staying in touch.

Google's Library of Babel

[2007]

By now you've surely heard about Google's Universal Library, a bibliotechnological project to make all the books in the world's major libraries available on the Internet at the click of a button. Stanford, Harvard, Oxford, the University of Michigan and the New York Public Library are scanning books page by page as fast as they can in hopes that before long anyone with a computer may browse or graze in their collections. The Universal Library knows no boundaries or borders, and in its infinitude promises freedom of information on the grandest scale imaginable, the democratization of knowledge, unlimited access for all. Whether more information means better information, or that people will be truly well informed, remains to be seen.

Due to my own skepticism, recalcitrance and technophobia, I am a relative newcomer to the dubious pleasures of the Internet. Now that I have my own email account and, for professional purposes, a Web site even, and occasionally search for facts and visit other sites for information, I am discovering the seductive, indeed addictive powers of this vast matrix of data.

Like the fruit of the Tree of Knowledge in the Garden of Eden, or like the deal Faust made with the Devil, Internet access has within it the seeds of a lost Paradise—no, not Paradise, a loss of the soul.

The Faustian bargain of the Internet is impossible to resist; it is human nature to embrace more knowledge, to reach for new discoveries, just as it is civilization's nature to advance its technical development. While some intellectuals, like Lewis Mumford and Wendell Berry among others, have warned against this trend, and while certain religious traditions resist such dangerous venturing into the unknown, for most of humanity the electronic juggernaut is not only unstoppable but desirable. For the developing world and its billions of hungry inhabitants, technological modernization, whether of farm equipment or desktop instruments, is the only plausible route to prosperity.

But for the individual, infinite information can be a vortex whose pull is perilous. Like the laboratory rat pressing the bar for more cocaine until its brain is fatally saturated, the Internet user is subject to the boundless allure of the machine of whose interactivity he may be as much victim as manipulator. Most people go to the Web for bits of information, facts or quotes that serve a particular purpose. Research is not comprehensive but highly selective. (People I know who teach tell me that their students routinely go online rather than to a book in search of documentation.) Of course this can be true of traditional research in books as well—only the most thorough scholars read every page of the available record. But the nature of reading on the computer screen, with its countless links which lead to other links, fundamentally alters the reading experience, and

the excitement of finding one's way through the ever-expansive networks of digital documents is a different and, to my mind, inferior procedure from the reading of actual books.

Literature, at least, can be called "information" only in the most generic sense. A novel or story or poem or play is neither a plot nor simply a narrative nor a system of data storage, though it may contain elements of all these abstractions. Works of literature are composed of idiosyncratic voices and strands of intertwining tales and melodies of wordsongs and imaginary people made from combinations of real people; they are informed and defined by such ineffable qualities as tone and mood and atmosphere and nuance and ambiguity and the rhythms of language as heard by a unique consciousness, the author's, in an idiom and style particular to his apprehension and interpretation of the world. While you can find plenty of information about whaling and whales in Melville's *Moby-Dick,* or about gloves and glove making in Roth's *American Pastoral,* that factual element is incidental to the ethical, moral, existential and esthetic questions raised in the course of their stories. By reducing the notion of books to one of information repositories, Google diminishes, dehumanizes and thus devalues the reasons we read books in the first place. The book as searchable cultural artifact displaces the book as a field of its own imaginary infinitude and mystery.

Jorge Luis Borges, in his 1941 story "The Library of Babel," invents a universe with a Library whose very architecture goes on forever in every direction in a cellular structure identical in each of its parts. On the shelves of this infinite Library are all the books ever written, in "all the possible combinations of the twenty-odd orthographic symbols...that is, everything

which can be expressed, in all languages. Everything is there: the minute history of the future, the autobiographies of the archangels, the faithful catalogue of the Library, thousands and thousands of false catalogues, a demonstration of the fallacy of these catalogues, a demonstration of the fallacy of the true catalogue, the Gnostic gospel of Basilides, the commentary on this gospel, the commentary on the commentary on this gospel, the veridical account of your death, a version of each book in all languages, the interpolations of every book in all books."

Sound familiar?

The millennial hopes of those who see in the Library's comprehensiveness a treasure of endless knowledge, even understanding, are revealed as delusional when the search for knowledge, for the books of "Vindication" which "vindicated for all time the actions of every man in the world," lead to chaos, violence and madness. People jump or are thrown over the railings of the Library's galleries, plunge through space and disappear. Borges's Library—initially a vision of Paradise— proves in its boundless bottomlessness to be more like Hell.

Another prophetic parable or fable, "The Remembering Machines of Tomorrow," written by W. S. Merwin in the late 1960s, envisions a future when the memory of all experience, then all experience itself, will be contained in machines, so that eventually every individual will have his own machine in which will be stored his own experiences. "The machines will retain, in flawless preservation…not only what their owners experience but what their owners think they have experienced, and will sort out the one from the other. More and more, such distinctions will be left purely to the machines. And it will be noticed that the experience to be retained is itself becoming a

dwindling fauna, clung to by sentimentalists, from afar, who still lay aside their machines for days at a time and secretly yearn for the imaginary liberties of the ages of forgetting."

Borges and Merwin, both visionaries anticipating the demonic allure of total knowledge, foresee a kind of informational apocalypse, a system of "intellectual content" whose immensity ceases to serve humanity the more it evolves toward being an end in itself. People lose their minds, figuratively and literally, in the face of such infinite totalities. The hazards of computers and their Internet-unreliable information, variable truths passing as absolutes, the dizzying and disorienting promises and possibilities of the Comprehensive—are brought home to the reader with maddeningly and thrillingly elusive suggestiveness. The warnings are implicit; they may not even be warnings so much as intuitive acknowledgments of humanity's destiny to progress inexorably toward self-delusion, an unfounded faith in the benevolence of progress.

It is this kind of faith in the goodness of Google's plans that I find suspect, the belief that humankind will benefit from the reduction of all the great works to "information." In a recent *New Yorker* article a Google executive speaks rapturously of a translation feature that will enable instant conversion of any book from or into any language. "In terms of democratization, you want to be able to access information," he says, and he expresses hope that "this world evolves so that there exists a time where somebody sitting at a terminal can access all the world's information." The idea that, say, Borges or Merwin, through the magic of translation software, might be read by anyone on the planet is in some way an exhilarating prospect— until you realize the inevitably comic results of literary trans-

lation done by robots. The *content* of such stories as "The Library of Babel" or "The Remembering Machines of Tomorrow" could not possibly survive the mechanical replication of a computer program. The literary art, the writer's signature, the flesh and blood of style and voice would be lost and only the skeleton of words remain to represent the original. The concept of information doesn't begin to touch what's going on in such a work.

I realize there's no stopping the inevitable, but I hope some individuals will proceed with caution into the black hole of infinite information. I hope that books in libraries remain physical objects for a while yet, enabling younger people, before they're completely consumed by their hand-held electronic devices, to expand their awareness in a different way through the wireless pages of a book that may open into imaginary infinities and reveal realities more enduring than the dancing pixels of the virtual. I hope that people will defend their own attention spans by refusing to let their machines do all their remembering, and that actual libraries, with finite collections of actual books on their shelves, will continue to seduce the curious with their limited but endlessly suggestive pleasures and revelations.

The Trouble with Publishing

[2009]

The unexpected death of John Updike in January came as a shock to me, not because I was a great admirer of his writing but because he was one of those authors you couldn't escape—practically every time you opened a magazine there was Updike's byline on a story or an essay or a bit of light verse, or a review of some new book of his, or news of his next one. Like Joyce Carol Oates, his chief competitor for most prodigiously prolific man or woman of American letters, Updike was a writing industry unto himself, and while I respected his energy and his skills I also thought there was something unseemly about his publishing so much—as if a little reticence would have added dignity and mystery to his gifts.

But publishing can be a kind of addiction: once you get a taste of your name in print, especially if it's you controlling the narrative rather than, say, paparazzi popping their flashes at you and gossip columnists chronicling your love life, you crave the gratification of seeing your work come to fruition, so if you're naturally driven to write a lot your instincts are reinforced, and you want more, and the pace of your production

is accelerated. Thus the drug of publishing—and the idea of fame, now all but obsolete for most literary artists yet still exerting a primal pull—draws more abusers all the time, especially now that anyone can upload their musings onto the Internet without having to submit to an editor.

Compared to the cacophony of the blogosphere—or the Babel Tower of most print, for that matter—the products of a traditional talent like Updike have a certain classical elegance with their finely wrought sentences and enormous erudition. Updike's vast learning was most evident in his criticism, where he could look at a painting or a show of sculpture or another novelist's work and appreciate it and analyze it in a large historical context. I much preferred his criticism to his fiction despite my occasional annoyance with its perennially sunny tone—even on the attack his prose seemed to wear a mild-mannered smile on its face—because he was so smart and could take apart whatever he was talking about with a kind of casual grace that was informative and even fun to read.

But Updike also bugged me because he wrote and published so unceasingly, and while admirably earning his living from writing rather than teaching (as so many writers are now compelled to do), he exemplified in some way the careerism that many a student writer now pursues as more or less an end in itself. The creative-writing-industrial complex is crawling with little aspiring Updikes whose idea of auto-apotheosis is getting their story or poem in *The New Yorker*. Now, *The New Yorker* is a fine magazine (though I generally prefer its nonfiction to its fiction, and don't even get me started on most of the poems), but the hunger for what *The New Yorker* represents, its tasteful respectability, its epitomization of success, its standard

of conventional accomplishment, can also represent creative death.

What makes for interesting art, as far as I'm concerned, is a kind of daring or terrible honesty that may not be quite polite enough to be considered acceptable by the tastemakers. Occasionally *The New Yorker* will publish such a thing—I remember in the 1990s Harold Brodkey's bitter meditations on dying of AIDS, a case of someone with nothing to lose who ripped the mask off of some of the uglier machinations of the New York literary and publishing worlds—but most often it stays within the boundaries where no one will take offense.

Perhaps the redeeming virtue of the Web (for all its vices that I've railed against) is that it opens up the discussion and allows for an infinite range of voices and points of view even if nobody's paying much attention. In print, people tend to be a little more discreet about taking a heterodox position and potentially stepping on someone's toes, thereby sabotaging their own prospects for advancement. The mainstream publishing subculture is such a close-quartered ship—and one that may be going down anyway due to the changing media seascape—that it's best not to rock the boat. The free-for-all of contemporary culture has leveled the playing field to such a degree that everyone's work is equally irrelevant.

People who do get published in print tend to be part of the vast network of professional networkers whose talent for forging strategic alliances and making connections has as much to do with their publishing success as the quality of what they write, in some cases maybe more. I know many authentic writers and poets who don't even try to publish anymore because the market is so glutted with hustling scribes that it's virtually

impossible to get an editor's attention. This could be a sign of cultural health, the proliferation of publishable stories and poems signaling a great imaginative fertility abroad in the land. Or it could just mean that what was once a vocation—the near-monastic commitment to the creative life—has been turned into a mere career path in the writing industry where the soul-making necessity of art has been reduced to just another profession where the practitioner's primary goal is to get ahead.

Ambition, of course, is nothing new, and there's nothing wrong with wanting what you've done to be acknowledged for its value. Most of us would welcome a little recognition for contributing a bit of truth or beauty or excellence of some kind to the world. But in the United States in 2009 visibility, for many, is the whole point, whether it's by creating a masterpiece or making an ass of oneself on television (let alone YouTube). Thousands of people pay good money every summer to attend conferences and workshops where they may hope to improve their writing but, more important, improve their chances of finding a publisher. These conferences and workshops—on top of the countless MFA programs that bring in the bacon for starving US universities—are symptoms of the ever-increasing meaninglessness of calling oneself a writer.

It's not that there's anything intrinsically wrong with publishing (I've done it myself from time to time) and writing is, after all, communication—it could be said to mean nothing if no one reads it—but most of the people who've inspired me have been those who would have been appalled or at least befuddled by the notion of a workshop as a place to develop their art. Rilke, Beckett, Hopkins, Kafka, Henry Miller, Virginia Woolf, Bukowski, even such sociable journalistic types as Borges and

Camus and Dostoyevsky, all created from a place of such deep individuality that their genius would have been compromised if not contaminated by subjection to the common denominator of other people's variously informed opinions.

Spontaneous communities of writers are one thing—those serendipitous convergences of (usually young) aspiring artists who find themselves in the same place at the same time and egg each other on in mutual inspiration and competition—but institutional and therefore artificial gatherings of these same types are something else, though I'm not sure exactly what. I know that writer friends of mine who teach are touchingly devoted to their students and to helping them find their own authentic voices. And surely these budding bards are grateful for the encouragement and some may well go on to create work that enhances their lives in some way and, who knows, maybe even get published.

I've led workshops myself, in amateur rather than academic settings, and one's natural instinct is to offer a positive response to anything that's alive in the students' work and try to explain what isn't alive, and why, in the hope that it will help them realize something gratifying—not necessarily for publication but for the satisfaction of catching in language some experience, some feeling, some combination of thoughts or ideas or perceptions.

But I also know that when I decided, at 18, that I wanted to be a writer, I took to the study of literature as a way to discover how it was done. I did take one course in expository writing and, later, a poetry workshop, and I suppose I gained at least a little more time to sharpen my technical skills and to exercise my imagination. But mostly I read real writers and tried

to write about them in a way that helped me understand what they were doing. And every time I would show my own poems to the teachers I thought might be supportive of my efforts— that is, the poets and writers whose courses I took—they universally advised me to stick to criticism. Nobody tried to boost my self-esteem by telling me I had any talent, but somehow this lack of affirmation only made me more determined to be a poet anyway and prove them wrong.

That's why I always advise my writer friends (only half-jokingly) to discourage their students from becoming writers, because then only the ones with the most irresistible motivation will press on with the effort and maybe amount to something. Not everyone (hardly anyone) can be a Czeslaw Milosz or César Vallejo or Melville or Joyce or Proust, but anyone with the courage to face the truth of their experience and the fruitful lies of their imagination and the magic of language may find reflected in their own pages, or staring back from their computer screen, a vivid approximation of something real. The desire to publish, powerful as it is, may eventually give way to the rewarding agonies and pleasures of the work itself.

Writers on Strike?

[2007]

The recent writers' strike in Hollywood got me thinking about the writers I know—mostly poets and fictionists—virtually none of whom earn a living from their writing. As there is little to no commercial demand for what they do, even the most "successful," i.e., published, of these writers either have day jobs (most commonly teaching) or are unemployed and living by the skin of their wits. Teaching can be rewarding in many ways, but for a writer it can also mean the dilution of one's creative and intellectual juices in an endless stream of bureaucratic and administrative duties, not to mention the aggravation of trying to impart a love of literature to students too umbilically attached to their electronic devices to be bothered to read a book.

Writing literature in the 21st century is, with a few exceptions for those whose luck it is to have hit a popular nerve, a losing proposition—at least in terms of material reward. I know many writers who would love to "sell out" if only they could figure out how. Yet those who have—the scribes responsible for television scripts and late-night comics' monologues (why alleged comedians can't write their own jokes remains a

mystery to me)—complain that they aren't receiving their fair share of the revenue generated by their efforts. They may be right, but for most literary writers such calculations are beside the point; of course they'd like to get paid for what they do, but it is precisely the lack of commercial value in their work that gives them the freedom to do it. The marginality of poetry and literary fiction in a marketplace increasingly dominated by nonfiction and even non-book products liberates these poor writers from the tyranny of popular demand. It's a cruel paradox, a joke at the expense of those who, oddly, benefit from their own irrelevance. They're free to say what they please because nobody's listening.

But what if poets and fiction writers were to go on strike—would anyone care? Surely there are plenty of books in print to keep what few readers there are busy for the rest of their lives; just catching up with the classics would take most of us a lifetime, and as Borges said, the real pleasure of reading great works is in rereading them. So very likely no one would miss the torrent of poems and stories currently pouring from the computers of so many struggling typists. Maybe if they were to take time off to picket the homes and workplaces of those who don't read them, demanding a little attention and respect and compensation for their unacknowledged labors, the great mass of nonreaders would realize how much they miss what they never noticed.

But probably not.

The world would simply get on with its business, and even publishers and Oprah wouldn't care because there's no shortage of already published books to recycle and promote and market and exploit. And the poets and the writers of stories

and novels, like the air traffic controllers of the 1980s who were fired by Ronald Reagan, would find themselves out of a job. But since it was a job they never really had, these unemployable wretches—driven by compulsions and obsessions even they don't understand—would meekly go back to work, slaving away for a master who does not exist except in their own imaginations.

For the truth is that real imaginative writers—and the greater the writer the truer it is—can't be kept from writing. This isn't to say that all of them write nonstop their entire lives—the Mexican master Juan Rulfo wrote only two slim volumes of fiction, *Pedro Páramo* and *Llano en llamas*, and they were enough to secure his place in the canon of Latin American literature—but that great art is born of necessity; that the artist, possessed by his muse or *daemon*, can't *not* proceed to elaborate his vision. Writing, like music or dance or painting, can be seen as a kind of pathology: the practitioner knows that what he or she does may well be pointless or useless or without an audience, yet goes ahead anyway because the impulse to create cannot be stopped.

That's why the notion of "writer's block" has always struck me as bogus. I know plenty of writers who are kept from their work by various concrete obstacles—jobs, family duties, practical circumstances of one sort or another that amount to no time left in the day—but somehow they manage to work around these blockages and do what they must in the way of writing, even if it means staying up all night or rising before dawn. The writer who feels "blocked" by his own psychic inability to put one word after another may just need to take a break—go for a swim, take a walk, wash the dishes, work in the garden, go

to a movie. The words will come when they have to and not before. Or if he simply must torment himself by sitting at his desk and facing the blank page or the computer screen, there are countless exercises that can get his language moving, and even the most nonsensical gibberish may sooner or later give way to something meaningful. But to blame one's inability to write on "writer's block" seems to me just another way of saying that one has nothing to say.

And there's nothing wrong with having nothing to say. It's not as if the world needs another poem, another story—there are more than enough already—and as my teacher Robert Duncan once said, poets aren't factories; there's no rule that says they have to produce a certain number of units in any particular amount of time. Duncan himself, a poet's poet, refused to publish a book for several years during the Vietnam War as a way of making a statement against America's murderous policies. Gabriel García Márquez, in a similar gesture, stopped writing fiction for a while in protest of the Pinochet dictatorship in Chile. But neither of these writers could be silent for long—and when one thinks of the poets and novelists forcibly silenced or driven into exile by various 20th-century tyrannies it seems a bit perverse, even as a gesture of protest, for writers to voluntarily silence themselves.

That's why the so-called writers' strike has hardly anything to do with the kind of writing that truly matters and everything to do with commerce. Hollywood's writers *are* factories, and are responsible for cranking out the crap that passes for entertainment for a public too stupefied by their own enslavement to do anything more than turn on a screen to take their minds off their condition. Perhaps if the screens went blank long enough,

people might go back to reading books. Then poets and novelists, now mostly ignored, would have something useful to do.

A Screen of One's Own

[2004]

Attendance at Broadway plays was up this summer. This is noteworthy because, almost everywhere else in the landscape of traditional culture and entertainment, business is not so good and getting worse. True, kids still go to rock concerts, and geezerly baby boomers drag themselves out to see the Rolling Stones and other hoary pop stars hopping around on the arena circuit, but the music industry is freaking out because tech-adept consumers' downloading skills are cutting into CD sales and rendering record labels impotent to control their product's distribution. Book publishers are panicking because apart from the occasional Harry Potter or da Vinci-meets-Dracula phenomenon, they can't figure out how to get people to buy their goods. Museums depend on extravagant blockbuster shows and related marketing campaigns, replete with gift shops and their kitschy tchotchkes, to pull in paying customers. And opera, classical music, ballet and modern dance, which have long been marginal enterprises from a business standpoint, have become even more financially precarious for their producers.

Even the movies, that most engrossing form of cultural diversion—the most costly, the most lucrative, the most mythic in its creation of celebrity—are in a slump that has the industry searching its soul for the causes of the sharp drop in attendance at the cineplex. Beyond the fact that so many recent films are lousy, witless, unoriginal, gratuitously violent, exploitative, special-effects-driven, formulaic rehashes of tired stories aimed at a target audience of testosterone-poisoned adolescent males too busy playing video games and fingering the keyboards of their own computers to want to shell out a small fortune for movie tickets, even older folks can now stay home with their flat-screen plasma sets and surround-sound systems and rented or bootleg DVDs and have their own private movie experience without the hassle of driving and parking and the other inconveniences of the outside world. Television sets, with their zillion satellite and cable channels and their seemingly limitless selection of "reality"-based and fictional programs, however moronic or inane, are also an obvious option for the exhausted consumer who just wants some relief from his or her own crummy reality.

Internet evangelists have been bragging for years about the Web-enabled democratization of information and culture, and now bloggers are proving that anyone with a few electronic tools can run their own 24-hour news and/or entertainment channel; people can publish their own virtual books online and circulate images around the globe without the intervention of a store or gallery; digital video cameras make it possible even to produce one's own little movies or visual diaries and post them for the edification or titillation of strangers—Andy Warhol's prediction that everyone will be famous for 15 minutes today

feels truer than even he might have imagined. Stardom may be reserved for the truly talented or exceptional, but celebrity is within anybody's reach.

So the cultural playing field has been both atomized and leveled, and advances in technology can claim most of the credit. Children have at their fingertips a dizzying array of information, and everyone may graze at a buffet of data more vast than anything previously known to humanity. But as the Mexican novelist Carlos Fuentes said in a talk I heard him give ten years ago, "The biggest hoax of the information age is the idea that people are well informed." On the contrary, sheer masses of so-called information, the quantity and multiplicity of disembodied "stuff" coming at us from all directions, including what passes for cultural life, minus the tools and skills of critical intelligence—the ability to discern what's true or useful from what's not and to organize it in some comprehensible form— is more likely to cause confusion than enlightenment. Virtual communities of like-minded people can explore their favorite subjects at great breadth, and access to such resources is one of the gifts or givens of our time, but looking around at what passes for culture one has to wonder about the value of so much indiscriminate access.

In the 1940s and 1950s, existentialist philosophers like Sartre and Camus explored the terrible burden of human freedom: if man is free, he is responsible for his choices, but the range of those choices can give rise to a kind of paralysis. Anyone who has ever dined in a delicatessen with one of those huge multipage menus has had a glimpse of such an existential crisis. This principle, as disconcerting as it is exhilarating, easily translates to the digital age where existential choices

are exponentially compounded. In his landmark 1979 book *The Culture of Narcissism* the American historian Christopher Lasch described some of the psychic and social defenses thrown up against an increasingly bewildering modern reality and lamented a retreat from the public commons into increasingly private, or privately constructed, fortresses of self. Now, as technology makes more and more possible the creation of one's own virtual world, Lasch's diagnosis feels even more profound than Warhol's prophecy of a universal 15 minutes of fame.

With the slow erosion of the public sphere—of which the movie theater may be the most telling symbol—and the rise of individual technologies (iPods, video-cellphones, etc., ad nauseum), it's easy to foresee a time in the near future when virtually everyone will be making their own movies, downloading them into their own home entertainment complexes, launching them into the ether via their own computers, and watching their own or their friends' or strangers' videos in the privacy and safety of their own living rooms, bedrooms, kitchens, bathrooms and cars. Narcissism meets voyeurism, which are finally two sides of the same mirror. New marketing techniques will no doubt channel these homegrown personal cultural products to their targeted demographics, celebrities and ordinary mortals will be indistinguishable, and everyone will consume their own and each other's images happily ever after.

Armageddon
Will Be Televised

[1983]

If Marshall McLuhan's dictum that the medium is the message required any additional proof, it was provided last week with the showing of *The Day After* on ABC-TV. Hyped relentlessly for weeks in advance by mainstream and alternative media alike, this pseudo-realistic nuclear soap opera had 100 million or so Americans glued to their sets for over two hours in search of images with which to stoke their pre-traumatic stress, as if the news of nuclear war and its horrors had not been circulating since 1945. Somehow believers in TV seem to need to see it on the tube before they can feel the reality of anything. Ronald Reagan's ascension to the presidency has brought this principle home in the worst way, along with the unfortunate corollary that, with Reagan on the box, radiation can't be far behind.

Speculation has it that the collective "experience" of watching this film may mobilize previously ignorant and/or uncommitted Americans toward some kind of antinuclear activism before the doomsday clock strikes midnight. Another line of thinking is that the movie will serve to further paralyze those already living in a state of despair on account of the impending

apocalypse. In either case, the nuke-u-drama which overnight became a "national event" appears to have carried some propaganda value—although for what cause, it's hard to tell.

One thing is certain: the sponsors of the show—peddlers of various breath-fresheners, nasal sprays, cameras, cars, computers and even a brand of microwave popcorn (presumably to scatter on the roof in case of nuclear attack for a light snack in the aftermath)—got maximum exposure for their advertising dollar. Fittingly, once the missiles started flying there were no further commercial interruptions. Even Hollywood has the good taste not to interrupt a holocaust-in-progress.

Now before going on to contemplate the implications of this picture, I'd like to consider the film itself as art, placing it in the context of a larger war/horror/disaster genre in order to better appreciate its weaknesses and strengths. As any politically creative person knows, there's a profound relationship between effective agitation and esthetics. If Dylan's declaration that "propaganda all is phony" contains a kernel of artistic truth, it's also true that certain kinds of propaganda, imaginatively staged, can open people's minds to changes they might not otherwise consider.

By setting their story in Lawrence, Kansas (rhymes with Lawrence Livermore), the creators of *The Day After* were aiming their message squarely at the dead-center of the American psyche, a suburban vortex innocent of warfare.

War comes to Kansas by way of special effects. The flashes of evaporating people, the engulfing firestorms, the steadily disintegrating flesh of survivor-victims are graphically depicted in the finest Hollywood tradition. If the makeup is less convincing than the more technical fabrications, that probably has

to do with the fact that makeup is connected to human faces and that the people in this film were the least realistic element of all. Clearly *Frankenstein* or *Dr. Jekyll and Mr. Hyde* or *Night of the Living Dead* are all superior works in terms of both fright value and characterization. The bland inhabitants of *The Day After* are far less interesting than the technology that wipes them out.

For technology is the star, and the Bomb itself the block-busting superstar. The most lyrical, awesome image in the entire film is the lingering shot of those just-launched ICBMs gracefully arcing out over the cornfields en route to blow the Russians to Kingdom Come. The *knowledge* that in half an hour complementary Soviet missiles will arrive to pulverize Kansas is more terrifying than the blast itself, and the suspense of the intervening minutes with their fatal understanding that it's too late to do anything but kiss-your-ass-goodbye is infinitely more agonizing than the subsequent sight of the blasted protagonists staggering through the streets.

Another poignant and effective scene is the one in which the electromagnetic pulse of the initial explosion simultaneously stops all the cars on the freeway—a horrifying scenario with which any anxious commuter can identify. In fact, the development of a weapon that would simply discombobulate automobiles would strike more fear into the hearts of Americans, and wreak more havoc with our way of life, than anything so abstract as total annihilation.

So apart from everybody's cars conking out, what's so scary about *The Day After*? I'd venture to suggest that it's the prospect of war—even imaginary/TV war—coming home to hassle the middle class. The fact is that every day nonwhite/Third

World people, primarily the poor, suffer precisely the kinds of torments depicted in this film (if not on quite so grand a scale). Being blown up by conventional bombs, or cooked with napalm, or disemboweled by a death squad, or simply sprayed with machine-gun fire while spread-eagled naked on the ground are certainly no less devastating experiences than being fried by a fireball. The Palestinians, Guatemalans, Salvadorans, Vietnamese and others who've been through hell in recent years would hardly be impressed by the ersatz agony of Jason Robards. There are definite connections between the little wars being fought in various corners of the globe and the Big One portrayed in *The Day After*. The radios and televisions in the film—which play an engagingly gripping supportive role to the more blatant military technology—faithfully report how a border skirmish in Europe escalates into total war. Local conflicts carry the seeds of all-out confrontation; the belief that the US can intervene elsewhere without eventual domestic fallout is naive. There's no such thing as a safe distance.

The grim reality of this configuration seems to have impressed a lot of people all of a sudden—even the Reagan Gang, whose Secretary of State was given first crack at rebuttal on the postgame show. Shultz, in classic Orwellian fashion, reassured the ruffled public that war is peace and that the multi-billion dollar nuclear buildup currently in progress not only reduces the chance of nuclear war but somehow amounts to an actual reduction of weapons.

Shultz's face, it should be noted, looked far more wasted than the faces of the actors we'd just seen nuked in the film. What this indicates about the rigors of Reaganoid statecraft— or the meltdown point of makeup mixed with alcohol—I leave

to the reader's imagination. (It's sobering to think what Alexander Haig might have said in the wake of *The Day After*.)

Actually, the postgame show, with its famous "panel of experts," was much more interesting than the movie itself. It was a treat to see William F. Buckley revealed as the imbecile he is, hopelessly mired in the slime of his own ego, from which no feat of polysyllabic rhetoric could rescue him. The Bob & Henry team of McNamara and Kissinger—the boys who barbecued Vietnam—looked almost rational next to Buckley's blubberings. Kissinger and McNamara are definitely experts on the mechanics of immolation, but so is Richard Pryor, who wasn't invited to testify.

I would have settled for Daniel Ellsberg, Helen Caldicott, Pauline Kael and a punk band as more appropriate commentators on the questions raised by the film. Carl Sagan's remarks about the reality of the situation being far worse than the TV version were refreshingly appropriate, however. And Elie Wiesel's comment that "the whole world has turned Jewish" may have been lost on the WASPs of the Midwest but must have struck a few chords in New York. It's healthy to recognize that no particular ethnic group can claim exclusive rights to words like "genocide." Numerous Third World peoples have known this for years. Now, with help from high technology, we can think of ourselves as all in the same camp, candidates for the same massacre.

If all it did were to raise this issue a few notches in the national consciousness, *The Day After* might finally offer some evidence of TV's redeeming social value. That the show has generated so much discussion is somewhat encouraging. The basic information in this movie, though, has been available for

38 years. Why it's taken so long to recognize the fatal implications of Hiroshima is a mystery. Still, one hundred million people is a lot of people, even if they're only watching television. It's an open question how many of those will have the sense to leave the screen before the show is over. "TV brings us together," claimed the generic commercial after *The Day After.* Maybe the bomb can bring us together, too.

Hollywood Wax Museum

[1989]

Hollywood Boulevard on a Saturday night is something like the inside of a pinball machine: lots of lights and noises and colors and barely controlled chaos, bumper-to-bumper cruisers with their basses booming, patrol cars parked in the median lane to keep people moving along, heavily made-up hookers in mini-shorts and spike heels on the sidewalks, young clean-cut Christians singing acoustic folk songs for Jesus, touristic gawkers with their cameras dangling...and visiting alternative newspaper publishers in town to attend the annual convention of the Association of Alternative Newsweeklies, held this year at the Hollywood Roosevelt Hotel. It was a homecoming of sorts for me, a chance to revisit an old stomping ground that echoes with many powerful personal and mythic associations.

My parents, young newlyweds from Seattle, spent their honeymoon at the Hollywood Roosevelt in 1933. It was the glorious era of the great studios, and Hollywood Boulevard perhaps the most glamorous avenue on the planet. Movies were the magic potion that lifted the American imagination out of the Great Depression and transformed LA from an offbeat outpost

of spiritualists and real-estate developers into the imagery capital of the world, an industrial center whose product was pure fantasy manufactured for the masses by vast money-generating mechanisms. Along with the aircraft and aerospace industries, the Industry—as the entertainment business is known there—still dominates the psychic and economic landscape of Southern California. A few months before I came into the world, my parents moved to LA and I was born within a mile or two of the hotel where they'd spent their honeymoon.

Growing up in nearby Beverly Hills, I started venturing into Hollywood at an early age. My grandfather, a Russian immigrant who taught me to play poker when I was three, lived with Grandma in their own apartment on one side of our house and often took me, before I was old enough to go to school, on the electric streetcar that ran up to Hollywood, where we'd go to whatever monster movie was showing. Gramps would hold my finger in the scary parts, and after the popcorn and horror were over we'd ride home into the sunset of a late afternoon among the commuters of early-fifties LA. You could still see the San Gabriel range, and on the other side of the Santa Monicas the San Fernando Valley spread out like a half-baked wilderness, too hot and remote to harbor civilization. The Los Angeles basin, a desert turned semitropical hothouse with stolen water and imported flora, still enjoyed good enough air that you could burn your garbage in the backyard incinerator and your eyes didn't sting after a day downtown.

Later, in the mid-sixties, when I was a tormented adolescent, a student at UCLA and a zygote writer, I used to drive up to Hollywood to cruise or, in more reflective moods, to explore the many excellent bookstores and all-night news-

stands of the boulevard. It wasn't really books I was looking for but the human drama of faces glowing in the unnatural light, people on foot after dark in search of god knows what but at least they were on the street—unlike the sad suburbs of the Westside where pedestrians were virtually unseen. Hollywood along its main arteries was truly urban and exuded a sense of ferment and decay, rich compost for the shoots of a young poet's soul. Each strange face had a strange story, possibly pathetic or grotesque but fascinating: losers looking for what they'd lost, or seekers of the magic already vanished from the fading theaters—so many illusions swimming in the same soup that the appetite for adventure was nourished.

Back on the boulevard in 1989, stepping on the implanted stars meant to immortalize both famous and long-since-obscure showbiz celebrities along the Walk of Fame, I found a Hollywood that remains one of LA's most interesting attractions but for different reasons, a street where the movies have gone to seed and the seamy, shabby, tawdry underside of the imagery business shows its ghoulish face. Like the figures in the wax museum a few doors down from the Chinese Theatre, strollers along the boulevard may become momentarily confused as to whether they're among the dead or the living. There is a glazed awe in the visages of tourist and junkie alike, an earnest faith printed in the pamphlets of the evangelists, a childlike curiosity in the hands and feet of pilgrims pausing to compare their prints with those of Marilyn Monroe, Clark Gable, Rin Tin Tin and whoever else stuck themselves in wet cement at the invitation of entrepreneur and impresario Sid Grauman.

In the cheesy storefronts of Hollywood Boulevard the image of Marilyn reigns, a religious icon cranked out by the millions

by the memorabilia manufacturers. She is the Virgin of Guadalupe bleached blonde, more innocent and pitiful than ever in real life. The chicken salad sandwich in the Roosevelt coffee shop is called a Marilyn Monroe. Her face is molded around table lamps, blown up into larger-than-life posters; her legendary lips that kissed John Kennedy and Joe DiMaggio and Arthur Miller murmur unspeakable stories; her body is the archetype without which there would be no Madonna. Marilyn is everywhere, lifeless, and sadder than ever.

If Monroe is the virgin queen of Hollywood, James Dean is her consort. I remember vividly the night Dean died because he was a racing buddy of my brother and his fatal accident occurred as I was throwing a party for my second-grade friends. Though I don't recall meeting him, he sometimes parked his motorcycle next to our garage, so news of his death had a personal relevance beyond his fame as an actor. Now Dean the legend belongs to everyone and his picture looks out from t-shirts and postcards and secular shrines reminiscent of those to Che Guevara in Cuba or Sandino in Nicaragua, only Dean is an almost purely commercial commodity, symbolic only of fast dead youth and nostalgia for an innocence that never was. The moody rebellion Dean the actor stood for has been sucked dry by the vampires of consumption, another image for the dreamless to feed on.

And then there is Elvis, to round out the ghostly trinity, an Elvis of the 50s like Dean and Monroe—not the drug-bloated decadent besequinned Las Vegas robot of later years—writhing in the possession of a wholesome rock and roll on oversize posters and sickening little knickknacks to decorate the poorest apartment back home in America or wherever else. Elvis the

scandalous—who lives to wiggle in the memories of millions of middle-aged women wandering dazed through shopping malls. Elvis the dark prince of sex and romance ultimately crushed by the pressures of his monumental success.

Above the boulevard in the Hollywood Hills and west through Beverly Hills and Bel Air, luxurious homes and expensive cars testify to the trappings of tremendous wealth—originally flowing from the film industry but no longer limited to that realm—which represents the good life of LA. Behind the walls and across the perfectly manicured grounds posted with warnings to potential burglars live those who can afford the isolation. In the neighborhood where I grew up I took a walk one night to see if any trace of my youthful musings lingered on the streets now empty of humans but literally lined with Mercedes Benzes. The air was soft, laced with the lush scents of flowering trees blended imperceptibly with smog; but the effect was that of a museum, an elegant exhibit where nothing could be touched.

Back on the boulevard visions of a lost and replicated Hollywood flicker in the shop windows like ritual candles of a tired but unkillable religion.

Disneyland Revisited

[1985]

One summer day in 1955 I piled into the family car with my sister and brother and mom and pop for an unforgettable outing: we were going to the opening of Disneyland. As a fan of TV's *Mickey Mouse Club*, *Walt Disney Presents* and the *Disneyland* show itself, I was primed to appreciate the wonders of this amusement park to end all amusement parks, this Magic Kingdom guaranteed to put all other forms of childhood recreation in the shade. Inching our way out some freeway bumper to bumper with thousands of other Los Angeles families under the punishing sun of mid-July, we were taking part in a rite of passage soon to be *de rigueur* for Southern California tourists. My eight-year-old brain was ablaze with the heat of an anticipation normally reserved for Christmas.

All I remember of that first visit to Disneyland—aside from the traffic jam en route and the brutalizing heat—is my claustrophobia faced with the crush of people crowding the streets and standing in endless lines for the rides and refreshments. The mass of bodies was overbearing for a little guy like me, and what made it worse was that I knew I was supposed to be

having a terrific time. What was so great, I wondered, about a place where all you could see were the butts of adults and the backs of bigger kids pushing their way around? The marvels of the Magic Kingdom were lost on me, and it was a great relief to climb back in the car and head for home along a freeway crammed with other exhausted pilgrims.

It was far more fun, I soon discovered (with my good friend Gary Ezor, who lived near the Disney estate in Benedict Canyon), to pay uninvited calls on Walt at home. We had heard about the miniature railroad that ran around his property and, being model railroad freaks ourselves, we wanted to check out the little train that Walt was rumored to ride around on when he wasn't out building his empire. One day after school, when we were exploring the Disney spread—which was so vast we still hadn't found the train after several trespassing expeditions—we were detected by a gardener who proceeded to chase us off the property. As I ran in terror from the swearing gardener I fell teeth-first on a sprinkler head, which bloodied my mouth and changed my bite forever. Gary and I escaped, but that was our last foray onto Disney's land.

During my high school years, when Orange County's orange groves were steadily being replaced by housing tracts, I made at least one more journey to the park in Anaheim. This trip I had a better time because I went at night with my girlfriend and we made out in the parking lot under the fireworks before we left. But I still wasn't too impressed with the rest of the spectacle. Even at the age of 16 or so, I could sense something deeply phony in the Disney ambience that turned me off.

A couple years later my big brother's best friend, recently divorced from Jill St. John, got married to an ex-Mouseketeer.

At the wedding reception—easily the wildest affair I'd ever attended, replete with Hollywood playboys and glamorous starlets in backless dresses and waiters carrying trays full of pink champagne—one of the young bridesmaids (also a former Mouseketeer) zeroed in on me as the target for her attention. She was a cute little thing, and a damn good dancer, and as a former fan of her show I was impressed that she found me attractive enough to flirt with. Before the night was through, her tongue was in my mouth—but frankly I didn't like the way she kissed. Alas, our Mickey Mouse romance was soon doomed.

You can imagine, then, my mixed emotions when, in December 1966, Walt Disney met his maker. Like most American youths, I had been raised on the Disney vision in all its glorious hokeyness; yet in addition I'd had the disillusioning experiences just described. By the summer of 1967, when several American cities were burning and my own eligibility for the draft was making me uncomfortably conscious of the war in Vietnam, I had researched and composed the longest poem I'd ever written as a way of kissing Disney's ghost goodbye. That mock-elegy, a bitterly satiric verbal cartoon in which I took out my rage over what I saw as the epic hoax that Disney had played on the people, was also a cranky tribute to his creative powers.

"We're selling corn. And I like corn," Walt had proclaimed when Disneyland first opened, and somehow the corn had grown to be more than corny; it was perversely nutritious.

By now you're probably wondering what's the occasion for these confessions. Well, last week I took my four-year-old daughter and a friend to Disneyland, and before offering an account of my findings on that excursion I thought it only fair to outline the background of my biases. In the 22 years since

my last visit to Anaheim, not only has Southern California's suburban sprawl completely overtaken the territory but my own evolution as a culture critic has made me even more intolerant of the Great American Lie—of which, next to Ronald Reagan, Disneyland is perhaps the preeminent example.

But four-year-olds couldn't care less about my skepticism. For them Disney's kingdom was a wonderland, and it was a treat to witness their delight in the sheer extravagance of so much pretend-reality packed into one small world. Here, after all, was the home of Mickey and Minnie Mouse and Donald Duck and Goofy and so many other mythic figures equal, as far as children are concerned, to the Greek gods of antiquity. Here was a place designed with children's fantasies in mind, and the childish fantasies of middle Americans (of whom Walt Disney was a paragon) longing for an innocence that never existed.

Unable to read the signs announcing the various attractions' corporate sponsors ("Wherever you go, you're never far from Bank of America") and probably oblivious of the insipid lyrics of the canned jingles blasting from assorted loudspeakers, the girls had a great time on the rides we took and were totally enchanted by the parade of Disneyoid characters marching down Main Street in celebration of Disneyland's 30th anniversary. This little self-contained universe of technological cartoonery was truly the apotheosis of escapism.

Nevertheless my incredulous eyes could not help but detect a number of disquieting contradictions. For all its accomplishments of landscaping, its artificial rivers and waterfalls, its fabulous architecture, mechanical creatures and other technical trickery, the so-called Magic Kingdom isn't magical at all but totally predictable at every turn. It is a plastic kingdom, where

every movement of every imitation beast and every line spoken by every guide is completely choreographed and preordained, leaving no room whatsoever for spontaneity or active imagination. It is a world absolutely under control, a totalitarian dream.

Observing the frozen smiles on the faces of the staff, hearing the cynical undertones of the raps repeated hundreds of times a day, I imagined the waking nightmare it must be to work in such a place. Unlike a circus or a carnival, where human and animal idiosyncrasies add an unpredictable dimension to even the most thoroughly rehearsed routines, the plastic kingdom is no place for individuality. The funky unruliness of your run-of-the-mill old-time amusement park is nowhere to be found, nor will you encounter any sense of danger, even in the darkest heart of Adventureland, despite its racist stereotypes of cannibalistic savages.

And this prefabricated security is precisely what the public wants. Visitors to Disneyland—a substantial portion of whom are adults, and not just parents or Americans either but tourists of every stripe—are looking for ways out of the surrounding emptiness. The orderly workings of Disney's machinery provide a comforting reassurance that this is an environment into which everyday chaos cannot intrude. Uncle Walt is watching.

At the end of our day in this charming world, after the big parade had come and gone and all the children were hyperactive from the combination of junk foods and excitement they'd been consuming, the only note of disorder arose with the search for souvenirs. By late afternoon every kid in the park was craving a Mickey Mouse hat (or, in the case of my girls, a Minnie Mouse hat), a Mickey Mouse t-shirt, a Donald Duck

doll, a stuffed Cinderella, etc. There were hundreds of items for sale in the shops along Main Street, and a shopping frenzy had overtaken the patrons, who jostled crazily in the aisles like New York ladies in a bargain basement. It was all the clerks could do to sustain their mechanical smiles as the multitudes of consumers rampaged among the racks, grabbing the available merchandise and cashing out at the registers.

Here was the true face of the Disney dream: capitalism with no holds barred and no apologies. Under the spell of the magic plastic, dazed Disneyfied customers wanted nothing more than to buy a little more stuff before they trudged back home. Their kids wanted evidence to show their friends, keepsakes and relics of their day in the land of Disney, and the parents were shelling out, and Walt was grinning from beyond the grave.

My four-year-olds had settled for their Minnie Mouse hats as we made our way back to the car. I explained, with some relief, that we had to go home because the park was closing; even Minnie Mouse needed a night off. We'd been there for nearly seven hours and I had survived the ordeal by watching their faces as they absorbed what I could never have stomached on my own. By the time we hit the freeway the girls were out, asleep in the back seat with an unfathomable sweetness.

Manson Demystified

[1989]

Allow me to be among the first to observe the 20th anniversary of 1969. I don't share the nostalgia some people feel for the sixties—those years for me were mostly a time of difficulty and confusion—and maybe some realistic memories of 1969 and the beginning of the end of that era will trigger a more sober assessment of what it was all about. A week or so before the Woodstock festival, the Tate-LaBianca murders occurred in Los Angeles, creating an atmosphere of terror in that city previously reserved for horror movies. When a few months later the culprits were captured and Charles Manson's face peered out from the cover of *Life* magazine, the nation had a mythic villain whose reputed powers of evil gradually grew to exceed even the enormity of his crimes. Manson and his "family," a hippie commune gone bad, were a deep dark side of the period's often magical transformations. *Rolling Stone* went so far as to call him "the most dangerous man alive." Last year Grove Press brought out the paperback edition of *Manson in His Own Words,* an autobiography (ghostwritten by Nuel Emmons) that goes a long way toward its purpose, as noted

in the dedication, of "destroying a myth." Having read Ed Sanders's *The Family* and Vincent Bugliosi's *Helter Skelter*, I thought I had a fairly good idea of Manson's story, but reading his own confessions gives a much more convincing picture of a kid who was a loser from an early age and got caught up in circumstances much larger than his powers to control. This is not to minimize Manson's responsibility for the atrocious acts to which he was a party, but to recognize the chemistry that turned a petty criminal, "a half-assed nothing" as he calls himself, into a legendary mastermind whose occult ability to control his subjects allegedly drove them to unspeakable deeds.

When Manson testified at his trial that he was merely a product of society, a creation of the very system prepared to condemn him for his acts, there was much righteous prattling in the press about the nerve of this remorseless monster. Even then-President Richard Nixon got into the act by declaring Manson guilty before the case got to the jury. The killer's coldness and contempt for the world of his accusers suggested correctly that here was a man beyond rehabilitation. *Manson in His Own Words* begins to explain the pitiful history behind this infamous image, and reveals his links to other lost souls—our country's homegrown terrorists—the kinds of guys who wind up firing automatic weapons into crowds of innocent people.

Charlie Manson was the son of a runaway, "a flower child of the 30s" as he calls her, a girl who fled her home at the age of 15 in hopes of escaping the "one-sided demands" of overbearing parents. She also kept running from her kid, leaving him with an assortment of relatives and friends and institutions that were to shape his character. After running away from some of these places and being busted for theft at age 13, Manson

entered the Indiana School for Boys, where he spent three years being abused in every imaginable way, both by his fellow inmates and the school's officials. "Confinement and punishment are necessary in the present society," he writes, "but having sadistic, perverted assholes working in an institution that is supposed to rehabilitate is the biggest bunch of bullshit going. You can't expect to straighten out an offender's life when the people in charge of him have worse hang-ups than he does."

Predictably, by the early sixties Manson was doing federal time for his adventures outside the law. On his release in 1967, he headed for San Francisco to look up a friend. The world he found was strange enough even to the people who had witnessed its evolution, but to a veteran convict it was like another planet, or possibly Paradise: Thousands of longhaired barefoot youths with kaleidoscope eyes and rebellious hearts were flocking to the Bay Area for the Summer of Love. Manson, who had taught himself to play the guitar and had written some songs in the slammer, was at least 10 years older than most of these kids but a virtual novice in the realm of freedom, to say nothing of love. Homeless and aimless, he discovered psychedelics and the joys of sex and the first real affection he'd had in his whole life with a couple of young women. A Volkswagen van was all he needed to hit the road with his companions.

In their travels up and down California, Charlie and his girls—all on the run from the cruelty or hypocrisy or indifference of their parents—lived an archetypal hippie odyssey, taking drugs, making love, seeing the sights, checking out assorted scenes, and attracting more members to their merry band. The VW van became a school bus, and the "sense of belonging" to one another bonded the group together with a fidelity they had

never felt for their families. Manson was the hub around whose street smarts and spiritual leadership the circle revolved. For the reform-school dropout and ex-con whose life up to then had been one hell after another, 1968 was a beautiful year, a moment of liberating fulfillment beyond his wildest fantasies.

One fantasy hatched in prison that he hadn't given up was the notion of himself as a singer/songwriter, and his ambitions in showbiz led him and his gang to settle in the outskirts of LA. Connections in Hollywood never worked out—despite his penning of such memorable lyrics as "Garbage dump, oh garbage dump, I can feed the world with my garbage dump"— and a series of spooky associations and bad drug deals degenerated into a murder committed by one of the family. The Tate-LaBianca killings, according to Manson's account, were originally conceived by one of his "girls" as a way of throwing the authorities off. He admits he could have stopped it from happening but that finally his lack of concern for the moral standards of "your world" led him to approve and ultimately encourage the mayhem of that summer of 1969.

Manson emerges from his own self-portrait as a much smaller, far more pathetic figure than the media would have us believe. He's dangerous not because of any superhuman ability to make his followers do his bidding—even though he still gets mail from maniacs willing to kill in his name—but because he has rejected society's values as completely as it rejected him; he's a man "without conscience" so far outside anything resembling a "mainstream" that he'll never get back in. Yet his story, as far as his personal ordeal as an unloved, neglected and abused child, is typical of more kids than most of us care to admit. Manson observes that "every kid who ever stepped

in my van had bad family relationships. I know too many righteous-appearing fathers who thump on their old ladies, beat their kids, play at incest, chippy with any strange broad who gives them a look, and yet thrive on the role of a family man, the king of respectability."

It was against this fraudulent model that Manson and his people measured themselves. "True, our lives were everything parents and society preached against, but that was the reason those kids were there in the first place. The dope, the sex and all the avenues we traveled were nothing more than rebellion against a world that preached one thing but failed to provide an example of it. The whole trip of the 60s—all the protests, the dropouts, the runaways, the flower children, the hippies, the drug addicts, and yes, the murdering outlaws—was the product of a society that spoke lies and denied their children something or someone to respect. And unfortunately, society remains the same."

Not a Pretty Picture:
Esquire in the Sixties

[1995]

It's been said, I forget by whom, that the New Journalism of the 1960s was in fact neither new nor journalism. Call it what you will, the most memorable magazine writing of that agitated decade—by the likes of Norman Mailer, Gay Talese, Tom Wolfe and Michael Herr among others—was a dramatic departure from many previous journalistic conventions and marked an extraordinarily vital chapter in US media history. Subjective, idiosyncratic, novelistic approaches to reporting proved to be fitting strategies for capturing the cultural turbulence of the times.

No major publication was more daring or successful in mobilizing literary talent to cover the tumultuousness of the moment than *Esquire* under the visionary direction of editor Harold Hayes, whose radical irreverence and creative risk-taking turned a gentlemanly girlie mag into a brilliantly dangerous forum for the unexpected. Hayes's anthology *Smiling through the Apocalypse; Esquire's History of the Sixties* (originally published in 1969) remains a very readable collection of the magazine's greatest hits, valuable both as documentation and literature. Now Carol Polsgrove contributes her less felici-

tously titled *It Wasn't Pretty, Folks, But Didn't We Have Fun?*, which supplements what appeared in *Esquire*'s pages with a backstage chronicle of how it all happened.

True, it's not an especially pretty picture, but it's revealing both of the inner machinations of a high-powered publication the likes of which hasn't been seen since, and of the larger context—historical and commercial—in which such periodicals, then and now, must fight to survive in the marketplace. With founding editor and publisher Arnold Gingrich as a buffer between him and the business side of the organization, Hayes proceeded to follow his smart-ass intuition into the witty, sophisticated milieu of the Kennedy years, turning loose talented scribes to discover the stories beneath the stories.

He also recruited ad-design genius George Lois to cook up covers at once eye-catchingly simple and provocative in their imagery: Sonny Liston in a Santa Claus suit (on the 1963 Christmas cover that wound up costing the magazine about a million dollars in subsequent lost advertising); a tiny Andy Warhol drowning in a gigantic can of Campbell's tomato soup; a corpselike Richard Nixon submitting his face to the ministrations of makeup artists; and most incredible of all, a smiling Lt. William Calley, chief perpetrator of the My Lai massacre, surrounded by four small Asian children. Hayes's ongoing struggle to persuade his colleagues on the advertising side that intelligent controversy was good for business (which, in terms of circulation, it generally was) is vividly recounted by Polsgrove, and his victories on that front seem all the more poignant in light of a current media culture where editors who wish to keep their jobs obediently follow the dictates of the marketing experts.

Garry Wills, one of Hayes's mainstay writers, is quoted as describing his editorial instincts as "centrifugal—get to the sidelines and watch." It was this ironic detachment that proved, in the early to middle sixties, one of *Esquire*'s greatest strengths: the ability to stand apart from or above the fray as reasonable observer, taking nothing and no one too seriously, smartly exploring whatever subject, from big-city political and social shenanigans to obscure folk phenomena in small-town America. But by late 1968, when the outrageousness of events had begun to outdo the outrageousness of the magazine's attitude, the terrible and tragic realities of the time—assassinations, urban riots, a genocidal war—were not so easy to laugh off. It was then that *Esquire*'s smirking glibness began to lose some of its charm, its engaging edge.

Calley's "confessions" were perhaps the most egregious example of a bad joke. Played as the plight of a normal American boy caught in the hellish workings of a war directed from afar by corrupt politicians and generals, John Sack's series of articles may have contained a kernel of truth in their perverse political insight. But one could make the same kind of argument for a Nazi death-camp guard who claimed he was only following orders. Even though Hayes, an ex-Marine, would never have accorded such empathy to a Charles Manson (who might be seen as the product of an abusive childhood and a rotten society), the magazine's moral neutrality appeared to have slipped into an amorality entirely inappropriate to certain subjects.

Despite her obvious awe and admiration for Hayes's gifts, Polsgrove is able to show, through meticulous and clearheaded reporting, the flaws as well as the brilliance of her protagonist. While she justifiably credits Hayes with establishing a new

imaginative standard for American journalism—engendering the competitive efforts of rival publications such as Clay Felker's *New York*, *Harper's* under Willie Morris, *The New York Review of Books*, *Rolling Stone* and *Ramparts*—she recognizes his ultimate inability to stay ahead of the times. The cultural power of rock and roll, the inexorable momentum of the women's movement, the growing horror of the Vietnam War apparently eluded his understanding.

In a heartfelt epilogue Polsgrove calls for a revival of the inspired journalism practiced by Hayes (who died in 1989) and his peers of three decades past. She laments the bottom-line ethic dominating most print media of the nineties. "If commercial magazines fill the space between ads with advice and manufacture celebrities for their covers," she writes, "it is certainly not because reality has not offered higher drama." She concludes by invoking "something Harold Hayes had: the courage to look at what is there."

Yet ironically her own book, solid as it is, remains a fairly pedestrian piece of journalism. I kept imagining how much more interesting the story would have been in the hands of a more Esquiresque author. One of Hayes's writers might have delved more deeply into the major characters, who are seen in Polsgrove's version mainly through a well-documented but somewhat superficial account of their professional conduct. But maybe that's being unfair. To explore those psyches in all their complexity would require the subtler art of the biographer, or the more perilous intimacy of fiction.

Dylanography

1 Bob & Sara & Joan & Allen, etc.
(1977)

An image of Bob Dylan wearing a translucent plastic Richard Nixon mask as he stands onstage in a concert hall singing "When I Paint My Masterpiece," presented in the opening frames of his ambitious new movie *Renaldo & Clara*, suggests a few of the central ambiguities riddling the songwriter's epic attempt at amateur filmmaking. Is this the Dylan myth at its most hideous, exploiting the singer's image at the expense of his integrity? Is it self-parody dancing dangerously close to the edge of playing it straight? Is Dylan a religious mystic, a messianic mariachi spreading the righteous news? Or is the Rolling Thunder Revue merely a *Magical Mystery Tour* in red-white-and-blue-face, with moccasins and mezuzas added for ethnic effect?

All these questions and more emanate from any serious viewing of *Renaldo & Clara*, which given the breadth of its intentions can't be dismissed as just a goof pulled off by some loaded rock-and-rollers with cameras. Still, as with his previous

creative breakthroughs, things may not be entirely what they seem.

Hardcore Dylan idolaters will be delighted to see so much of their hero's changing face projected in Technicolor through nearly four hours of documythic celluloid melodrama. Others may feel bored or disoriented without a Baedeker to help them sort out the players' apparently interchangeable roles and the "plot" of the pseudo-narrative interwoven with concert footage of the 1975 Rolling Thunder tour, backstage and café encounters and conversations, scenes in bohemian nightspots and cabarets full of middle-aged Jewish ladies, with occasional jumps to the streets of New York City for glimpses of Christian evangelists and impromptu interviews with African-Americans concerning the conviction of Rubin Carter.

One wonders what Dylan and Allen Ginsberg are doing in the graveyard where Jack Kerouac is buried, besides making fools of themselves exchanging anecdotes about the famous graves they've seen. One might even wonder why Joan Baez (as "the Woman in White") is speaking with some kind of East European accent. And who are all these other seemingly meaningful individuals? Whether you can identify the people or are content to let their faces fall where they may, one aspect of *Renaldo & Clara*'s attraction as entertainment was intimated by a young woman standing in line on LA opening night: "I like to sit up close because it makes me feel like I'm more a part of the film."

Indeed, a spectator-tourist along for the ride with none of the risks and discomforts of the actual road may enjoy the cinematic rush of witnessing a few of the inner theatrics of the Bob & Sara show. Big gobs of gossip are laid ludicrously bare

and rewrapped in synthetic Dylafame, that warped wide-screen surface guaranteed to distort the facts and throw the posse off the outlaw's trail. And it's instructive to watch Bob macho-off among his grouped wives and admirers; it shows he's just a regular jerk like any other fantasy-fevered star-sexed American male.

In all fairness, *Renaldo & Clara* is in the dramatic tradition of the masque—which Webster's explains is "an allegorical dramatic performance...performed by masked actors...and consisting of dumb show combined with music, dancing and sometimes poetry culminating in a ceremonial dance participated in by the spectators." As such it must be looked at as a case of mixed and mistaken identities, the lead minstrel himself retaining that enigmatic and shyly evasive self-consciousness which has characterized his public style since the beginning.

The number of immortal songs he's written and the acclaim he's received in consequence would be enough to give even the least vainglorious of bards a big headache. A large part of Dylan's posturing is obviously a defensive maneuver against those who would invade his privacy and become a nonstop nuisance, blindly deifying the Master at his expense. Dylan, like "the President of the You-nited States," doesn't seem eager to "stand naked" on film even for a second. The pains the writer/director takes to be certain that nothing is revealed of the person Bob Dylan are evidence that he's still engaged in the game of hide-and-seek he's always played with his followers.

But it's on the conceptual level that *Renaldo & Clara* is most adventurous and interesting as film. Cut from some 100 hours of footage, the movie explores the idea of cinema-as-collage, with little attempt at conventional narrative continuity apart

from recurrent themes of love and fame and nothingness, background motifs of Christ's and Kerouac's quests, and David Blue's coked-out pinball riffs on the roots of culthood in the good old early sixties in Greenwich Village. There are lots of songs performed (and filmed with admirable craft, clean sound and subtlety), pregnant symbols cryptically plastered across the screen, artfully contrived cuts and rhymes between one scene and another, and numerous routines staged or improvised by the players on the street or in unidentified rooms and hallways. The film is actually a long-drawn-out and carefully edited home movie: the tale of a family on vacation in their mobile commune touring the USA as electric troubadours. (Compare the Merry Pranksters or the Manson Gang.)

In this light it can be seen as picking up the tradition of Kerouac's novels, wherein a highly personalized mythos is constructed from the common experience of a small group of people. But where Kerouac gives himself and his awareness selflessly to his subject—which is America perceived through a Whitmanic "self" which transcends the first person singular— Dylan's film is never so generous in its revelations. Unlike his best songs, where the poet's voice spills brilliant insights out of sheer lyric genius and heartbreaking vulnerability, *Renaldo & Clara* seems for the most part an exercise in vanity, showing the shifty image of a narcissistic singer up to his waist in the freedom-of-speech swamp admiring the absurdity of his own reflection.

A major artist will often risk utter failure by attempting something outside the bounds of existing esthetic values, a work whose excesses are intrinsic to its conception, which by way of its imaginative extravagance may reveal a vision of the

previously unthinkable. At best the realization of such a work (as in *Leaves of Grass, Moby-Dick, Look Homeward, Angel*) may approach or equal the scope of its own ambitions. One may give Dylan the benefit of the doubt in this regard and appreciate his movie as a daring experiment that doesn't quite come off.

But I'm reminded also of an essay by Camus called "Create Dangerously," where he writes, "Any artist who goes in for being famous in our society must know that it is not he who will become famous, but someone else under his name, someone who will eventually escape him and perhaps someday will kill the true artist in him." Maybe it was fear of this Frankenstein-like fate—the artist as Promethean doctor tormented by his creation—that caused Dylan to have the excellent but unflattering 1965 D. A. Pennebaker film *Don't Look Back* withdrawn from circulation and the prints destroyed.

It wouldn't surprise me if, some years from now, he similarly purges *Renaldo & Clara* from public view, thus further perpetuating his "who-was-that-masked-man?" mystique, as Bob and his mindguards and his 8½ women ride off into the sunset locked in a limousine whose tinted windows flash blinding reflections in the eyes of his mystified fans.

2 The Gospel According to Bob (1979)

Bob Dylan's latest incarnation, as revealed in his recent San Francisco concerts, is no less perplexing than any of his old personae, despite the apparent singlemindedness of the minstrel's new message. Praised by some for his breakthrough into Faith and the plainness with which he gets his ideas "a cross," dismissed by others—many former fans—as a born-again idiot

obviously finished as an artist, Dylan continues to be a compli-
cating figure in our electric folklore. I came away from the show
(presented, according to its deadpan star, "under the authority
of Jesus Christ") moved by the hard-rocking gospel- and blues-
based music, bothered by the singer's punk piety, unsettled to
see the noticeably young and clean audience—many of whom
were no doubt *listening* to the singer for the first time serious-
ly—relishing every syllable from the master's mouth. The few
hecklers and the skeptical seemed far outnumbered by a righ-
teous majority that brought the band back for three encores.
As I left the theater (a vaudeville hall resurrected for rock and
roll), after passing under the indoor marquee whose large red
letters reminded the crowd YOU GOTTA SERVE SOMEBODY,
a "Jew for Jesus" handed me a propaganda pamphlet.

Dylan's genius as a musician is rooted in his ongoing abil-
ity to assimilate the most vital traditions and trends in Ameri-
can music and turn them into a natural and highly personal
sound. Gospel, among other black spiritual strains, has from
the outset been a crucial resource in the songwriter's creative
reservoir. From the traditional selections on his first record
through *Highway 61 Revisited* with its demonic treatment
of biblical motifs to the creator-praise of *New Morning* and
now the downright evangelical religiosity of *Slow Train Com-
ing*, God and his offspring have boogied their way through
much of the best of Dylan's work. Even his "protest" and "civil
rights" songs of the early sixties had that laceratingly prophetic
Midwestern nasal firebreathing Hebrew preacherliness which
once again drives his voice to barely bearable but often stirring
extremes of stridency.

As popular spokespoet of liberation struggles and later as

living testimony to the psychic explosion of the times, Dylan assumed a position of cultural leadership he's been inhabiting ever since, even at his most reclusive, and if he has ceased to "influence" people as he once did, his *phenomenon* continues to be interesting. He is prematurely historic and always changing, which is more than one can say for most musicians of his popularity. The venom of some recent criticism is clearly in reaction to an earlier veneration. (Other venom comes in the form of triumphant sniggering from those who never took him seriously and now see his Christianity as further proof of his insipidness.)

Exhortation, stories with morals, persuasive argument—all have been main modes from early on; it was Dylan who told us, "don't follow leaders, watch your parkin' meters," and who leaped to the defense of many a dead Negro, so it's no surprise to hear him giving advice and pleading some other case. As before, he'll attract fans and fanatics with his new line because he's expressing something a lot of people feel. While putting down those who need "spiritual advisers and gurus to guide your every move," Dylan once more plays the role of charismatic mouthpiece, sucking into his harmonic orbit the very saps he'll inevitably want to spit out. Invoking spiritual liberation, he may really be building another jail to house his followers, leaving himself just that much freer to ditch them at will. And having lost or at least alienated a lot of his former idolaters, the performer has nothing to lose but one more mask.

Dylan the messenger goes on instructing with his stories, which smack of poetry, proposing *values* by which to change one's life—this time allegedly eternal values rooted in New Testament rhetoric and in the poet's own burning bushes—still

raising dust because his words and music and voice remain strangely contagious, chilling, challenging.

"We're livin' in the end times," he said between songs one night in San Francisco—"We all need something solid to hang on to." ("Yeah," from the congregation—"Tell it, Bob!") It's no joke that Apocalyptic Consciousness has assumed awesome dimensions in California's cosmological fricassee. Pagans who never thought twice about Johnny Revelator before are suddenly talking Armageddon. With the millennium upcoming, the arms race, the radiation already rampant on the planet, it's not too hard to fear for our civilization. When a bestseller like the Bible and such a popular show bizness prophet holed up in his Malibu mansion come to the same conclusion as to a cosmic showdown, and those forecasts are borne out by the daily news and a sense of pervasive social hysteria and barely contained chaos, the "end times" idea need not be dismissed as the name of some New Age newspaper.

As an imaginative theme, the last days are fertile turf for the deep thinker and religious dilettante alike. To thousands—more likely hundreds of thousands—of Americans convinced that "the end" is in fact what's happening, and who'd like to rely on some authority or security larger than their own, the concept of a God/father must be very appealing. Deliberately or otherwise, Dylan is again playing weatherman for those too scared to go out and see for themselves how hard the rain is falling.

But like Shelley's cloud, the poet himself is a shapeshifter, in Dylan's case more than most; the vision, in its prolific uneven outflow, is constantly in progress and subject to revision, a moving target for admirers and assassins both. The artist is "saved" to the degree he continues to create himself. Like the

Israelites in Egypt and the African-Americans in Mississippi, Dylan has made escape a way of life: Houdini and Steve McQueen have nothing on him. If the rigidity of his recent salvation appears to have boxed him in, the enduring power of much of his music, including a few of the new songs ("Do Right to Me Baby," to name one), makes me suspect his hardcore holiness is only another temporary phase.

If he stays Christian, perhaps Dylan will gain the compassion his latest pose is lacking. Maybe a little doubt, a little more vital anguish, a reawakened uncertainty as to having the Answers will add useful perspective to his journey through a narrow unknown. Surely awe of the mysterious is necessary to sustain creative as well as religious faith. The ironic humor, the tension between love and fear, pain and praise, which have characterized much of his finest writing and singing, are healing forces in art. The comic dimension and the tragic too are equally absent from the messianic self-righteousness and wrath of songs like "Slow Train Coming." The spooky and sometimes snide edge on the singer's voice sounds less vulnerable than ever telling us where it's at. The didactic side of these recent compositions sounds to me less like praising the Lord than the echo of some personal bitterness, resignation or even cynicism. Range as an indicator of artistic strength, formerly so manifest in Dylan's variousness of voice, was missing from the concert I attended. The driving tunes were livelier than the hymns because the one-track lyrics didn't matter much, back of the beat. I imagine the native diversity of the artist's mind will move him on eventually beyond his current ecclesiastic limits.

Even within the boundaries of his dogmatism, however, Dylan's reappearance as a public nuisance, his appeal to a new

audience, his rabid turn toward a bottom line of conscious if not too original gospel prophecy, may possibly move some newer listeners toward an appreciation of his numerous brilliant and irreverent earlier (nonetheless up-to-date) works, and make old fans and foes rethink their sense of any refugee's bent to leave wrecked expectations and shed chains in his wake, reserving the creator's right to fashion new ones.

3 If Gods Run Free
(1981)

When Bob Dylan came out as a Christian a couple of years ago a lot of people who had hitherto respected him as an artist stopped taking him seriously. How, they reasoned, could the iconoclastic (if not anarchistic) author of such songs as "Subterranean Homesick Blues" and "Ballad of a Thin Man" suddenly be raving about Salvation by way of Jesus Christ, the most famous icon in the Western world?

Leaving aside the inquisitions and holy wars carried out in the name of Christianity; leaving aside the fact that many people are still unable to see Dylan as anything more than war surplus from the sixties; and leaving aside any resemblance between Bob and the savior it's clear that Dylan has been a religious poet and a moralist all along. His faith, while a bit revolting in its more self-righteous moments, relates quite naturally to the record his spirit has been cutting for 20 years.

Of course Dylan himself became a kind of religion for many folks stuck in 1966. Like any doctrine, the Bob-image of that period—frozen in the minds of its believers—became a caricature of its original energy. People developed definitive feelings about the man, as if he belonged (or were answerable) to them.

But I don't see how a person's religion need be an obstacle to creative imagination. Ernesto Cardenal of Nicaragua, one of the foremost poets on the planet, is not just a Christian but a Catholic priest—and a revolutionary to boot. Cardenal's poetry will curl your hair. And I don't hear people putting Dostoyevsky down on account of his adherence to Russian Orthodoxy. It's my belief that if people would *listen* to what Dylan is saying rather than merely reacting to the dreaded specter of dogma that lurks in some of the weaker songs, they would still hear the voice—the always changing and evolving voice—of one of the best poets alive.

Now the main distinction between Dylan and Jesus—or Dylan and Jim Morrison (Jimi Hendrix, Janis Joplin, James Dean *et al.*)—is his refusal to be crucified on his own guitar. Always on the run from his public image, Bob has been playing cat-and-mouse with the media for as long as I can remember. Part of his genius has been his ability to outfox his followers every time they thought they had him figured out.

Sucked by mysterious historical forces into the role of "leader" during the cultural revolution of the sixties, saddled with the weight of massive popularity (the artist-as-commodity), Dylan's teenage dream of being "bigger than Elvis" soon mutated to a nightmare from which the only waking could be a rude one. His famous obnoxiousness dates from the time when he first had to fend off his fans. Listening to his latest album, *Shot of Love*, I realize that Dylan is no leader (and never could be) because he's always been too far out in front to keep up with. Like Lenny Bruce—whose memory he honors with a beautiful elegy on the new album—Dylan "just had the insight to rip off the lid before its time." If the man is indeed "saved,"

his salvation lies in his ability to move on, shedding his former selves like so much sawdust on the circus floor.

The aspect of Dylan I value most—besides his hard-rocking musical eclecticism, the ability to cultivate simultaneously several distinct and dynamic beats—is his continuous concern with *values:* moral values, spiritual values, issues of meaning to the inner heart. There's always been an intimacy in his voice that the listener feels on a very private level of understanding. I believe the extreme reactions he provokes—from awe to repulsion—are closely related to his ability to get inside his audience. Because in addition to any musical or lyrical genius by which he may be possessed, the *inwardness* of his vision is what penetrates so deeply. Dylan gets down to essentials—love, faith, justice, death, the state of the soul—which few other popular artists have the courage or the urge to touch. His power derives largely from the nerve to plunge into personal waters where others would scarcely wade.

But maybe the most amazing thing of all about the man is his perseverance: nothing has been able to stop him—not love, not hate, not churches, not states. He keeps on regardless, opening his art the way a poker player cagily unfolds a full house. His faith is obviously in *life,* his eyes are wide open; he may be a joker but he's no fool. As he says so plainly of Lenny Bruce: "Maybe he had some problems / maybe some things that he couldn't work out / but he sure was funny and he sure told the truth / and he knew what he was talkin' about."

4 Notes from Underground
(1997)

As the Jerry Garcias and Timothy Learys and Allen Ginsbergs

of our time steadily disappear from this world, grizzled survivors of the 1960s realize that none of us will live forever. Even Bob Dylan, only 56 and arguably the most immortal of all, was hospitalized not long ago with a chest infection that reportedly could have been fatal. Evidently Dylan pulled through, but his illness was enough to send deathly chills through even the healthiest of his appreciators. In the 35 years since the release of his debut album, the harmonica-blowing bard from northern Minnesota, through all the changes of his shapeshifting career, has been one star whose light seems inextinguishable.

By 1967, five fast and eventful years since his appearance on the national scene, Dylan's provocative art had excited, seduced, repelled and puzzled millions of fans as he mutated from the seemingly wholesome Dr. Jekyll of acoustic folk song and righteous protest to an electrified Mr. Hyde of surrealistic rock, crashed his motorcycle after the consciousness-altering *Blonde on Blonde* album and disappeared like some premature legend into the Catskills to recuperate. It was there, in and around Woodstock, New York, that the songwriter-singer and his backup band, The Hawks (soon to emerge independently as The Band), made an informal series of recordings that came to be known as *The Basement Tapes* and which, via the records of other artists and various bootleg editions (and eventually a legitimate if much abbreviated double album in 1975), spilled a whole new barrel of red herrings across the unfollowable trail of Dylan's musical evolution.

Thirty years later, 1967 is remembered in the mainstream media mostly for San Francisco's so-called Summer of Love, but that was also the summer of deadly riots in Detroit and Newark, and the deepening nightmare of the Vietnam War, and

the massive October March on the Pentagon eloquently documented in Norman Mailer's *The Armies of the Night*. For all the hippie love fests and trippy revelations of that era it is the darkness that burns most deeply in my memory—the disorienting sensation that one was living in a schoolbus-funhouse without lights or brakes wildly hurtling off the edge of history.

In the midst or over to the side of such insanity Dylan and his colleagues were hiding out in the hills and messing around with their music. It is the strangely timeless and often goofy sounds they made in those few months that rock historian Greil Marcus attempts to illuminate in his new book, *Invisible Republic*.

Anyone familiar with Dylan's work knows that his poetic imagination is steeped in a rich brew of American musical traditions ranging from Anglo-Appalachian ballads through country blues and gospel to rock and roll, with side trips every which way, the mix of elements synthesized with Hebraic prophecy and visionary poetry from many times and tongues, all processed through his personal psychic blender to produce a fertile lyricism often imitated but never quite matched in depth or breadth or brilliance. Every couple of years since the mid-sixties we've heard about some "new Dylan," but even the best of these upstart minstrels has never come close to the prototype in range or radical originality. Dylan's simultaneous uniqueness and profound connection with tradition is one of the themes explored by Marcus in his study of *The Basement Tapes*.

The author of *Mystery Train*, *Lipstick Traces*, *Dead Elvis* and other books on US musical culture, Marcus in his *Invisible Republic* proposes *The Basement Tapes* as essentially a recapitulation of the history of American folk song—putting the

lie to the widespread idea at the time that Dylan had forsaken his folk and blues roots by going electric and fronting a rock and roll band. In Marcus's view, the singer's (and The Band's) encyclopedic knowledge of practically everything that had preceded them informs even the most absurd improvisations they caught on their anarchic tape.

Though he tends at times to make too much of nothing—attaching portentous implications to riffs tossed off in a spirit of stoned nonsense—Marcus is persuasive in his argument that the dopey madness of the *Basement* sessions is underpinned by recognizable precedents in the folk canon and may in fact be more gravely sobering than what at first meets the ear. Unearthing specific songs from the 1920s and earlier whose style and spirit prefigure selections on *The Basement Tapes*, Marcus also proves that those presumably innocent tunes are themselves much darker and more bizarre than the contemporary listener might think. The primitive sophistication and worldly weirdness of such early masters as Dock Boggs, Furry Lewis, Jesse Fuller, Mississippi John Hurt and Frank Hutchison are naturally complementary to the sophisticated primitivism of Dylan, Garth Hudson, Rick Danko, Levon Helm, Richard Manuel and Robbie Robertson.

According to Marcus, the bedrock source of *The Basement Tapes*, as of the entire 1960s folk revival, was Harry Smith's landmark *Anthology of American Folk Music*, a three-volume, 84-selection set of LPs issued on the Folkways label in 1952 (and recently reissued on CD). Along with his engrossing psychobiographical portrait of backcountry banjo legend Boggs, the most fascinating chapter of *Invisible Republic* is Marcus's meticulous account of the eccentric Smith and his compila-

tion of the seminal *Anthology* gleaned from hundreds of old 78s by all-but-forgotten artists, many of whom were still alive at the time and soon to be "rediscovered" by folkies of the late fifties and early sixties. Smith's strange career as amateur musicologist and accidental guru to a generation of musicians is intriguingly evoked by Marcus as he interweaves a portrait of the compiler with vivid descriptions of the songs on his *Anthology*—from hillbilly murder ballads to country blues to gospel to tortured love songs—all of which informs his foreground discussion of Dylan and The Band and what they were up to in the Catskills in 1967.

In addition to exposing the native spookiness of much folk music—what Marcus calls "The Old, Weird America"—he presents the songs of Dylan and The Band as an effort, conscious or coincidental, to rescue those original traditions and voices from the hallucinated context of that chaotic year of US history. To support his thesis he cites not only Dylan's early recordings of classic folk and blues and his gnomic remarks in interviews on Death and Mystery and the genius of the old masters, but also his albums of the nineties, *Good as I Been to You* and *World Gone Wrong*, where Dylan redoes, in solo acoustic format with a voice that sounds dredged out of some ancient swamp, many of the songs included in Smith's *Anthology*. The aging artist has come full circle to honor the historic sources of his art.

The Basement Tapes themselves—with their remarkable assortment of songs ranging from the much-recorded "Tears of Rage," "The Mighty Quinn" and "I Shall Be Released" to more obscure and enigmatic ditties like "Clothesline Saga" (a parody/reply to Bobbie Gentry's smash hit "Ode to Billie

Joe"), "Apple Sucking Tree" and "Please Mrs. Henry"—can be listened to, or eavesdropped on, as an intimate free-form conversation among comrades exchanging ideas and jive in an orgy of musical exuberance, an exuberance all the more free for its spontaneous assumption that nothing was at stake commercially: the whole thing was just for kicks.

At the same time, as Marcus astutely observes, there are undercurrents of anguish, despair and fear which intermittently surface in the carnivalesque music to make it even more interesting. Though many of the songs are plainly ridiculous and hysterically funny, a sense of doom and bewilderment is never entirely absent. As in so many tripped-out intimate gatherings of those years, a certain giddy paranoia and perplexity, a tragic lostness, pervade the desire to just cut loose and party. Demons of the uneasy psyche flicker at the edges or ooze up through the subsurface of the music—like the smell of some rotting (Vietnamese?) corpse underneath the house rising inexorably through the floorboards. This subtle ambivalence between play and horror may be one of the things that gives *The Basement Tapes* their enduring resonance.

The songs on *The Basement Tapes,* like other ambiguous works of art, are a Rorschach test for the beholder. They may be alternately creepy and hilarious or both at the same time, and they may mean absolutely nothing and/or plumb the profoundest existential truths. At his best, Marcus does not attempt to pin simplistic meanings to these pieces but guides the reader/listener through their oddnesses, pointing out connections he discerns with many aspects of American experience. While some of these connections are more convincing than others, *Invisible Republic* is a suggestive reading

of Dylan's and The Band's epic artifact of aural graffiti—their sonic mural which makes sense only insofar as one is able to decipher those wild scrawls on the wall. As musicologist, cultural historian and literary critic, Marcus has done an admirable job of translating that cryptic script in ways that don't pretend to be definitive. More valuably still, he leads us back beyond the accomplishments of Dylan and The Band to the equally unique precursors who made them possible.

5 Lives & Times
(2001)

Biography is gossip—at best meticulously researched, placed in historical context, artfully recounted and enlightening with regard to important lives, but gossip nonetheless—on a grand scale. Even the least prurient and most scholarly among us relish revelations about the famous, just as we do about our friends and acquaintances, that are really none of our business. But human nature loves a good story, and what could be more interesting than a well-told tale of somebody else's life? Even though the work of any major artist invariably speaks volumes more than whatever can be exhumed about its background, the circumstances of its origins fascinate; we want to believe they can tell us something about the mystery of creation.

Bob Dylan, among the most slippery and enigmatic of contemporary culture heroes, began his career by inventing incredible stories about himself: he was an orphan, was part American Indian, had lived in New Mexico, worked in carnivals, bummed around the country, played backup piano for Elvis, etc. When *Newsweek* revealed in 1963 that he was in fact a middle-class Jewish kid from Hibbing High, Dylan became

resentful of the press's investigative curiosity and, as he grew more famous, increasingly protective of his privacy. Immensely ambitious from the beginning, he wanted fame and set out to win it but failed to take into account the invasive consequences of being a "music star," and ever since then has been on the run from his fate as a public figure.

Dylan turned 60 on May 24 and that unlikely event (he should, by all rights and romantic myths, have blazed out like James Dean or John Keats) occasioned a good deal of retrospective Dylanography, typically focused on the breakthrough years of the 1960s and his early permutations from funky folk singer to poet of protest to bard of the absurd to psychedelic rocker of existential rebellion, author of dozens of classic songs that captured the tumultuous spirit of an especially agitated era.

Less noted, though equally if not more remarkable, was and is the artist's subsequent development as an increasingly accomplished and resourceful songwriter, singer, musician and bandleader whose later work, on such albums as *Blood on the Tracks* (1975) and *Time Out of Mind* (1997), and in his many live performances, matches or surpasses much of what he did in the 1960s.

For aficionados and students of both early and ongoing Dylans, two recent books provide revealing glimpses of the person in progress, and while neither quite succeeds in unriddling his genius, both make for interesting reading in their exposure of certain facts and dynamics of the life.

People still nostalgic for the early sixties or just curious about the folk-music boom of that time will find David Hajdu's *Positively 4th Street* a delicious account of a love quadrangle composed of equal parts talent, romance, passion and ambi-

tion. The convoluted interrelations and rivalries among the protagonists—Dylan, Joan Baez, Joan's sister Mimi and Richard Fariña—are the stuff of historic soap opera, and the tragic finale, complete with matching motorcycle wrecks, is almost too symmetrical to be true. (As it turns out, it may not have been, but more on that in a minute.)

Those interested in a more panoramic picture of Dylan's life and work will find in *Down the Highway*, by Howard Sounes, a sober retracing of the artist's trajectory from his boyhood efforts as an aspiring Little Richard to the tirelessly touring, obligation-beset, twice-divorced, disillusioned, seemingly lonesome grandfather troubadour traveling in his customized gypsy bus to venues as diverse as the Vatican and the Visalia Convention Center. Sounes takes a just-the-facts approach to his subject, diligently interviewing hundreds of Dylan associates, friends, lovers and fellow musicians, and snooping around in the public record to piece together a persuasively complex if not especially dramatic portrait of a restless, aging artist.

Dylan, according to both these books, became a folk singer mainly because folk music was *happening* in New York when he arrived there in 1961. Yes, Woody Guthrie was his hero and an early model for assorted mannerisms (some adopted by Dylan without realizing they were symptomatic of Guthrie's degenerative Huntington's disease), but Dylan wanted to make it *big* in a way that Guthrie never dreamed. As Bob was making the scene in Greenwich Village, up in Cambridge Joan Baez was emerging as a star in the local folk clubs, and when the two inevitably met, Baez's greater fame was a convenient vehicle for Dylan's desired rise.

While it would be an exaggeration to say that Dylan's leg-

endary liaison with Baez was purely opportunistic, it's clear that her growing popularity provided a platform—which she generously shared—for him to reach a much larger audience sooner than he might have otherwise. Conversely Baez, who up to then had been singing all traditional material, found her social conscience voiced in Dylan's "political" songs and became a diva of Peace. As painfully documented in D. A. Pennebaker's *Don't Look Back*, by 1965, when Dylan had become a star in his own right and was turning away from folk to his roots in rhythm and blues and rock and roll, Baez was of no further use to him as a companion.

Meanwhile, in an overlapping universe, a comparably charged-up, ambitious, gifted, charismatic, self-mythologizing, ruthlessly manipulative character named Richard Fariña, cleverly married to another folk diva of the moment, Carolyn Hester (on whose debut album Dylan played *his* first recording gig, on harmonica), and trying to hitch a ride on her rising star, meets and falls in love with 16-year-old Mimi Baez, sister of Joan. Hester and Fariña divorce, Fariña marries the younger Baez and the two embark on a "folk" career *together*, with Richard writing the songs and strumming the dulcimer and Mimi, the more practiced musician, singing duets and playing guitar.

Fariña's strongest suit may be his prose, and after five years' work he publishes a novel, *Been Down So Long It Looks Like Up to Me*, on Mimi's 21st birthday. At his book party in Carmel Valley, where the Baez sisters have settled, Fariña impulsively takes a ride on the back of a friend's motorcycle and is killed when the speeding bike veers off the road. He, it turns out, is the James Dean figure, cut off at the start of a hot career, while

Dylan, touring Europe at the time (1966), staggers home half-dead from exhaustion, strung out on various drugs, recently married to Sara Lownds and, under the energetic management of Albert Grossman, booked for a huge tour of the United States among other professional demands.

It is at this time that he conveniently crashes his own motorcycle, an accident that, as Sounes discovers in *Down the Highway*, may never actually have happened. Sobered by Fariña's sudden death and possibly inspired by it to slow down and retool his itinerary, Dylan, with his wife's help, may well have staged the most ingenious escape act of his life.

Supposedly recuperating from unspecific injuries, he retreats into domesticity, starts a family, privately makes *The Basement Tapes* with his backup group and Catskill neighbors, the Hawks (aka The Band), and proceeds to wrap his increasingly elusive persona in several more layers of camouflage, all the while over the next years putting out a shapeshifting series of albums that keep the multitudes scratching their heads trying to figure out who, if anyone, he really is, or was.

While Hajdu's book is the more compellingly novelistic in its braided plot lines, Sounes has more to offer, in his tenacious pursuit of the facts, toward unpacking the mystique of Dylan's inscrutable identity. What becomes evident as we see the artist develop into maturity is that he is both more and less than the sum of his multiple incarnations.

Rather than attempt to explain how Dylan does it or over-analyze the songs or trace the countless connections with his musical antecedents, Sounes tries to follow the critical events of an increasingly complicated life. We learn of the deranged fans stalking the star; the overbearing management of Gross-

man and subsequent legal battles; Dylan's increasing shrewdness as a businessman; the excruciating and expensive divorce from Sara and the epic complexity of his love life; his role as a conscientious father; the enormous overhead of his empire; and his nearly nonstop traveling and performing, as if to prove the line in "Things Have Changed," his Oscar-winning song from *Wonder Boys*: "I've been tryin' to get as far away from myself as I can."

On the much-acclaimed album *Time Out of Mind* Dylan engages what he has called "the dread realities of life" with the soulfulness and authority of the oldest living blues singer (even though he was only 55 at the time). As Sounes understates it, this music "would probably resonate with many listeners whose lives had not turned out the way they had hoped." But the grief and loss recorded in these bleakly beautiful songs, from the existential despair of the dirgelike "Not Dark Yet" to the dark comedy of the rambling ballad "Highlands," testify to a deep disillusionment and desolation that only the craftiest master could turn, as Dylan does, into an art so thoroughly triumphant. The biographer who might illuminate this paradox of creative transformation would have to be an artist of genius comparable to that of his subject—like Richard Holmes in his electrifying life of Shelley—but Sounes doesn't pretend to be in that league.

Thorough reporter that he is, he closes his book with his own eyewitness account of the first leg of Dylan's 2000 US tour, with stops in Visalia, Santa Cruz and Reno. The Santa Cruz concert that I heard was superb, ranging from his earliest "Song to Woody" through a rich hour-and-a-half mixture of some 35 years of his best original compositions as well as

gospel standards like "Rock of Ages," capped with a rocking encore of Buddy Holly's "Not Fade Away."

Those song titles suggest the durability of Dylan's art and the stamina of the man as he keeps his show on the road, in Sounes's telling words, "way out into the heart of America and on around the world."

Beauty's Truths

[2009]

Pope Benedict and I don't often see eye to eye. On issues like gay marriage, birth control, abortion rights, and the alleged divinity of the Jewish prophet from Galilee, we have deep differences of opinion. But recently the pope invited some 500 artists to the Sistine Chapel to give them a pep talk about beauty. Only half that number showed up, but like a poet reading gamely to a disappointing turnout, the pontiff pressed on with his homily, cajoling his guests to be "fully conscious of your great responsibility to communicate beauty, to communicate in and through beauty."

It must have felt strange for the assembled "artists, architects, musicians, directors, writers and composers" (as reported by *The New York Times*) to hear a lecture on esthetics from the pope. Perhaps in emulation of the high priestess of television, Oprah Winfrey, Benedict feels it is time for him to give his imprimatur not to any particular work of art or literature (and thus ensure its commercial success) but to a principle, a conceptual standard that any artist can strive to abide by.

Beauty, for John Keats, was both an ideal and a reality often

encountered—and in my own Romantic experience, I am with him: living for beauty, in awe of the Beautiful, ever alert for its surprises, recipient or victim of its random gifts or ruthless cruelties, servant of its majesty, aspirant to its realization in my work. And so, as far as beauty is concerned, for once the pope and I appear to be on the same page.

But what is beauty? *The New Shorter Oxford English Dictionary* defines it as "that quality or combination of qualities which delights the senses or mental faculties; *esp.* that combination of shape, colour, and proportion which is pleasing to the eye." It can manifest in a human face or body, in the grace of an animal, in a landscape or a cityscape, a piece of music or a dance performance, a sentence or a line of poetry, or an unexpected perception of visual harmony—say, streams of headlights and taillights snaking along a freeway seen from the air one evening when your plane is landing in a city where your mate awaits you.

Like pornography, beauty is something we know when we see it. But in the same vein, what we perceive is often a reflection of ourselves—our own predispositions, perversions and desires. Our subjectivity colors our understanding. A rose may be ravishing to one person, while a motorcycle engine excites another. So when the pope asks artists to make beautiful things, he's asking them, in effect, to faithfully serve their individual muses. And I'm not so sure that's what he really intended.

My guess is that he meant to promote a certain kind of beauty, like the Chopin preludes my mother and her boyfriend used to put on the turntable at cocktail hour to accompany their Scotch, the kind of delicate background sound that calms one down at the end of the day and offers an antidote to the world's

cacophony; the kind of music played on classical FM stations to soothe you through the rush-hour commute, a gentle, dignified alternative to the nonstop babble of news and opinion and rehashed information issuing relentlessly from radios everywhere. This sort of soft-focus, smooth-jazz, tranquilizing art—boring as it may be—is in some way preferable to the blabbering noise of contemporary culture, not to mention the dispiriting spectacle of politics and the neverending cycles of violence and corruption and all-around agitation.

Beautiful art, however tame, can serve as a corrective to the aggravations of everyday life. And great art, however unsettling in its representation of reality, however strange or disturbing it may strike us, almost always embodies the beauty of felt truth. Perhaps this is something of what Keats had in mind when he wrote, in his "Ode on a Grecian Urn," "Beauty is truth, truth beauty."

If more people listened to Mozart than to Rush Limbaugh every day, the world would surely be a more pleasant place. If somehow, through an angelic act of digital sabotage, Modigliani nudes would appear on their screens when teenage boys fired up their video games, maybe a few would be diverted from violent fantasies into reveries of tenderness and delight in what William Blake called "the human form divine." If people could slow down enough to read a Wordsworth ode or a Lorca ballad, or even listen to such language on their private e-media instead of whatever other trivial message is coming in, surely the psychic economy would improve.

These are the kinds of beauty (except for the Modigliani nudes) of which the pope would probably approve. But what about other kinds? When he was a youth in Nazi Germany

did he aspire to and honor the Aryan ideal of the robustly athletic young man or woman who marched with their rucksack through the lovely countryside marveling at the splendor of their nation and their exalted race? Has he been able to appreciate the paintings of Jackson Pollock? Has he ever paused before a Robert Rauschenberg assemblage to marvel at the way, out of what at first glance looks like garbage, the artist has constructed not only something formally harmonious but a subtly witty commentary on our time? Has His Holiness ever listened to the edgy sounds of Bartók or Schoenberg or Charlie Parker or Ornette Coleman and found there the kind of beauty he seeks in the works of current artists?

Innovative creators, often using their knowledge of tradition as a base from which to subvert the very traditions they're building on, frequently are greeted with critical scorn or abuse or are just ignored by the guardians of established cultural norms. It is only later, after they're gone, that their apparent barbarism becomes iconic and sets a new standard or expands the notion not only of the acceptable but the beautiful. (Vincent van Gogh comes to mind as such a creator.) So in asking for beauty Benedict may get more than he bargained for.

Still, I sympathize with the desire to find esthetic alternatives to the almost continuous (and almost always electronic-mediated) assaults of popular culture. A huge proportion of the outflow from our computers and TVs and radios and iPhones and other portable instruments is just static and distraction we'd be better off without. A walk on a country trail or city street with unplugged ears, a stroll through a neighborhood attentive to the styles of its front yards and to the smells of dinners cooking or domesticated flowers—not even "nature" but

human husbandry—can be richly restorative of one's equanimity. A movie that doesn't insult the brain but bathes us in the visual magic of cinema while engaging us in a plausible human drama, even with dark themes, can be an invigorating escape from the onslaught of opinionators on cable TV or the catalogs of crime on your local network affiliate.

Beauty, when it speaks to us, or touches us, or catches our eyes or other senses, somehow stimulates our psychic chemistry, our mix of emotions—it gets the dopamine or serotonin going—so that we actually feel better physically. Moved to tears by a happy or sad story on the big screen, or by a Walt Whitman poem or a Dvorak symphony or Billie Holiday singing "You Don't Know What Love Is," we find release otherwise available only through orgasm—a flying out of ourselves into momentary oneness with the world (the lover). Not to get too misty or mystical about it, this kind of esthetic-body-soul connection works better for some people than institutional religion in keeping us attuned to the sublime, the transcendent, the divine.

But too much of a good thing can be sickening. Stendhal Syndrome is named for the French novelist who famously became ill, during a visit to Florence, from looking at too much Italian Renaissance art. And what of the effete connoisseur wealthy enough to retreat to a private collection as a way of avoiding engagement with the world beyond the estate's perfectly manicured grounds? Beauty can be abused, like any drug. Yet its greatest potency derives from its appearance in relief against a contrasting background. A gorgeous girl or boy seen on the street will outshine a model on a runway every time.

Philosopher Elaine Scarry, in her beautiful little book *On Beauty and Being Just*, writes of the scene in *The Odyssey*

where Odysseus catches sight of the young Nausicaa: "The beautiful thing seems—is—incomparable, unprecedented; and that sense of being without precedent conveys a sense of the 'newness' or 'newbornness' of the entire world." It is the sense of newness that can awaken us to the world in a way that makes us want to perpetuate whatever it was that brought us alive to its wonders—we want to spread the beauty—and so we are moved to make art, and if that makes the pope happy, all the better.

Of course the academic postmodernists have long since disposed of beauty, dismissed it as a colonial imposition of the artist's vision when it is really the critic (or theorist!) whose vision counts. But tell that to Borges about a pink store he saw on a walk in predawn Buenos Aires, which revealed to him a vision of the Eternal; try to tell *him* beauty is a figment of the Romantic imagination.

The oasis of calm and solace created by a beautiful work of art or a handsome face can be located and cultivated in such a way that we may not need to visit a museum or strap ourselves into earbuds or even read a book in order to receive our daily dose of the gorgeous. The way a room is arranged, or a meal is prepared and served, or the random fragments of overheard talk in a public place can be mined for their fleeting lines of unwritten poetry—these are the kinds of everyday gifts that make life not just bearable but a source of secret delight if we pay attention. Perhaps the pope should encourage people, artists and civilians alike, to indulge in this sort of noticing.

To contribute something to the universe, to create an object—a book, a picture, a song, a sculpture, a crafty artifact, a visionary building—is also to do spiritual work, to perform an act that affirms, if not a deity, at least the living breath that's

continuously flowing through our lungs, brightening the blood and providing the most immaterial yet essential means of animating us. Inspiration—this is how even a smell can hit us with unexpected force, evoking a rush of feelings and memories we'd forgotten. And so, even air can be beautiful; invisible, weightless, yet bearing our whole lives.

Arts

The Discreet Charm
of Luis Buñuel

[1983]

"What interests me is a life full of contradictions and ambiguities," Luis Buñuel told an interviewer in the early 1960s. "Mystery is beautiful. To die and disappear forever doesn't seem horrible to me but perfect. The possibility of being eternal, on the other hand, horrifies me."

With his death Buñuel ironically has joined the ranks of fellow Spaniards Miguel de Cervantes, Lope de Vega, Goya and Picasso as deathless contributors to their times. Born at the dawn of the new century, Buñuel came of age in Madrid in the twenties amid a constellation of creative geniuses that included García Lorca, Rafael Alberti, Salvador Dalí, Vicente Aleixandre and many others. The "Generation of 1927" or "Generation of Friendship" blew Spanish poetry wide open with their adventurous excursions in the unconscious. Without an esthetic doctrine but with a visceral apprehension of the terrors of the post–World War I world, reading Joyce and Freud and Góngora and each other, traveling to Paris and New York, young Spanish poets invented their own distinctive versions of surrealism. One of Buñuel's earliest known works—a

poem called "The Rainbow and the Poultice" (1927)—begins, "How many priests will fit on a gangplank?" He spent the next five decades razzing the Catholic Church, among other institutions.

The development of film technology provided Buñuel with the perfect medium for his mischievous imagination. During his fifty years of making movies—from *Un chien andalou* in the late twenties to *That Obscure Object of Desire* in the late seventies—he never stopped experimenting with ways to tell an enigmatic story, remaining strange-but-true to the real-life mysteriousness of everyday experience. While one of the most admired and influential of all directors (Alain Resnais's masterpiece, *Providence*, alludes eloquently to Buñuel), the Spaniard's style or range of styles was uniquely idiosyncratic. A pioneer surrealist, he put his movies together like poems, emphasizing evocative qualities of particular images and associations rather than enslaving himself to a linear narrative logic that might put the audience at ease or encourage complacency. Fantastic images—a cow in a bed, a self-propelled coffin snaking its way through the desert, a rubber chicken falling off a silver tray—are generally presented in a matter-of-fact manner, which makes them seem all the more astounding. Usually humorous, always provocative, Buñuel's movies invariably challenge the viewer's assumptions and expectations while skewering the status quo. A consummate satirist, his use of irony is never cruel but consistently humane: there's something touchingly vulnerable about his characters even at their most obtuse and idiotic; he never sets himself up as their superior.

Buñuel wrote and directed nearly forty films, many of which are among the most memorable ever to reach the screen. The

classic 17-minute *Un chien andalou* was followed in 1930 by another surrealistic landmark, *L'age d'or*, the first of his merciless satires on the Catholic Church. Then came the phenomenal documentary *Las Hurdes* (*Land Without Bread*), a nightmare "travelogue" account of a journey through a poor and barren region of western Spain. The contrast between the wild inventiveness of his first two films and the sober factualism of *Land Without Bread* is startling, but what they have in common is a visual hunger for reality, a clear-eyed intent to pierce the veil of appearances. The famous opening sequence of *Un chien andalou*, where an eyeball in closeup is slit by a straight razor (wielded by the director himself), stands as a fitting image for the thrust of his entire career.

The Spanish Civil War and subsequent dictatorship of *Generalísimo* Franco meant death or exile for Buñuel and many of his contemporaries. A partisan of the Republic, he came to the United States in the late thirties with the intention of making films on events in Spain, but none of these projects materialized. He worked as a dubber and translator on dozens of documentaries for the Museum of Modern Art and later on several films for Warner Bros. but discovered that there was little room in Hollywood for his unsettling brand of imagination. The one scene for which he was responsible in a Hollywood film is the sequence in *The Beast with Five Fingers* where Peter Lorre observes with creeping distress a disembodied hand crawling up his chest—a typically disturbing Buñuelian image. (In 1944 Buñuel and Man Ray planned a film called *The Sewer of Los Angeles*, which was never produced. One can only dream or hallucinate what this movie might have been like.)

After a period of obscurity in Mexico cranking out grade-

B movies, Buñuel surfaced again in the fifties with a number of unforgettable low-budget films, among them *Los olvidados* (literally "the forgotten ones," released in the US as *The Young and the Damned*), the story of a couple of teenage street boys living hand-to-mouth on the fringes of Mexico City. Fearlessly realistic yet charged with the lyric energy of adolescence—and one dream sequence from the depths of a dawning sexual subconscious—it is one of the most powerful treatments of poverty ever committed to celluloid. *Subida al cielo* (*Mexican Bus Ride*), *Adventures of Robinson Crusoe* (a hilarious adaptation of Defoe's novel) and *Illusion Travels by Streetcar* are among his lighter and equally brilliant works from the early fifties—the latter being the tale of a couple of Mexico City transit workers who take a streetcar out for a phantom all-night ride after the car barn is closed. It captures beautifully Buñuel's affection for the invisible people who are the soul of cities.

With age Buñuel's vision became increasingly penetrating and audacious. *Viridiana*, *The Exterminating Angel*, *Diary of a Chambermaid*, *Simon of the Desert*, *Belle du Jour*, *The Milky Way*, *Tristana* (all produced during his sixties) and his masterworks of the 1970s—*The Discreet Charm of the Bourgeoisie*, *The Phantom of Liberty* (also translatable as "*The Specter of Freedom*") and *That Obscure Object of Desire*—whether made in French or Spanish, Paris or Mexico or Spain, color or black and white, gently but vividly strip religious piety and middle-class respectability of their pretenses. *The Phantom of Liberty*, with its seemingly plotless sequence of comic sketches, and *That Obscure Object of Desire*, with its subplot of terrorist explosions providing the backdrop for a tale of sabotaged seduction, associate clearly with the maestro's earliest films in

their defiance of narrative convention while revealing a sweetness of tone and luscious sense of color unavailable to the youthful illusion smasher.

A child of the bourgeoisie himself, Buñuel reserved his most elegant and engagingly devastating portraits for the class he knew best. *The Exterminating Angel* and *The Discreet Charm of the Bourgeoisie* are undoubtedly among the most bizarre and insightful dissections of polite society ever performed. Both explore, in radically original fashion, the myriad difficulties involved in throwing a successful dinner party. The protagonists in *The Discreet Charm*, perpetually thwarted in their pursuit of something to eat, respond to the most ludicrous and outrageous turns of events with a genteel poise that borders on buffoonery—but they really are charming! In *Angel*, the makeshift civilization set up by the guests in the spacious salon from which there is no exit resembles a wilderness expedition stranded in fiercely inhospitable terrain. It is indeed weird, Buñuel implies, to be stuck in the company of socialites. While most of Buñuel's jokes are in the tradition of the non sequitur, avid imagery analysts and symbol hunters can feast their interpretive brains on select passages from virtually any of his films. One inquisitive critic approached Buñuel's son and assistant, Juan Luis, to ask about the significance of the bear that suddenly appears on the staircase of the elegant mansion in *The Exterminating Angel*. The young Buñuel replied, "My father likes bears."

Buñuel lived a quiet, quasi-reclusive life, mostly in Mexico City. He was a meticulous gentleman of regular habits, which included the cleaning and polishing of his extensive collection of antique firearms. He seldom went to the movies. His own

films, looked at again through the depth of additional years, continue to reveal more layers of amazement and compassion and subtle wit than one or two viewings could suggest.

For the sake of people puzzled by his work—or flabbergasted by the relentless irreverence with which he treated organized religion and its agents—Buñuel explained himself 20 years before his departure: "People always want an explanation for everything. It's the result of centuries of bourgeois education. And for everything without an explanation they resort finally to God. But what good does it do them? After that they'd have to explain God.

"Look: if my best friend, dead many years, were to appear and touch me on the ear and my ear caught fire, just like that, I wouldn't believe he came from Hell; it wouldn't make me believe in God, nor in the Immaculate Conception, nor that the Virgin could help me pass my exams. I'd simply think: Luis, here's one more mystery you'll never understand."

Keats's Star Turn

At the end of Jane Campion's new movie, *Bright Star*, the doomed-love story of John Keats and Fanny Brawne, virtually the entire audience at the show I attended remained in their seats until the closing credits were over. This was no doubt partly because people wanted to see the names of the cast and crew who'd made such a ravishing film; but more than that, they were captivated by the voice of Ben Whishaw, who plays the poet, reading Keats's sublime "Ode to a Nightingale." It's a longish poem, 80 lines, and Whishaw speaks them with exquisite precision and perfect understatement.

Where most actors typically over-emote when reciting poetry, Whishaw (and presumably Campion) understands that the language itself is where the power resides in Keats's poems. The words require no embellishment or melodramatic emphasis. Throughout the movie, when Fanny (Abbie Cornish) and "Mr. Keats" recite parts of his poems, it is always in a nearly flat, sensitive but low-key tone. This emotional restraint, a sense of cool objectivity, is also evident in Campion's direction, so that the movie's style imitates that of the poet.

Campion's engaged detachment, her quiet attention to the sounds (most notably birdsong) and visual textures of the English countryside that forms the background of her story, and to the subtle feelings of her chaste young lovers, casts a spell akin to that of Keats's verse. You want to pay close attention in order to enter into it more deeply and experience its layers of meaning. But mostly you want to listen to its sounds and immerse yourself in its sensuousness. As Keats explains to Fanny when she laments her difficulty in understanding poetry: when diving into a lake, one's purpose is not to understand the lake, but to "luxuriate in the sensation of water."

Of course, Keats wrote in the early 19th century, so his language may strike our contemporary ears as a bit obscure, even precious in places, but he remains even today probably the most revered English poet next to Shakespeare. The adoration so many readers (and writers) feel for him is surely due in part to his death, of tuberculosis, at 25. He wrote most of his greatest poems—including the five gorgeous Odes: to a Nightingale, to Psyche, on a Grecian Urn, on Melancholy, and to Autumn—in the course of a few months when he was 23. (This is the age when most young poets today are working on their MFA degrees.)

Keats's prolific writings, both poetry and letters, reveal the artistic and philosophical sensibility of someone of far greater experience. There is a sweetness and ardor in his voice combined with a wisdom that's hard to fathom in such a young man. So his early death—like, say, James Dean's—is all the more tragic for what it deprives us of in yet-to-be-created art. But unlike Dean, who made just three feature films before crashing his Porsche, Keats left a large, rich legacy of accomplished work that subsequent generations are still relishing.

We love Keats, I think, because he not only left us beautiful poems but lived and died with absolute devotion to the Beautiful—an abstraction that he bodies forth in his close observation and reinvention of the natural (and human) world. Trained in medicine, he brings a scientist's as well as a painter's eye to what he sees; his ear is naturally musical, his heart is open, and his fevered imagination is working overtime.

It's understandable then that he would fall for Fanny Brawne, portrayed by Cornish (and Campion) as a smart, bold, witty, willful, high-spirited, burning flame of a girl. (She was 18 when they met.) Neither John nor Fanny, as depicted here, looks like a movie star, but their keen intelligence—and their soul-attraction and contained passion—charges their romance with tremendous energy. We are seduced by them as they seduce each other. The fact that their desire is never consummated makes it all the more moving.

Will *Bright Star* do for Keats what *The Postman* did for Pablo Neruda—take an already famous poet and make him "popular" at another order of magnitude? Will moviegoing American readers discover there's more to the art of poetry than Billy Collins and Garrison Keillor have to offer? Will filmmakers realize, via Campion's example, that gratuitous violence and special effects are nothing compared to intelligent dialogue and subtle nuances of thought and feeling?

Maybe not. But even Quentin Tarantino, on seeing Campion's movie at Cannes, remarked: "I'm not really into poetry. But the movie made me think about taking a poetry class. One of the best things that can happen from a movie about an author is that you actually want to read their work."

I look forward to seeing Tarantino's life of Arthur Rimbaud.

Grave New World

[1983]

My long-standing prejudice against "science fiction" has never been something I've felt the need to defend. As a recidivist Earthling I'm not impressed by art that stresses technological redemption via special cinematic effects. Although as a kid in the 1950s I enjoyed my share of monster movies—the best of which always seemed to have something to do with mutations brought on by atomic testing (giant insects, shrinking men, etc.)—the technofuturistic/Space Age emphasis of most sci-fi films in recent years has left me cold.

Seeing the movie *Blade Runner*, though, has opened my eyes to the future in much the same way that razor at the beginning of Buñuel's *Un chien andalou* opened the cinema to poetry: Ridley Scott's vision of post-apocalyptic 21st-century Los Angeles is spooky with the truthfulness of a bad dream, beautifully hideous, a strange blend of Raymond Chandler and Hieronymus Bosch.

Among its other imaginative strengths, *Blade Runner* is a philosophical essay on mortality—and on the relationship between creation and creator. The Tyrell Corporation, one of

whose specialties is genetic design, has developed a race of android "replicants" who function as slaves in the Off World. As with Dr. Frankenstein's lovable "monster," the relative innocence of the replicants makes them much more appealing than the humans in the film. In both cases the doctor/scientist pays a heavy karmic price for his creation, but in *Blade Runner* Tyrell's sanity is assumed: fabricating slaves is big business.

After about four years, like high school students, replicants start to develop their own emotions. This makes them dangerous. It's also the point at which they're designed to expire. Prohibited on Earth ("retired" on sight by assassins known as blade runners), a little band of them have commandeered a space vehicle and returned to the planet to meet their maker, Tyrell, in hopes of extending their lease on life. The fact that the manufacturer himself is helpless to increase their lifespan makes the androids' predicament all the more poignant.

Rachel, the lovely experimental model with whom the blade runner makes off in the end, has had memory implants—giving her the illusion of a past—and, who knows, may last forever. Perhaps she and the reptilian protagonist will live happily ever after in the Off World suburbia hyped continuously by hovering megamachines that blast their ads into the downtown inferno.

The language of the street is Cityspeak, a combination of Japanese, Spanish, Chinese, German and "what-have-you," spoken among themselves by the teeming urbanoids. The city's claustrophobic bleakness reeks of unbreathable air and the light is a minimal mixture of smogged-over sun and video glare and neon. Los Angeles in 2019 is a has-been town still barely functioning by force of inertia and perverse perseverance.

While the love story serves as an artificial sweetener, the film's real theme is dehumanization. Emotions are virtually extinct.

Still, it's better to be alive than dead—even an android knows that—and the sordid misery of the streets is ameliorated for the viewer by the anything-goes esthetic of its citizens: there's clearly a comic side to this nightmare. Within the grim confines of a hellish setting, amazing details keep the eye delighted.

While *Blade Runner* is a fierce critique of *current* big city culture—even its wildest exaggerations have a weird familiarity—the universality of its religious content makes it more than just a biting high-tech adventure. The ringleader replicant, who at first seems fairly innocuous, turns out to be a being tormented by his dawning consciousness, dying to understand the mystery of existence. His last compassionate gesture makes *him* the hero of the film. The hardboiled protagonist, rewarded with a cute android for having efficiently offed her genetic siblings, looks truly lame compared to the eloquent Christ-like replicant he kills.

Actually there is one beautiful human in the movie: a young genetic designer stricken with Methuselah Syndrome (precocious aging) who lives by himself in an abandoned apartment building called The Bradbury and makes himself toy companions, funny little humanoids who are his family. He befriends a couple of the replicants—"There's part of me in you," he tells them proudly—but he is as powerless as they are to stop the clock.

The human race in *Blade Runner* is doomed and these remarkably sympathetic replicants are literally replacements for a disappearing species. Designed as slaves, their neohumanity far outshines their masters' coldblooded gloom. The

twisted hopefulness of such a notion transcends both tragedy and comedy.

This movie, while exploring a grave new world, has the feet of its inventiveness firmly on the ground. The metropolis Scott and his partners have created is fully recognizable, however "unreal." Even if the future never *really* looks like that, it does now.

A Whale of a
Monster Movie

[1999]

Amid the cacophony of exploding cars, afterlife fantasies, costume epics, insipid comedies, testosterone-soaked bloodlettings, animated insects, computerized dinosaurs, cartoon heroics, futuristic space adventures and the other high-tech spectacles that pass for mainstream Hollywood entertainment, a modestly budgeted, subtly performed dramatic film is a rare and welcome gift. *Gods and Monsters* proves that a good script and great acting may be the most powerful special effects of all.

Adapted for the screen by writer/director Bill Condon (from the Christopher Bram novel *Father of Frankenstein*), *Gods and Monsters* is a fictional speculation on the final days of the real-life motion-picture director James Whale, creator of such horror classics as *Frankenstein* (adapted from Mary Shelley's novel), *The Bride of Frankenstein* and *The Invisible Man*. After the peak of his artistic and commercial success in the 1930s, Whale himself faded into invisibility and a comfortable retirement at his home in Pacific Palisades. There, under mysterious circumstances, he was found dead in his swimming pool one day in 1957, presumably a suicide.

Gods and Monsters is no docudrama and makes no pretense to factual accuracy or Oliver Stone–style conspiracy theories; what it does is re-create convincingly a certain decadent late-fifties Hollywood atmosphere and—through Ian McKellen's uncanny performance as Whale—a persuasive psychological portrait of the legendary director, who, like McKellen, was both British and gay. In the movie, Whale's infatuation with hunky young gardener Clay Boone (Brendan Fraser) leads both men into unexpected depths of emotional risk and self-knowledge. The action of the story is mostly internal and the plot minimal, but the interplay of the two main characters is so compelling that the viewer is inexorably seduced.

Condon's writing and direction are crisp and unobtrusive; and while flashbacks and dream sequences bring vividly to life some of the interior drama, there's nothing flashy or tricky about this movie. Slowly as it seems to unfold on the surface, it moves—in every sense of the word—via the awesome power of the acting. McKellen especially, in his timing, facial expression and tone of voice, conveys a world of feeling as experienced by an ailing, aging artist in decline, mournfully facing the loss of everything that made his life worth living. Whale's grief and nostalgia are embodied in such delicately nuanced gestures that we hardly know what's being done to us as an audience until, in the final scenes, we are overwhelmed.

Part of the beauty of this movie is in its respectful homage to Whale's great Frankenstein films. Unlike today, when "horror" depends mainly on shock tactics and special effects, Whale's 1930s melodramas were works of atmospheric spookiness suffused with pathos and even a certain campy humor. The original "monster" and his "bride" are poignant figures,

bewildered by their own unnatural natures. The complex echoes resonating between Whale and Boone on one hand and Dr. Frankenstein and his stitched-together, revivified corpses on the other are remarkably touching. The fact that the parallels are inexact and unstable makes them all the more engaging. We are denied easy insights and understandings but, rather, drawn into a dark and ambiguous dance.

The critical acclaim and modest commercial success of *Gods and Monsters*—a small, independent production that was undoubtedly hard to finance in the mindless climate of Hollywood megablockbusters—makes one wonder why such unsensational movies are so few and far between. One obvious answer is that superior writing and outstanding acting are not so easy to come by. But it's also true that huge, overproduced, multizillion-dollar, star-bloated, high-tech extravaganzas with their screaming publicity and marketing tie-ins and appeal to an illiterate adolescent audience simply drive more artful efforts off the playing field.

This mindlessness has a lot to do with the overseas market, where dialogue and dramatic subtlety can't compete with formulaic, action-packed escapist fantasy. Profit, of course, is the motivator, and if Bruce Willis (or his stunt double) has to crash through a plate-glass skyscraper and blow up half of Manhattan in order to sell tickets in Japan, no studio executive is going to argue for adaptations of Chekhov. As Universal Pictures chairman Casey Silver is quoted in a recent *Washington Post* story: "Studios don't give a damn how they make their money. It's business."

The funny thing is, though, that nobody in Hollywood has a clue as to what will score—no matter how much is spent on

its production and promotion—and what will bomb at the box office. The herd mentality of the industry is such that they tend to try to replicate whatever the last big hit may have been. One can cling to the slim hope that low-budget, small-scale successes like *Gods and Monsters* may at least suggest to the financiers that this sort of thing may be a good investment.

Meanwhile all the money in the world won't turn an Arnold Schwarzenegger, charmingly monstrous as he may be, into an artist like Ian McKellen—or even a Brendan Fraser, who, in his fine performance in *Gods and Monsters*, has come a long way from *George of the Jungle*. When Fraser's Clay Boone enters the life of McKellen's James Whale on screen, they and the audience find themselves in that zone of esthetic and emotional enchantment experienced by the original Frankenstein monster when he chances upon the hut of a blind violinist and the old man kindly invites him in for a bite of bread ("good") and a drink of wine ("good") and a smoke ("good").

It's been a long time, the blind man tells his guest, since anyone paid him a visit; it's not good to be alone. "Alone—bad," replies the monster, puffing a cigar with a goofy grin on his face. "Friend—good." McKellen and Fraser make equally strange and splendid friends in Condon's excellent film, and the despairing moviegoer, starved for substance, will find the encounter good.

Werewolves on Speed
(The Movie)

[1994]

So Jack Nicholson is this bus driver, see, and he's driving this tour bus through Beverly Hills pointing out the homes of the stars, and this teenage runaway tourist from Colorado played by Michelle Pfeiffer is one of the passengers, and just as they're going past Marlon Brando's house Dennis Hopper runs out in front of the bus, and Nicholson slams on the brakes but too late, Hopper disappears under the bus, but the show must go on so Nicholson keeps driving, but pretty soon he gets a call on his cell phone from Hopper who says he wants revenge for Nicholson's upstaging him in *Easy Rider* 25 years ago and if he slows down to 69 miles an hour Hopper's going to bite out the tires and they'll all die without getting their zillion-dollar paychecks and besides that, he wants a bite out of Pfeiffer's neck, and all of a sudden they're being tailed by James Spader and Keanu Reeves in a police car and a couple of plainclothes black guys in a white Bronco, and then these helicopters appear overhead and Sandra Bullock is lowered on a cable right through the windshield into Nicholson's lap and the bus is whipping around curves on Mulholland Drive trying not

to slow below 70 but it's impossible and as the speedometer drops to 69 there's a blowout—two, three, four blowouts—and the bus hurtles over an embankment and everybody on board turns into werewolves who somehow through sheer animal magnetism levitate the bus back onto the road and it keeps speeding along despite four flat tires and Dennis Hopper hanging on by the tailpipe sucking its fumes and whispering into it at the same time a stream of sweet nothings intended for Pfeiffer but she's busy running her fingers through her face fur in amazement at the wonderful transformation, it's so *animalistic*, and Nicholson's snout is sticking through the windshield, and Bullock is working the pedals with her paws, and Reeves and Spader and the two black guys in the Bronco have turned on their sirens because they're scared that Hopper is going to explode from an overdose of diesel fumes, but this is nothing for Hopper, he's used to snorting dynamite and radioactive waste, he's a mad scientist for christsakes, or at least a thrift-shop Boris Karloff, and some literary agents on motorcycles overtake the cops and pull up alongside Hopper brandishing contracts, it's a true crime story, and behind them here comes an ambulance with Alan Dershowitz chasing it on foot, and by now the bus is on the San Diego Freeway but the bomb squad has blown up the Sunset Boulevard overpass in a training exercise, just a coincidence, so the bus has to clear a 50-foot crater but no problem, the werewolves get their primal thing together and jump it like a pile of shit in the woods, Hopper still dangling from the tailpipe, and what else can happen after all since the moon's coming up over Westwood and the ticket takers are tearing their own flesh in all the excitement and the big chain bookstores are open late because the paper-

back version of the chase-in-progress is already on the stands, and meanwhile back inside the bus Nicholson is chewing up the scenery, which is the seats, so the rest of the werewolves are hanging from the monkey bars trying to stay out of his way while Bullock drives the bus toward LAX and Pfeiffer keeps looking at her hairy face in the rearview mirror and cackling and rambling on about how she once studied acting with Clarissa Pinkola Estés and now it's paying off, *See*, she screams, *I'm not just a pretty face*, when suddenly the trapdoor in the floor over the driveshaft opens and out climbs Hopper, he's sucked himself right up the tailpipe into the bus and takes a bite out of Pfeiffer, but then he sees Nicholson chewing up the seats so he, Hopper, starts chewing them up too lest Nicholson steal the screen from him again, and the rest of the werewolves—except Bullock, who's driving the bus, and Pfeiffer, who's admiring herself in the mirror, and they're the bravest ones anyway because they're more in touch with the Mother Goddess and they Want It All because they're New Women and they're running for Congress as soon as this movie's over—the rest of the werewolves climb through the emergency trapdoor in the ceiling out onto the roof where one by one they're rescued by a transport helicopter full of animal-rights activists, Veterinarians Without Borders, and it's a good thing because by now the bus is approaching LAX and Nicholson and Hopper have eaten all the seats and they're looking hungrily at Pfeiffer and Bullock and at each other, and Spader and Reeves are playing through their loudspeaker what sounds alarmingly like Placido Domingo doing a rap version of "You Better Slow Down," and the guys in the Bronco are falling back, they're running out of gas, and so are the helicopters, they're crashing in magnificent

special-effects explosions as the flat-tired bus, all teeth and fur, careens through a breakaway chain-link fence onto the nearest runway where, incredibly, Air Force One just happens to be landing and Clint Eastwood, personal bodyguard of President Elvis Kennedy, played by Arnold Schwarzenegger, comes running (Eastwood does) to stop the bus but splat! Bullock runs right over him, and Hopper and Nicholson are peeing all over each other and what's left of the bus's guts, marking their territory or maybe just scared of colliding with Schwarzenegger, and Pfeiffer's still staring at her fetchingly furry million-dollar snout in the mirror, and Air Force One is rolling down the runway and so is the runaway bus, and suddenly Nicholson snarls *Hey this is my bus, I'm the highest-paid animal here* and takes the wheel just in time to throw the bus into a controlled spin averting a deadly collision, and while it's slowly spinning and the camera is following self-consciously the surrounding airport scenery flying by in the moonlight and the television news crews' floodlights as the faces of the star passengers grow more and more loathsome and lovely and sexily deranged in their approaching climax courtesy of advanced computer graphics Reeves and Spader in their police cruiser now blaring a Dan Quayle self-help golf tape skid up alongside and Reeves leans out à la Robert Redford and slips a Denver Boot on the bus's right front wheel and everything screeches to a shrieking stop!

Reeves and Spader, consummate cops, slowly approach the bus. The two black guys in the white Bronco roar out of nowhere onto the runway and up a wheelchair ramp into Air Force One. The pilot, a Bob Dole lookalike, methodically drives the plane into Santa Monica Bay. Nicholson, Hopper, Pfeiffer

and Bullock, in that order, attempt to evade the approaching police by leaving the disabled bus through the exhaust pipe. But Spader and Reeves intuit the ruse and are waiting with muzzles and drugs to subdue the stars. Fangs dripping money in the moonlight, Nicholson bites off Hopper's head before the cops can get a muzzle on him and bounds off into the bay after Air Force One. Pfeiffer and Bullock follow, growling something about a sequel…

Mary Holmes, 1910–2002

[2002]

"I think there has to be a new interpretation of the meaning of life," Mary Holmes said to me in 1981. She was being interviewed for the premier issue of the Santa Cruz *Express* and we were talking about the arts and the role of artists in times of despair and confusion, as at the first millennium and the one that was fast approaching.

"There has to be something which will tell people that life has meaning and will tell them what the meaning is," she continued. "And when that happens there'll just be an explosion of the arts, because the arts are dedicated to conveying meaning— I mean they're dedicated to telling people the significant, valuable things in the world."

Substitute her name for the arts in that sentence and you have the essence of Mary's contribution to the lives of those who heard her lectures, saw her paintings, or were lucky enough to be her friends. She was dedicated to telling people the valuable things in the world.

A legendary professor of art history at UCLA in the early 1960s when I first heard her name, she was among the band

of visionary educators who started the experiment of UCSC in 1965. Though the University of California's corporate reality eventually caught up with and defeated that experiment, much-loved teachers like Holmes and her longtime colleague Page Smith had an indelible impact on their students.

Mary Holmes died last week at the age of 91, and her disappearance, like Smith's seven years ago, leaves a hole in local culture that won't be filled. Smith's daughter Anne Easley remembers Mary's lectures as "mesmerizing, funny, enchanting, informative, inspired, eloquent, insightful." A consummate storyteller and natural philosopher, she was able to communicate not only historical facts and esthetic observations, and the contexts in which various cultures' art had been created, but also her tremendous enthusiasm and amazement and awe at what those artists and cultures had accomplished.

This ecumenical appreciation for a great range of cultural traditions may have originated in her early days as a teacher at the University of Iowa during the Second World War. She had to fill in for other professors who'd been drafted mid-semester, so, as she told me, she "had to learn an awful lot of stuff" she might not have discovered otherwise, or at least so soon. Though she was already a painter at the time, she chose to teach art history rather than painting so as to keep the great works in front of her and thereby maintain "the standard" she aspired to as an artist.

Later she created the murals that can be seen at Cowell College, and she kept on painting right up to the final months of her life. "She went on a building rampage in the last 10 years," her friend and landmate Bruce Cantz told me, because she needed more places to put her paintings. She was also a

collector of "found and maimed objects," and her home on a Santa Cruz hilltop had some of the fertile chaos of a salvage yard combined with Old McDonald's Farm, with dogs and cats and horses and chickens and—if you believed the warning sign on the perilously steep and treacherous driveway—unicorns.

Known as Little Mary Sunshine when she was a child, all her life she had an almost supernatural aura of sublimity. While others dreaded the millennium, she looked forward to it for its Aquarian promise of "a change in the quality of compassion." Without trying to be funny, she consistently made people laugh because, she explained to a puzzled friend, "People delight in the truth, and they express delight by laughter."

Teaching returning veterans at Ohio State in the years after World War II, she admired what she called "the toughness of their minds" and cultivated that trait in her own thinking even as she radiated benevolence. Just minutes before I learned of her death I was thinking of the time she spoke to me about the way that studying history revealed how few contemporary crises were really anything new, and how this understanding had "a calming effect on the mind."

She could look at something—a work of art or a person or a piece of junk from the dump—and see its value, recognize its beauty, find some meaning in it and articulate that meaning. At the Penny University, a downtown open-door seminar she started with Page Smith and Paul Lee decades ago and which continues to meet weekly, she carried on that tradition of passionate inquiry and advocacy until she was physically unable to climb stairs.

A great painter who is also a great talker is an unusual combination. Mary's verbal and visual gifts seemed not only to

complement but to stimulate each other and nourish a sense of mutual interrelation, so that talking about art and creating it were, for her, part of the same process, both of them equally spontaneous, equally crafty acts of praise.

"An act of imagination," she said, "a visible act of imagination, is the greatest affirmation of people, you know—where you see, really, that this mind and this gift could create this extraordinary thing." She could have been describing her own life, as when she added: "You have to have your eyes open, or your mind open or something, so that you can receive these things."

That openness of eyes and mind, of heart and spirit, the joyful generosity that wants nothing more than to spread revelation, were constant qualities of Mary Holmes. Her powerful example keeps resonating in the countless souls she touched.

Museum Mysteries:
A Self-guided Tour

[2010]

Art museums, those great graveyards of culture, tend to evoke in me unruly mixtures of emotions. The most moving works on display inspire awe and wonder in their manifestation of the artist's spirit, their transformation of joy or anguish or passion or irony or despair or formal experiment—or all these abstractions at the same time—into a material object that holds their creation in time as evidence of an extraordinary existence, an example of what a human being can do in the service of the soul's truth. Yet I also find an inescapable pathos in these works, a sense of loss, of the artist's individual transience, for which this kind of frozen perpetual presence is small consolation. What good is immortality if the creator can't live to enjoy it? And yet the prospect of anyone actually living forever is even more horrifying.

Such thoughts swirl through my consciousness as I stand, stunned, facing a Hopper or Vermeer or Matisse or Hokusai or some ancient anonymous Chinese scroll or Greek vase or marble sculpture or other untouchable artifact.

I understand how some museumgoers might want to temper

such a response and arrive at a more rational understanding by way of a guide to the art—some knowledgeable docent or teacher to place the work in historical context and explain its compositional elements, or one of those telephone-like devices that leads the visitor on a helpful "self-guided" tour of the galleries, piece by piece—but I much prefer an unmediated encounter, possibly assisted by a card on the wall, whereby I can meet the art on my own, and its own, terms, absorbing as fully as possible its immediate sensory impression. I remember discovering, at age 19, Géricault's *The Raft of the Medusa* in the Louvre and being almost literally knocked off my feet by the impact of that epic image. Fifteen or 20 years later, at the Metropolitan in New York, I had a similar experience with Jackson Pollock's *Autumn Rhythm*. These monumental paintings hit me with the full force of their virtuosity, driving home to my exposed psyche the genius and passion of their creators and their mastery of the medium more than a century apart in radically different styles yet conveying their respective stories with comparable power.

Later I would read about the historical source of Géricault's canvas, the 1816 shipwreck of a French frigate, and about Pollock's technique of action painting as a way of expressing inner states, but to stop and gaze at either picture in ignorance and amazement was an enriching lesson in surrendering to the esthetic experience, which is finally so much more than merely sensory. A great work of art can invade you in a way against which you are utterly defenseless, and for me this is the most illuminating aspect of the encounter. How one of Cézanne's still lifes—say, some apples or onions on a table—can be so moving is a mystery that no amount of formal explanation can

account for, any more than I can rationalize the ravishment I've felt while listening to a Dvorak symphony or a Rodrigo guitar concerto.

These reflections were set in motion by recent visits I made to three museums: the Philadelphia Museum of Art, and MoMA and the Metropolitan in New York City. (Yes, I know about the Impressionist and Post-Impressionist shows at the De Young in San Francisco, but you needed a reservation to get into those spectacles, and I'd rather decide to walk in casually on the spur of the moment than drive to the city, park and stand in line at an appointed time.) At each I had a quintessential museum experience—not only with the art but with the settings and my fellow spectators—which reminded me of why I love museums and often find them exasperating.

On a Wednesday afternoon in Philadelphia I had the enormous building almost to myself. Since my capacity to contemplate masterworks is limited, an hour or so in such a place is about as much as I can take, so I went straight to the wing that houses works from Europe of the late 19th and early 20th centuries. There were some wonderful things in there, including one of the aforementioned Cézannes, but what stopped me in my tracks for an extended stare, and brought me back for a longer look, was a van Gogh landscape I'd never seen before—not even in a book or a calendar. Poor Vincent: so broke and tormented and neglected in his lifetime, now worth countless millions on the art market and reproduced ad nauseum in prints until reduced to part of the cultural scenery, domesticated, merely decorative. But more than once I've unexpectedly come upon one of his pictures and been overwhelmed by its extraordinary energy and embodiment of feeling.

In Philadelphia the picture was called *Rain* and showed, apparently from the artist's window in the hospital at Saint Rémy, a walled wheat field and the landscape beyond—the same field seen more famously in some of his other pictures—but in this case instead of vibrant colors and dramatic swirls of form, the whole large image was muted by slanted vertical streaks of what at first glance looked like gray sheets of a downpour. The entire countryside is drenched under the force of this torrential storm. No wonder I'd never seen this picture reproduced. It seemed to lack the color and drama of Vincent's more sensational paintings.

Yet the longer I looked the more I saw, until what at first appeared to be a grim gray curtain became, one slender stroke at a time, an almost psychedelic array of subtle color, each streak of rain containing its own rainbow, until I could feel not just the richness of the paint and the patience of the painter's meticulous technique but the correlation between the visible image of that seemingly washed-out landscape and the inner condition of the artist: his tears—of grief and sorrow and loneliness, for sure—but also the flooding joy of the creator able to channel his despair through passionate skill to bring into being an object of astonishing beauty.

I was grateful to be all by myself in the gallery and to be able to linger in front of this heartbreaking, inspiring and consoling work without the distraction of other spectators or anyone trying to explain what it meant or where it fit in van Gogh's oeuvre. The fact that I'd never seen it before, unlike so many of his better-known pictures, lent it a quality of increased uniqueness, a sense that, for the moment anyway, it existed for me alone in the intimacy of discovery.

A few days later in New York I had a different kind of museum experience. The Museum of Modern Art was featuring a big retrospective on Abstract Expressionism, that volcanic mid–20th-century movement which, for a few years there, tore open tradition with greater force than anything before or since, establishing American painters as the most daring and original masters of the time and New York as the new creative capital of the world, displacing dusty old Paris. Gallery after gallery displayed an impressive array of these seminal paintings, none more astounding to my eye than the Pollocks—but the blockbuster context was inescapable. Moving in swarms through these immaculate rooms with their white walls and explanatory cards were hundreds—more like thousands—of visitors, mostly tourists like me, looking, with various kinds and degrees of attention, at the artifacts, and taking away or leaving behind whatever they may have found.

What struck me most troublingly, apart from the power of many of the paintings themselves—the Klines and Rothkos and de Koonings and Motherwells—was the strange behavior of many of my fellow tourists. Rather than gaze at the pictures long enough to begin to absorb something of their mystery, many of them would position themselves adjacent to the canvas on the wall and have a companion snap a photograph with a cellphone. The art, like any other tourist attraction, was there to serve as background for a souvenir. *Look*, the photo would declare back home, *I was there with this crazy painting—how cool is that?*

I couldn't help wondering what the artists, those departed souls, would think if they knew this was happening to their works. Of course, in their lifetimes they and their products

became commercial commodities, so it's not as if they ever existed (beyond the walls of their studios) in some pristine realm of pure creation. And while museums serve, especially in a cacophonous city like New York, as oases of calm and contemplation, they're not exactly sacred zones of spiritual refinement where the vulgar reality of commerce is not admitted (witness the gift shop). Nevertheless, there's something slightly unsavory about the cluelessness of those who would reduce the life-and-death struggle of a great artist to a scenic setting for their own vanity.

Part of the genius of Andy Warhol, who came on the scene toward the end of the Abstract Expressionists' glory and helped to finish them off as an avant-garde force, was to celebrate surfaces and commodification even as the Ab-Expressos were baring their souls. Warhol could see through the crassness of the art business and sought to give back to the public a reflection of its most superficial self. His dry wit and blatant commercialism undercut and ultimately superseded the self-styled spiritual heroism of his immediate predecessors.

Still, I confess that I was disconcerted by the antics of the picture-takers taking each other's pictures in front of or next to the famous pictures, as if trying to steal a bit of immortality by the cheapest, easiest means. (Or perhaps this was merely postmodernism in action.)

My art safari came full circle a few days later at the Met. The destination was a small exhibit of Joan Miró's *Dutch Interiors*. The Spanish painter, sometimes identified with Surrealism, had his own unique take on tradition, and in these few canvases took an assortment of 17th-century domestic genre paintings from the Netherlands and riffed on their subject matter and

visual patterns to almost unrecognizable quasi-abstract, quasi-figurative stylization. Playful, colorful and strangely funny, Miró's parodies of his predecessors have a buoyant insouciance miles removed from the angst of the likes of Pollock and van Gogh. Miró is having fun—not at anyone else's expense but, like all great innovators, in the interest of creating something fresh, of revitalizing the medium, blowing away clichés and leaving his own unmistakable mark on the museum wall. Seriously silly, his pictures radiate irreverence.

I must say, though, that Vincent's gloomy Dutch interior—objectified in his rendering of that rainy wheat field—filled me with a paradoxical happiness that has outlasted my amusement with the Mirós. Van Gogh's is a dark joy wrested at great cost from the jaws of despair, a kind of pleasure that perhaps only the saddest souls can alchemize out of their suffering. How such a grave material object, held behind glass and affixed to a wall, can generate such death-defying delight is something I'll never understand.

Bearden's Burden

[2004]

For many of those lucky enough to have seen it, the Romare Bearden retrospective this past spring at the San Francisco Museum of Modern Art must have been a revelation. I half-knew what to expect, having avidly admired Bearden's work since catching a generous exhibition of it at the Studio Museum of Harlem in 1991, but even I was surprised at the power and scope and beauty of this artist's achievement. Bearden is not exactly a household name—several culturally literate friends and acquaintances of mine I mentioned the show to had never heard of him—and his pictures have not been reproduced ad nauseum, thus giving him no Coca-Cola-logo-esque brand recognition in the popular art marketplace. Unlike such peers as Picasso, his pieces don't sell at auction for dozens of millions of dollars. But by the time I left the museum, in that inspirational daze one feels following a rare encounter with greatness, I was already starting to appreciate how an artist's relative lack of name (and image) recognition can be a blessing for artist and appreciator alike.

When one thinks of the icons of American art—Whistler,

Sargent, Homer, Hopper, Pollock, to name a few—the names evoke corresponding images of paintings that have come to be part of our cultural landscape. Sargent's opulent portraits, Hopper's spookily desolate cityscapes, Pollock's wildly energetic abstractions are all familiar to lovers of painting in a way that makes it a challenge to see them freshly. Endlessly reproduced in books and prints and postcards, they lose what the critic Walter Benjamin, in his seminal essay "The Work of Art in the Age of Mechanical Reproduction," called their aura. It is only the power of the original art itself—its aura felt unmediated in person—that can transcend its endless replication. A van Gogh landscape on a postcard is one thing, the actual painting on a wall quite another.

Frida Kahlo is perhaps the most dramatic and poignant example of a fine and original painter who, through just the last 20 years or so of commercial overexposure and exploitation, has been rendered completely kitsch, cliché, a Hallmark mockery of her own distinctive accomplishment. In the SFMOMA gift shop the Kahlo tchotchkes—the coffee mugs and mouse pads and appointment calendars replicating her by-now-ubiquitous images—were a depressing reminder of how even the most idiosyncratic creator can be degraded by the descent into mass marketing. Andy Warhol's perverse genius was to turn his grasp of this corrupting commercial reality into a satiric and hugely successful artistic career.

What made the Bearden show so astounding was partly the unfamiliarity of his images. While his style is completely recognizable—once you know his work you can spot one of his pictures a mile away—he has remained beyond the reach of the marketing mainstream. Which isn't to say he was unknown

or unsuccessful. Born in North Carolina in 1911, he came of age as an artist in New York during some of the most fertile years of that city's creative ferment. But he was also African-American and chose as his subject matter a "black" reality that may have limited commercial value. By the time of his first big retrospective at the Museum of Modern Art in 1971 he was widely acknowledged as a contemporary giant, easily in the same league with the biggest stars of the day. But even since his death in 1988 he hasn't gained the public visibility of many lesser painters, and one can only speculate as to why.

Race aside, his choice of media may have something to do with it; he was not primarily an oil painter but a mixed-media collagist whose synthetic use of materials—cut paper, magazine photos, ink, graphite, watercolor—gives his pictures an almost playful quality of childlike improvisation. Drawing on many different traditions—Romanticism, Impressionism, Surrealism, Cubism, Fauvism, Expressionism, abstraction, Pop—Bearden's pictures integrate a remarkable range of styles in such a way that it's hard to identify him with any single school or movement. His unerring sense of formal harmony, the exquisite visual rhythms of his compositions, their sense of controlled spontaneity and strong yet shapely feeling—as in the music, blues and jazz, whose players he often depicted—reveal a consummate mastery of technique wedded to a tremendous imagination.

Bearden's blend of abstraction and figuration, of lyric and narrative elements, is held together by the central presence of people in his pictures. Based sometimes on mythic or literary figures like Odysseus, at others on his family members in rural North Carolina or urban Pittsburgh—drawing as much on childhood memory and life in the city streets as on images in art

history or literature—his collages, even at their least "realistic," have a recognizable and inviting quality rooted in their warmly human atmosphere. There's a folk-art innocence of vision at work within a highly sophisticated sensibility. The distortions of perspective, the explosive colors, the witty juxtaposition of images, the flat surfaces, the intricate and elaborate background detail, the cut-out eyes and noses and lips and arms and legs combine to create a sense of balanced calm, a deceptive order, amid what might at first glance look chaotic. Bearden's Whitmanic generosity, his openness to experience, his spirited embrace of the world radiate from practically every picture. You can feel his joy in bringing the composition into existence.

And yet there is nothing easy about these works. Beyond the obviously painstaking effort required to create such perfectly composed pieces, the artist challenges the viewer to fully engage with the images in order to understand what's going on. There are no simpleminded sentiments or homilitic lessons presented, but rather a head-on encounter with the world in all its messy complexity. There is plenty of irony but no protective cynicism. The specific celebration of African-American perseverance in the face of poverty and adversity—without resorting to polemical denunciations of racial injustice—translates to the universal human story of people making the best of difficult conditions. Deeply committed to the everyday struggles and dignity of a particular community, Bearden's art attains a global dimension thanks to the breadth of his own humanity. He demands of the viewer a responsive effort to absorb the richness of the artist's large ambition. He makes you rise to his level of perception.

Faced with such inspired and inspiring art, I wanted to tell

everyone I know to try and see this show while it was in the city. Another way to alert people to Bearden's magnitude was to write and publish something that would encourage them to watch for his work and see for themselves what I mean. Yet at the same time I'm fully aware of the terrible paradox of popularity, of the diminishment of an artist's accomplishment that can come from being over-publicized. Consider for example most of the French Impressionists, cheesy prints of whose masterpieces decorate the walls of hotel rooms and dentists' offices everywhere.

And it isn't just painters this can happen to; novelists, poets, musicians, filmmakers who hit the jackpot of popular success must have exceptional reserves of focus and integrity in order not to be reduced to parodies of themselves. Anyone who has published a book in recent years knows the distasteful feeling of having to turn yourself and your work into a product, a cultural commodity, regardless of its original intent. Many good writers and artists, lacking the stomach for such self-debasement, opt out of the quest for fame and fortune altogether. I know of many superb creative workers who don't get the recognition they deserve, yet maybe their very obscurity is part of what gives them the edge required to keep from becoming smug recyclers of their own greatest hits.

Perhaps Romare Bearden privately thought he should have been more widely recognized as one of the preeminent 20th-century artists, but for me he remains one of those semi-private treasures whose wonders are known mainly to a community of admirers that may or may not eventually evolve into a greater mass. For now, I'm grateful for the unspoiled gift of this open secret.

City Light: Edward Hopper in San Francisco

[1982]

Last week I drove to the city to see the Edward Hopper show at the San Francisco Museum of Modern Art. Hopper is one of those Famous Painters whose images in their multiple reproduction have nearly become clichés in our shared esthetic unconsciousness. *Gas*, *Nighthawks*, *New York Movie* and many of his other canvases are as much classical/popular facts of American art as those movies Hopper himself loved looking at.

But except for a three-story show of his graphic work (mostly commercial stuff he did to survive when his paintings weren't selling) I caught a few years ago at the Whitney in New York, a lot of Hopper's most familiar images were pictures I'd never seen in person. Looking at a print or postcard of a great painting is like watching some epic film on a ten-inch TV: it is not just the scale that's reduced but the entire texture of the original that is lost or at least diminished in the process. I thought of the light in Hopper's pictures and how interesting it would be to feel it wiggling up out of the actual oils.

One of the best things about art museums is how they smell. For all the sanitary tidiness there is always the wild odor of oil

paint in the air, the only trace of the studio apart from the art objects—which, the longer they are displayed and revered as Immortal Works, the more they tend to shade into some grotesque parody of themselves. Just think of all the mustaches you've seen or doodled on the Mona Lisa: an image that overexposed eventually loses its dignity.

In the so-called realism of Hopper's mature work the paintings have a sense of the grotesque built into them to undermine or mask their bald romanticism. The faces on his people are indistinct but clearly desolate, turned inward or emotionally nowhere. They are stranded in twilight zones of stark objects and architecture, lonesome as Jack Kerouac or Sherwood Anderson characters. Like those writers, Hopper is a voyeur, visually eavesdropping on isolated lives behind windows, in lobbies, on trains, in restaurants. All the barrenness of a small apartment blazes out of the cold light slashing across a bed.

But Hopper's head is cool, you can tell these pictures were brought into being deliberately over slow time. They are meditations and it is in their extraordinary extended silence that we can hear whatever we bring to the brooding images.

In a videotape that accompanies the exhibition Hopper is pictured as a man of few words whose methodical intent is to recognize and render what's "outside" by way of what's "inside." His paintings have a stark honesty that seems almost cruel at times except that the artist's attention is so compassionately attuned to the scene at hand. Far from being realistic in any photographic sense, Hopper's vision seems to take a general impression with all inessential detail stripped away. The harshness in many of the pictures is not just the eerily clear light in the paint but the naked/raw simplicity of the perception.

Words don't really work to describe museum pieces; the things are there, you look at them—filtering out the murmurs and exclamations and explanations of your fellow spectators—and maybe you are stopped by one canvas long enough to be touched by something the artist saw or felt. For me, some of Hopper's early paintings done in Paris before the First World War, bathed in soft light and shimmering with subtle color *à la* Monet—various buildings along the Seine at different times of day—were the ones that got to me somehow even more than his harder and stronger American work.

Maybe it was their sappily nostalgic air that drew me to the Paris pictures, the romance of the artist as a young man and all the sad beauty of that vanishing situation, but after gazing at a twilit Notre Dame it was hard to face the rigid figures of Hopper's mercilessly vivid New York.

Skipping the souvenirs for sale at the Hopper Shop—including a "lavishly illustrated" and largely unaffordable catalog—I stepped back into the streets of San Francisco Civic Center a little unsettled. It was loud outside with a cold wind cutting across the parked cars. I headed toward North Beach with eyes as if peeled by Hopper's paintings: each line of light/shadow, each beam of color leaping off a wall zapped its way through my windshield.

Standing in City Lights leafing through the latest little magazines, eating pasta al pesto at the US Restaurant (where Gregory Corso wandered in with a simian snarl on his mug like something out of William Burroughs), shooting 8-ball with a drunk in the Caffè Italia, I found Hopperesque compositions spontaneously shaping up before me as if to illustrate the billboard that declared: "Art is a lie which makes you realize the truth."

The truth on display in the city is much more baroque and sordid, more dangerously personal than Hopper showed it: people on the move up and down Columbus are crawling with an incredible range of expression—exhausted faces and faces shining with erotic radiance, machinery screaming in the real street—millions of otherwise missable impressions are distilled by painterly silence and patience into ways of seeing that wake you to what's there.

Net Art Man:
Stan Fullerton

[1982]

Seeing Stan Fullerton's etchings and collages on display at the Caffè Domenica makes me think of the time I first met the artist a decade ago in Bonny Doon. I was living in a house whose mountainside was slipping out from under it and was told by Stanley (from whom I was buying some old barn siding) that if anyone could hold back a landslide, he was the man. Big Stan, smoking his pipe and talking a streak of downhome knowhow, designed a system of drains and bulkheads to keep the steep hill standing. Like Zorba battling the lignite mine, Fullerton took on nature's forces with the zeal of a fool superman.

The builder from whom I had bought the house had graded a road to the place without the required permits (as I learned later during the lawsuit) and this road had so destabilized the already shaky geology that each time it rained great cracks would open in the earth on which my home was supposed to stand. Just uphill from the building several second-growth redwoods leaned precariously over the roof. The redwood retaining walls that Stanley proposed to hold the hillside made esthetic as well as structural sense. (In my impatience to own

my own mountain retreat, I hadn't understood the meaning of the extensive bulldozer damage at the building site.)

No house, as it turned out, belonged there but it took us two months of anxious labor to realize that the task was too much for anyone short of the Army Corps of Engineers. Sitting around the woodstove at lunchtime in early winter hoping for no rain, four or five of us would wonder out loud if we weren't idiots for attempting to keep the slope from finding its angle of repose. Stanley was sure it could be stopped but eventually even he became discouraged by the immensity of the effort. Besides, he'd just turned 40, his blood pressure was up and his doctor recommended that he cut back on strenuous physical effort.

For someone who'd spent several years dismantling Victorian buildings board by board and recycling the lumber, to lay off physical labor was an almost ridiculous proposition. Stanley, while quite the philosopher, was a man who expressed himself in physically epic terms. Large and unruly, yet meticulous, he was thrilled to build his own fishing boat, to singlehandedly raise himself a two-story studio with mammoth timbers, or to have it out one-on-one with a whole mountain. In his eagerness to fell a 50-foot redwood behind my house without the aid of a cable, he had dropped the tree on top of the garage.

But not all of his work was on such a titanic or catastrophic scale. As I came to know him over the next few years, visiting his studio now and again, I saw the playful lightness of his drawings, the bright energy in his comic/impressionistic oils, the slender welded sheetmetal sea birds. Three of his paintings—a self-portrait with white rhino (#7), a dreamy invocation of Pablo Casals and his muse, and a vibrating little

visionary landscape—have been hanging in my house for several years: I'm still amazed and inspired by the simple depths of his vision.

It's that depth and simplicity that jump out of the etchings on the walls at Caffè Domenica. Fullerton's images are predominantly satirical (he cites Goya as among his masters) but the irony in his pictures—sharp as it is—is extremely genial and gentle. The joke is on everyone, including the artist. His ludicrous creatures are caricatures of us all strutting our stuff—whether we're a fish on roller skates or a small owl nesting in a rhino's ear.

Fishes and rhinos are emblematic beasts for Fullerton, who works as a professional net fisherman (on the aforementioned hand-built boat) and who vaguely resembles a rhinoceros. Listening to Bach each morning on the bay, mending and untangling his "harem" of nets, Stanley has time to hatch his artwork at sea and bring it to life in his studio all afternoon with his favorite music booming in the background. The joyful turbulence of his workspace is obvious from the orderly mess surrounding his drafting table. He's a kid who clearly loves what he's doing.

His paintings and sculptures and graphic works are popular—keen-eyed Fullerton fans have bought a lot of them (at pre-inflation prices) over the years—but it's been ten years since he's had an exhibition. Unpleasant adventures in commercial culture have led him to cultivate a studied reclusiveness since the early 1970s. During the previous decade in Santa Cruz, having stayed here for keeps after 1961 when his motorcycle broke en route through town, Stanley was known as the Wooden Indian: a formidable woodcarver whose massive hand-hewn

doors were legendary. Now he's working largely with finer lines—which rhyme with the lines of his fishing nets—and is ready again to make his art more public.

Although more elaborate shows may be in the works, I like the feeling of looking at Stanley's stuff in the intimate informality of a café. The presence of people eating and sipping and conversing establishes the properly nutritious social context in which to appreciate his whimsical, penetrating imagery. The inconvenience of having to lean across an occupied table in order to get a good gander at the art is reason enough to come back more than once.

Where the artist's appetite is concerned, however, it's much more than what's on the wall that matters. The value and savvy of well lived hours echo in whatever the man puts his hands on. The sense of someone who lives his art (and his crafty life) fulltime emanates gently from each line, each color, each piece of ripped and collaged currency; from the facial expression of each creature he cooks up, childlike, in the fenceless playpen of his brain. Humane enthusiasm wiggles right out of its frames, just as that flash/gleam leaps from Stanley's eyes when he speaks of the pleasures of mending his many nets.

The Nutzle Enigma

[2007]

A few miles southeast of Watsonville, across the line into San Benito County, on a side street behind the bakery in San Juan Bautista, is a little antiques and collectibles shop called Fool's Gold. The shop's proprietors, Halina and Bruce Kleinsmith, live nearby in what used to be a truck or tractor barn, a cavernous space with steel beams in the ceiling, divided by an adobe wall into living quarters and an art studio. The artist in residence is Kleinsmith, better known to Santa Cruz old-timers as Futzie Nutzle, at one time the most widely known visual artist in town. From the late 1960s through the 1980s Nutzle's drawings, paintings, cartoons and posters were practically everywhere in the Santa Cruz cultural landscape, especially in the various newspapers that came and went during those years. Nutzle's distinctive, spare, fine black ink line, set off against its stark white background, was unmistakable in its minimalist clarity, sophisticated wit and nutty originality.

At a time when Santa Cruz was rich with talented cartoonists—pungent pens like Karl Vidstrand, Tim Eagan and A West among others—and when the local press was daringly creative

in its violations of journalistic convention, Nutzle's images were a revelation to readers and an inspiration to other artists and writers. From 1975 to 1980 a Nutzle drawing graced the letters page of every issue of *Rolling Stone*, and from 1985 into the late 1990s his work appeared continuously in Tokyo's *Japan Times*, further internationalizing his visibility. For a while in the 90s he was on the letters page of *Metro Santa Cruz*. Then he pretty much dropped out of sight, at least as far as most of the world was concerned.

Last year I received an unexpected announcement of a new Nutzle exhibition at the Aromas Public Library: plein air oil paintings of the San Juan Bautista Mission. Such a show was news to me not only because I hadn't heard from Nutzle in many years, but because the subject matter and style of the pictures were such a departure from the cartoonish surrealism of his earlier work in oils, let alone the surreal cartoonism of his drawings. But in several visits with the artist over the last year I've come to understand how his effort to master a more conventional genre fits a lifelong pattern of "cutting new ground," moving beyond any comfort zone he may have created in whatever medium. As evidenced in the course of our conversations, Nutzle has evolved into what could be called a pure artist, one who works not for a market or a career but for the satisfactions of his own sense of discovery.

Ambitious yet with no taste for self-promotion, unafraid of silliness yet deadly serious, uncompromising yet not too proud to publish almost anywhere, inhabiting an ambiguous zone between cartooning and fine art, Nutzle is a paradoxical character, sharing affinities with such diverse artists as Otto Soglow (creator of "The Little King" comic strip of the 1940s

and 1950s), Salvador Dalí (plumber of the unconscious), James Thurber (master of the simple satirical line) and the great Saul Steinberg (imaginative improviser extraordinaire and Nutzle's acknowledged model for genre-defying flights of visual invention). His drawings, while often jokey, are at the same time mysterious and enigmatic. In an age of blatancy and exhibitionism, Nutzle deals in subtlety, inviting the viewer to slow down and look at his images for a clue to what's really going on.

His silver-white hair pulled back in a ponytail, intense gaze shaded by formidable eyebrows, a tiny triangle of Chinese whiskers gracing his lower lip, Nutzle at 65, still trim and physical, has the severe demeanor of a hipster-philosopher who brooks no nonsense. His deep voice resonates with conviction rooted in experience. His studio has the feel of a funky loft or garage-museum shaped by the artist's eclectic eye. The barn-like space boasts dizzying collections of old-time movie-cowboy memorabilia, toy cars, old books, crates of LPs, shelves full of movies on videotape, miscellaneous tchotchkes, a manual typewriter, lots of paintings, and of course a vast archive of original works on paper. He has no computer—he threw one out the door in a fit of techno-exasperation—wedded as he remains to old-school notions of manual skill and unplugged self-invention.

Nutzle's model of "a real artist" is his friend Phil Hefferton, who in the 1950s was rising in the ranks of young New York painters only to abandon that path and turn up in Santa Cruz where they met in 1968. In subsequent years Hefferton, according to Nutzle, "concentrated on creating his own language," singlemindedly devoting himself to painting. "He's the

person that actually got to the painting; he's got *miles* of paintings, and they're so provocative, and so otherworldly, and so connected with his own spirituality, and the path of his thinking in philosophy. And it includes his family and the world. Paintings with real paint quality and paintings that are interpretive; but he arrived at the paintings, the paintings dictated what he needed to do to arrive at the finish of the painting. So *he's* a real painter."

Such a rigorous, almost monastic idea of the commitment art requires runs counter to the stereotype of Santa Cruz as a laid-back place where anyone's personal effort at creative expression can be called art. "This is not an art town," Nutzle declares—"people don't need it; you can go down and look at the ocean." It's the uglier places, like Cleveland, where he comes from, that demand of the artist a fresh vision of reality. "The only kind of art that I felt was needed here was humor."

But in Nutzle's exacting judgment, even many New York artists have lost touch with the fundamentals. "Sometimes I think of some of this crap that comes out of New York that they're selling for $100,000—I mean some of those guys need to go out and look at a tree or something. They don't even know what a source of light is; they have no idea."

The rise of conceptual art in America since the late 1970s and 80s is a trend he regards with even greater disdain: "Let's light this room in an interesting way and call it art. Well, it's lighting, it's not art. It's lighting. And you see, I didn't fit because I don't have that mentality. To me," says Nutzle, "art is something from the practiced hand. Somebody practiced for years to be able to *do* this—whether they're a Chinese pottery painter, whether they're an Eskimo carving his ivory,

whatever—it's the practiced hand that creates art. And I'll go down in flames protecting that idea, because I can't see it any other way."

Asked his definition of artistic success, Nutzle replies: "Somebody asked me that 20 or 30 years ago, and I think my answer's the same: it's free time.

"I've always had a chip on my shoulder about my own personal slavery. I think we're all slaves to a degree, but very early on I worked for Ford Motor Company in a factory, and had these jobs that were basically slave-labor jobs, which I think inspired me, not only in content but also kind of pushed me away from that whole idea of not being free—free enough just to think about what *I* want to think about and not having any interference with that."

Born in 1942, Nutzle as a small child lost his father in the World War II Battle of the Bulge and grew up in the blue-collar town of Fostoria, Ohio, about 100 miles from Cleveland. His mother, an orphan with good looks and an artistic intelligence but not much luck, remarried a local man, an Irish Catholic from a large family, "basic street-fighter kind of guy," as Nutzle describes him.

"My stepdad started working in this foundry in town when he was about 13 years old. Here's a town of 16,000 people that manufactured two brands of automobiles; it had a spark-plug plant, a slaughterhouse, the foundry, three or four other major industries, so basically everybody in town was employed, everybody was a blue-collar worker. And when I saw the model, I rejected the model."

Little Bruce Kleinsmith started drawing when he was three, and was a dreamy child from early on. "I was born with this

thing of tuning into something," he says. "I'll show you a photograph when I was little and it's me staring out into space, and it was always, Hey Bruce, yoo-hoo, wake up—and I'm like, Wake up to what? This is what's really happening."

Still, he acknowledges that as a teenager hard physical labor had the effect of sharpening his senses. "By the time I was 16, 17, I was driving a dump truck and shoveling iron and sand, and actually melting iron. And I have to say as an artist, the baseness of the job was beautiful. We'd take the iron dumped from the foundry and put it in this smokestack and melt it, and then the slag would go off on one end, and I would tap the hole of clay on the other, and pure white iron would shoot out into these black sand grooves that I'd made by hand; so they would just come out, and then they would turn orange, and then they'd turn red, and then they would turn lead-color, and then I'd break it up with a sledgehammer and throw it on a truck—and that was my job.

"But doing this at sundown, these colors, the indigo sky—I mean I had to watch that I didn't burn my foot off—but it was fantastic, and I didn't mind the labor. The esthetic of that was better than any Hopper painting."

Nutzle's definitive revelation about working for other people, corporations especially, came a few years later, in the early 60s, when he was employed by an advertising agency in Cleveland, "and seeing the torture, the torment, and the absolutely brutal approach to commercial art. And these guys, by the time they were 30 they were alcoholics, they were so stressed out by running across Cleveland with their portfolios—if you can picture me with a portfolio, flying on a private plane alone into Detroit to take this portfolio to General Motors that had the

brand-new Cadillacs, in full color, drawn perfectly," he recalls. "And here's General Motors and I'm running up the steps and it's 12 o'clock noon and I've got the portfolio, and I'm thinking, What in the fuck is this? And then I get back to Cleveland and these guys are getting fired because they put a photograph crooked or something like that. So I ditched everything."

After a spell working for resorts in Florida and then a casino in Lake Tahoe, he found himself in Santa Cruz in 1965. At that time it was a sleepy little town of surfers and pensioners, invaded on weekends and in the summer by working-class tourists from over the hill looking for some fun at the beach or the Boardwalk. But UCSC was just opening and beginning to infuse the city with fresh intellectual life, what we now call "the sixties" with its wide-open experimental ethos was just getting going, and it was easy to find a cheap place to live.

"Santa Cruz to me was like discovered Paradise," says Nutzle. "When I landed in Santa Cruz I just thought, This is it." Without much more than a pen, a pad of paper and a sleeping bag to call his own, he rented a little turkey shed on empty land across the street from what is now Dominican Hospital. "It was at that point I realized that I was nothing and I had nothing, and I was going to design my own life."

Teaming up with young cartoonists Spinny Walker and henry humble, Nutzle and his friends started a little cartoon newspaper called the *Balloon*—really more of an artpaper or folded broadside than anything resembling today's comic or alternative tabloids. Nutzle calls it "a printed sketchbook, a place to learn. We were developing our individual styles, working together on the principle of making each other laugh."

By this time he was starting to publish and show in galleries

under his real name, but his first encounters with the art world gave him the creeps. "I felt there was a mystery that I wasn't getting that I wanted to find," he says. He wanted to discover "what makes some artists great and others not," and had no interest in the struggle between artists and gallery owners and promoters and critics and museum curators over who controls art—the politics of art, the business of art.

"When I hooked up with Spinny and henry we decided to go underground and we invented our pen names in 1967," around the time of the Monterey Pop Festival. "That's exactly when it was happening; that weekend was like the pinnacle, for me, of shifting gears into this new world and new identity and new work. And seeing how things were going psychedelic," Nutzle says he thought to himself, "I'm going simple while everybody's going psychedelic."

The *Balloon* crew started out intending to do traditional cartooning, with panels and characters, Nutzle says, "so I came up with something about a railroad, and Futzie Nutzle was gonna be the clown kinda railroad guy and Uncle Flap was the other character, and we were trying to come up with pen names, and I saw the Z's in Futzie Nutzle, the Z's and how it popped off the page, and it was phonetic—so I ripped off my own character."

By the early 70s the Balloon artists were increasingly visible in Santa Cruz, and Charles Atkins, director of the public library, gave them a show. "Charles Atkins at the library," says Nutzle, "I have such respect for him—he gave us the whole library. I remember Spinny taking down this traditional California landscape and putting up his *Jesus Christ on a Bicycle* painting, and people are standing around just going, What the

hell? That was the first show at the Santa Cruz library. We did it. And it was fantastic and everybody loved it and there were no problems. And then we met Charlie Prentiss and Nikki Silva of the Natural History Museum, and they supported us and we started SCAMP [Santa Cruz Artists Museum Project] downtown."

The anarcho-democratic premise of SCAMP was that anyone who wanted to show could show; all they had to do was walk in with their art and demonstrate a degree of competence. The project lasted scarcely a year, due to the artists being artists, not art administrators. There was no business model, much less a plan. The space was on the third floor above the bank at Pacific and Soquel avenues. "It was a beautiful space, it had those turret kind of windows, it had hardwood floors, we painted all the walls white. We were all maintenance men; nobody was the boss. We just thought that once we had it set up people would help us."

But help never arrived. "I think it scared people off," says Nutzle. "It was a little bit out of the box because before that there were just a couple of landscape galleries in town."

The spontaneity of SCAMP was a natural extension of Nutzle's improvisational method. "I don't have ideas," he says, "I have no ideas at all. I don't use white-out. I don't use any pencil. That was my discipline, to train myself, because then every drawing would have a value. I guess it's like building a drawing, instead of having an idea. I could never draw a character more than three times. So what I'm getting at is, I'm not really a cartoonist. My lines are kind of funny, and sometimes I come up with something, but you know, my method of working is not a cartoonist's. That's my association with jazz, it's

improvisational, I can only do the drawing once; if it doesn't come out I throw it away and start another one."

After years of practice in the local fly-by-night papers, by the mid-70s Nutzle's mastery of his medium and a sequence of serendipitous introductions earned him his coveted spot in *Rolling Stone*. "That was my opportunity to really get sharp, because I knew I would be in the public eye," he says. But he'd been trying for ages, without success, to place his drawings in *The New Yorker*, which he calls "the pinnacle of cartooning—at least until 10 or 20 years ago." Accustomed to inhabiting various seemingly incompatible worlds—hanging out with surfers, musicians, hippies, poets, drug dealers, manual laborers, artists and academics, but never belonging to any particular camp— he saw no contradiction between his outlaw lifestyle and his desire to be a part of the nation's most prestigious mainstream magazine.

"When I went to New York in 1979 and met the *New Yorker* cartoonists—not all of them but some of them, over lunch—it was really interesting because they were into one-upmanship," he remembers. "Cartoonists really are square, but these guys were ultra-square, and they were looking for a one-liner that's gonna crack up the whole table. We're drinking martinis, and I think this was a Wednesday afternoon; they all go down to this bar after they've been critiqued at *The New Yorker* and they're like little puppies with their ears back, but after a few martinis they're really rollin', and they're chesty, and they're comin' up with all these one-liners.

"And I'm going, Is this what it's like? I can't be an artist with *The New Yorker*, I can't do this! I really liked some of those guys. Anyway, I pulled out this huge joint, from Califor-

nia, and I said, Would any of you guys like to try this? And they looked at me like, Oh my god, narcotics! Jesus Christ! It was like, Holy shit, put that away!"

Finally, he says, "they got me so mashed on martinis, they had me so whacked, they literally tied my briefcase to my wrist, because I had all my drawings in there, and I thought, I'm so mashed I'm gonna lose all this stuff if they don't tie it to my arm. Man, those guys are too much. They were still slammin' 'em down when I left the bar."

Disillusioned with New York and its peculiar customs, Nutzle returned to California and various jobs as a laborer, a smuggler, an auction-house worker, an antique and junk dealer, a cemetery groundskeeper and gravedigger, all the while continuing to refine and extend his skills as an artist, drawing and painting, now doing a lot of pastels. When his run at *Rolling Stone* expired due to their five-year policy for certain features, he kept publishing locally and showing where he could, eventually landing what he calls his dream job at the *Japan Times*, sending off piles of drawings from which they would select whatever they wanted. As he gained a whole new audience abroad, his visibility here was gradually decreasing.

"The earthquake of 1989 was another turnaround," he says, "because I was going to show at the Art League in Santa Cruz, which was where I was teaching. I was going to have a big kind of retrospective at that point, and after the earthquake I just decided I didn't want to do that, and I retreated to my cabin."

After meeting Halina in 1991, Nutzle moved with her to Marin County, where they were married. He was hired by a computer company to develop a CD-ROM with a team of other artists. Two or three years along, the project was killed for no

discernible reason. This experience only served to remind him once again that he had no place in commercial or corporate culture. So they returned to the cabin he'd kept in Aromas.

Nutzle and Halina have now lived in San Juan for about a decade, with Halina managing Fool's Gold, their shop. As they were being evicted from their cabin, they saw the FOR RENT sign on their current residence. After cleaning it up and hauling away four and a half tons of junk, the artist couldn't wait to get back to work. "I was so stoked," he says. "I mean to have a real studio, it was fantastic. I'm friends with my work. I could literally just work around the clock, every day all day: get up, coffee, come into the studio and start working. So that's why I'm here."

"Honestly," says Nutzle, "I think the hardest thing for me has been being at least two different personalities: like the third-dimensional guy who has a little shop and goes to the flea market, and then the artist guy who nobody really knows— and nobody really knows if they want to know him—in his little hovel doing his thing."

Vidstrand Is a
Many-Stranded Thing

[1995]

Vidstrand was born, or sprang, from the string stretched between two tin cans—one of those primitive telephones his parents, who were kids, were playing with while watching cartoons on TV in a living room located somewhere between the Winchester Mystery House and the Watts Towers. The gifted boy learned to pick up junk very young and bang or glue it together into animals with moving parts and mouths that recited familiar quotes from Beat poets and spat real saliva.

As an adolescent in the Santa Clara Valley he groomed fruit trees and honed his Rapidograph, which he toted in a quick-draw holster like Hopalong Cassidy, until he could nail a Persian miniature to a Blue Gum eucalyptus at a hundred paces. No wonder he soon became an Eagle Scout, capable of building a bonfire by rubbing together a couple of Crayolas or tying the scoutmaster in knots with Zennish non sequiturs.

Vidstrand thinks in pictures but when words come they pour overboard as if in tongues, Tijuana street Spanish mixing intimately with pseudo-Shakespearean mock soliloquies that ask if he has any idea what he's saying as it spills out of him.

"I don't *do* art, I *am* art," he brags à la Dalí on drugs, between sips of high-octane home-brewed Folger's, puffs of Drum and bolts of Bud once the sun goes over the yardarm. But it's morning when he works best, sipping and puffing to the rhythm of the nearest radio which infuses his ink with news which he bemuses into manic ironies of line whose meanderings become cartoons that even the humorless may find amusing.

Funny man, this Vidstrand, and amazingly enough no boy anymore but a family man with wife and son and a house to husband somewhere on the edge of the desert where Space Shuttles swoop in at regular intervals like the arrivals elsewhere of subway trains. "I like living at the fringes of Space," he alleges, "it gives me that kozmic sense of being out of bounds at all times."

Indeed Vidstrand is beyond the pale. In Santa Cruz in his twenties he was a poet for a time but one reading when he recited his Ode to the Moon, which began "O Moon..." the Poetry Police raided the café and revoked his license for eternity. Ever since then he's been drawn to pages where his pen leads him into strange zones where no ink has flown before and he surfs that black lore like a Nobel laureate under the influence of young girls.

These pictures appear in obscure papers and are clipped and pinned to refrigerators as reminders or crumpled and fed to woodstoves which fly smoky hallucinations from their pipes into rainy nights. Even in drought cartoons turn up on newsprint and melt unguarded readers into pools of laughs.

The bats in his belfry peel rubber out of hell, which is the artist's darker side and deepens his comic genius with the light of demons, those bright spirits without whom life itself

would be almost impossible and much less scary and certainly far less interesting as humor would be doomed to happy-face feel-good inanities no tragicomedian could stomach. "I like to chortle and cringe at the same time," says Vidstrand, "it keeps me from feeling too stupid to understand what I can't stand."

But cartoons aren't half of the whole enchilada rolled into Vidstrand's portfolio. Out of dumpsters, out of ducked-down alleyways, from out-of-the-mainstream aisles in suburban supermarkets, from shelves in specialty stores and the floors of abandoned factories he salvages stuff that others would overlook; from roadkill or litter past which he has sped at the speed limit and stopped and backed up to scrape or pick off the pavement, Vidstrand gathers the miscellaneous waste and shapes it into shrines of futuristic primitive religions, flying sculptures that flap their wings or light up like xmas trees, constructions of exclusively Vidstrandian conception which defy description, like the artist himself, existentially enigmatic and just-out-of-the-picture.

Or maybe he'll take a sheet of sheetmetal and, properly tanked and goggled, bend and blowtorch it into Spanglish galleons to hang from the beams of unsuspecting restaurants, rusty reminders that the laws of nature no longer apply when alchemical metallurgists apply themselves.

Vidstrand: a name itself welded from cables of video-spaghetti into long unraveling wires through which messages move at the speed of caffeine and liquid ink, black-magical, or the flame at the torch tip delicately lighting a smoke.

And his green thumb! His prolific flowers and vegetables climbing from rocky terraces whose dirt he has imbued with earthy urges to push plants upward! His skill with succulents!

And his hand with a wok, with sauces, with oak-bark barbecue! Vidstrand is an *artiste* of many media, a neo-ex-post-Renaissance man who would pistol-whip himself with a fresh shark just to understand what it felt like before turning the fish into a succulent ceviche—or a tasty taco on a dusty street in Mulegé. His imagination has rambled without a passport where no government was open. And he has returned, with pictures to prove it.

Chips off the Old Watts

[1985]

Thanks to a friend in Los Angeles, I recently received clippings of a series of articles that appeared last month in the LA *Herald Examiner* on the effort to restore, preserve and otherwise "save" that city's greatest work of art, the Watts Towers. Written with obvious passion by *Herald* architecture critic Leon Whiteson, the articles are part of what the paper calls its "civic campaign" to "galvanize" the community in support of its unique architectural treasure.

Also enclosed with the clippings was a copy of a seven-page letter to the editor that my friend—who goes by the professional name of Mr. Chips (for reasons soon to be explained) —had written in response to the series, acknowledging its good intentions but critiquing its fundamental premises. Several years ago Chips, an artist and teacher now employed as a security guard, wrote a lengthy article of his own entitled "The Watts Towers—Burned by the Politics of Art," a brilliant analysis of how the cultural elite appropriates creative work to its own purposes, which finally have nothing to do with art and everything to do with money, prestige and power. The article,

needless to say, was never published.

I expect that the letter lately sent by Chips to the *Herald* editors will not be published either, partly due to its length and to the imaginative leaps of its reasoning (which are eccentric enough, from a journalistic perspective, to qualify as the work of a "nut") and partly because it punctures the very assumptions that motivate the paper's crusade on behalf of the Towers.

Sam Rodia was an Italian immigrant with little or no formal education who, sometime during the 1920s, purchased a small triangle of land in the neighborhood south of downtown LA known as Watts. Rodia (whose original name was Sabato, and who has been mistakenly called "Simon" for many years) was a construction worker by trade and, according to those who knew him, a rather cranky hermit by disposition. Over the course of some thirty years this little man, who stood about five feet tall, collected an assortment of castoff materials—steel rails, pipes, iron bars, chicken wire, cement, broken bottles, sea shells, pottery shards, pieces of tile—and built the intricately structured and incredibly sturdy complex of shapes and spires that climb to a height of nearly a hundred feet at its pinnacle.

He called his creation *Nuestro Pueblo*—Our Town—and signed it by imprinting his tools in the wet cement of one of its walls. By the time he was finished he was nearly 80. "One day in 1954," writes Whiteson in the *Herald*, "Sam Rodia gave his Towers away to a poor neighbor, and gave his goods and chattels away to anyone who happened to be around at the time." He moved to Martinez in Northern California, where most of his family lived, and died there eleven years later.

Meanwhile, his Towers had become world famous when, in 1959, the Los Angeles City Building and Safety Depart-

ment attempted to demolish them as "an unauthorized public hazard." Not only did the Towers refuse to budge when the city's cranes tested their strength, but internationally renowned artists, architects and critics declared them a work of genius and sprang to their defense. Still, Rodia refused the role of cultural celebrity, and after his death his anomalous masterpiece was neglected for many years through a combination of public indifference and bureaucratic incompetence. Vandalism, weather and the local smog also conspired in the Towers' gradual decay.

For the last six years, the state of California has been responsible for repair work on the Towers, and the structure has been visible only through a maze of scaffolding; but this July the scaffolding comes off and maintenance duties revert to the city, provoking the *Herald* to call on the Los Angeles community to pool its resources in the ongoing care of this monumental macro-sculpture. The Towers are seen by Whiteson as a potential focal point for the cultural and commercial redevelopment of Watts—which suffers from most of the social pathologies of other urban ghettoes—and as an inspiration for LA's artists and designers to come together collectively in a grand esthetic revitalization project for the entire city.

Whiteson cites as an example of such a project the large-scale sprucing-up Los Angeles underwent in preparation for last year's Olympic Games. Why not, he suggests with convincing zeal, use the restoration of the Watts Towers as a point of departure for a reconceptualization of artists' and architects' roles in suffusing public life with the vibrant presence of art. Drawing on "private and public funds," the maintenance of the Towers could spark a gathering of the city's diverse talents

toward the development of "a shared urban consciousness" which would "knit our many segments into a coherent civic pattern."

Enter Mr. Chips: artist, teacher, founding father of wood-scrap sculpture, and letter-to-the-editor writer. We'll get to his letter presently, but first a few words about woodscrap sculpture, an activity he developed in the mid-1960s as a medium for the democratization of art.

Utilizing the marvelous and varied shapes discarded by furniture factories—scraps of leftover wood usually ground to sawdust or incinerated—Chips conceived of an art form in which anyone could participate and thereby liberate their own imagination. First in San Francisco's Ghirardelli Square, later in Santa Cruz and then Los Angeles, Chips instituted what he called the "Glue-In," where, in his words, "woodscraps are dumped on tables with bottles of glue and everyone makes his own thing!" The simplicity of this process is equaled only by the gleaming eyes of kids and adults as they construct ingenious forms of their own spontaneous design.

Employed for several years by the LA County Parks & Recreation Department, Mr. Chips took his Glue-Ins to public places all over LA, turning people on to the artists in themselves. A longtime enemy of what he calls "the elite Art & Cultural Establishment," he saw his revolutionary mission as one of changing—by way of woodscrap sculpture—the concept of art from something one "appreciates" or purchases to something one *does* with whatever materials are at hand.

Which is precisely what Sam Rodia did. The Watts Towers, Chips wrote in his unpublished article, "employ technics, skills and materials that are available to anyone who has something to

say and the need or desire to say it. The only marvel about this primitive technology and these wasted materials (outside of what can be done with them) is that they are as widely ignored as they are available. What they lack is prestige (by elitist standards) and that is something that only money can buy!"

When Proposition 13 passed, the funding was cut for his program and Chips lost his job with the county. The LA Art & Cultural Establishment didn't bat an eyelash and carried on with its galleries, museums, performing arts complexes and multimillion-dollar van Gogh acquisitions. And now this same Establishment, which generally couldn't care less about *living* artists (except for those it can convert to commodities), is called upon to "save" the Watts Towers! No wonder Sam Rodia walked away from his creation. As Chips points out in his letter to the *Herald*, "In his own instinctive, intuitive way he could feel it coming."

The reason the Towers were neglected for so long—and also the reason for their pricelessness—is that Rodia never wanted anything whatsoever to do with the cultural elite; he was just "making his own thing." For the "saving" of the Towers to have any meaning beyond that of a "tombstone" for the artist, writes Chips, social institutions must "evolve in terms of human or 'cultural' values until the Sabato Rodia in all of us can be realized on the highest level of its creative potential."

His letter continues: "The only real justification for the restoration and preservation of the Towers would be for the Towers to serve as a model and inspiration for the development of a non-elitist curriculum for creativity. Such a curriculum would, first of all, be all-inclusive (public) rather than exclusive (elitist) and would encourage participation rather than discourage

it as the 'star system' of the elitist curriculum does. For every genius that the elitist system supports, develops and acclaims, 100,000 are destroyed. We haven't really explored what an art curriculum that wasn't dependent on capitalistic imperatives could do for this country. No one has made a more profound contribution toward this end than Sabato Rodia."

Turning the Towers into a monument or perfectly restored museum piece, however glorious, will be a futile gesture unless the spirit they embody—the democratic ideal of self-realization—can be conveyed, in practical terms, to the children of Watts and beyond. While Whiteson of the *Herald* makes an honest effort in that direction, the more radical perspective of Mr. Chips is conceptually much closer to what Rodia was up to.

The *Herald*, in any case, by calling people's attention to the Towers, to Watts and to the neglected notion of a creative community—especially in a city as vast and scattered and oppressively competitive as Los Angeles—sets a good example for newspapers as agitators of cultural evolution. The fact that hundreds of tons of woodscraps are going to waste while Chips does time as a security guard, and that the *Herald* won't print his letters because he thinks more like an artist than an art patron, is what moves me to be a medium for his message.

Robert Gold,
Bohemian Everyman

[2006]

Soon after my family moved to Los Angeles from Seattle shortly before I was born, my eight-year-old brother Rick made friends at Third Street School with a kid named Bobby Gold. In the years that followed I remember Bobby as jumpily energetic and a grinning wiseacre in a sweet-spirited, just-joking-around sort of way. For a long time Ricky and Bobby were inseparable, a fact of which I was acutely aware because I wanted as much of my brother's attention as possible. But at those ages eight years' difference is an eternity, and I wasn't yet big enough to tag along on their preadolescent adventures. Bobby Gold was the lucky dog who got to hang out with Ricky, and that was just the way things were; he had been there as long as I had and was one of the dramatis personae of everyday life, the archetypal Best Friend of My Big Brother.

When both the Golds and Kesslers moved to the Westside as their fortunes improved, Bobby and Ricky stayed close, but since they were going to different schools and lots of other buddies entered the picture, gradually Bobby became a less-regular presence around our house, even though his name

remained a household word.

By the time Robert Gold died in October he had mostly lost touch with my brother, but over the last decade he had become my friend—and an occasional contributor to *The Redwood Coast Review*. I heard the news of his death from another of Rick's boyhood friends, Jake Fuchs, who as it happens has also published stories in the RCR and become a friend of mine. I leave the literary incestuousness and brotherly complexities of these relations for critics and psychiatrists to decipher, but I must say I'm glad that Robert Gold took the trouble to look me up when he did, because the contact and communications we had were always characterized by an irreverent and wry imagination, a bohemian insouciance tinged with a trace of wistful pathos that things hadn't worked out quite the way he had hoped.

A gifted artist in many media who attended Stanford then gravitated to the Beat scene and the counterculture of the sixties, Gold never quite settled on a profession—though he worked for years as a display installer at Moscone Center in San Francisco—preferring to remain a "dilettante" (his word), an amateur, someone who does things for delight and love rather than as a career.

"His love of music and vast knowledge of jazz performers," Robert's partner of the last seven years, Virginia Hanley, told me, "was impressive, to say the least. He would often tell me, upon hearing a selection on the radio, the name of the tune, the name of the performer, who else was in the group, and where and on what label it was recorded. I found this amusing, because he often couldn't remember what we had eaten for dinner the day before."

Robert's paintings that I've seen have a Miróesque playfulness, a childlike dance of humanoid abstractions against fields of color—one we have on our wall includes the Zennish caption "Nothing is finer in this whole world than…nothing"—and his writings a deadpan wit and relaxed economy. He wrote for these pages on author Tony Cohan, another schoolmate of his who became a successful memoirist and travel writer, and he contributed a vivid portrait of his mentor the late John Thomas, a legendary writer and LA cult figure whom Charles Bukowski dubbed "the best unread poet in America." Robert seemed to aspire to Thomas's sense of imperturbable cool, which was disturbed and enhanced late in life by a passionate love alliance. Robert too, after a couple of marriages and three children, by the time we met up again in the late nineties was in a romantic partnership with Virginia and appeared to have found a certain domestic contentment.

"One of the main things about Robert," Virginia said, "is that he meant what he said, and he didn't pull punches. He inspired and encouraged me to become a better person, a better artist, to believe in my ability. He said early in our relationship, 'I'm going to appreciate you the way you should be appreciated,' and he did. His sister told me that people have said over and over that he lived by his principles.

"At his memorial gathering there were several people who had known Robert since high school and early college days. He kept in touch with his friends; they stayed friends."

Home from college back East in the summer of 1967 I opened the front door of my parents' house one afternoon to find a fringey-looking couple I didn't recognize. The man introduced

himself as the former Bobby Gold, and presented the woman as his wife, Liza Williams, whose name I knew as that of a columnist for the *LA Free Press.* Robert was writing and taking pictures for the paper, an "underground" weekly in the days before what is now known as the "alternative" press went corporate. Owned by independent-minded antiestablishment eccentrics with just enough money to get them launched, such lively sheets as the *Free Press* had a short but obstreperous heyday until they went broke or their publishers burned out from the historic intoxications of the times. Robert with his rebellious creativity was a good match for that heady atmosphere.

Bukowski was also a *Free Press* columnist, and as fate would have it eventually got together with Liza Williams (an affair chronicled in his great novel *Women*), leading Robert later to refer to Bukowski as a "wife stealer." But moving in such freewheeling circles in such tumultuous times entailed a higher-than-average risk of sexual treachery and melodrama, and surely Robert was fully aware of the rulelessness of that universe. Besides, it's not every hipster who can say that his wife was stolen by Charles Bukowski.

Some 30 years later my phone rings in Gualala and it's Robert Gold, now living in the North Bay and interested in getting together sometime. Eventually we did; he and Virginia came by one afternoon and we enjoyed a few congenial hours talking about everything from his telepathic experiments with my brother (intuiting, for example, what baseball player the other was thinking of) to his painterly pursuits and my writing projects. I felt a little strange about that meeting, because I couldn't be sure if Gold was just a slightly geezerly eccentric or if maybe he was a little mad—not angry or crazy, just mildly wiggy in the

way of people who've become more and more themselves as they get older until it no longer matters to them how odd they may appear to others.

A correspondence followed, first by notes and postcards, later longer letters and the occasional email, and I realized Robert had evolved not into a lunatic but into an individual who finally, after an adulthood compromised by the need to earn a living at various pointless jobs, had found the comfort level of his nonconformity and in retirement was living exactly as he pleased, painting and writing and seeking the philosophical equanimity of the monk who has gone to the mountains to become invisible.

Year before last when he was diagnosed with esophageal cancer—followed by months of radiation and chemotherapy, then surgery, from which his recovery was, as Virginia describes it, "heroic," and then various unconventional treatments and regimens—he didn't expect to have much time left, and in between his medical ordeals he became extremely productive, painting a lot, and writing, with artful randomness, memories of his life, freely associative sketches that he called *But I digress…So I digress.* (The chapter "Negro Song," an amazingly fresh and candid account of his relations with black people over the years, appeared in last summer's RCR.) Our mutual friend Jake Fuchs described these writings as "recording events in his life without any apparent effort to make them seem meaningful or even interesting—but they are these things." Jake noted Robert's "calmness," the quality of attention that rests on the fine line between complete engagement and detachment, a cool clarity that focuses the mind, infusing the reader with a sense of cognitive comfort.

In his last months Robert seemed to me exemplary in his determination not only to stay alive as long as possible despite a deadly illness but to reaffirm longstanding friendships and savor available pleasures and cultivate the realizations of full consciousness—of deep involvement with his own experience yet also transcendence of self.

"Paint as you like and die happy," said Henry Miller. Happiness is hard to quantify, but Robert Gold appeared to make the most of the final years of his life.

Uneasy Listening

[2000]

Jazz. True to its roots in sexual slang, the word itself sounds vaguely pornographic. Setting aside the vast range of musical styles that fall under its general heading, "jazz" is still seen, or heard, by many as incomprehensible and even somewhat threatening. Despite its rise to respectability in recent decades, thanks in part to the educational efforts of neo-Ellingtonian ambassadors like Wynton Marsalis, the most creative music in the tradition remains well outside the popular mainstream. Jazz, as some people perceive it, remains too urban, too intense, too cacophonous, too demanding, too unsoothing to be enjoyed for the recreational pleasure of entertainment. And even within the jazz world there are ongoing arguments between the more conservative traditionalists and the more innovative experimenters over who is carrying forward the truest spirit of the music. To the listener it's finally all a matter of taste.

But what is this thing called taste? How is it cultivated? How does one educate one's ear and mind to receive and appreciate unfamiliar sounds? Exposure counts for a lot, but I don't know how much bubblegum music or Chinese opera or

misogynistic rap or atonal electronic avant-garde minimalism I could bear listening to before learning to enjoy such noises. And yet, until my late twenties, I might have said the same about jazz.

A longtime fan of rock and roll, rhythm & blues, folk, blues, country and even some so-called classical music, I had never really connected with contemporary jazz beyond a few popular albums of Dave Brubeck, Bill Evans, Stan Getz in his bossa nova mode, Dixieland trumpeter Al Hirt (all white players, it must be noted) and the dignified classicism of the Modern Jazz Quartet. The musicians who would eventually become demigods in my personal artistic pantheon—John Coltrane, Miles Davis, Thelonious Monk, Charles Mingus, Billie Holiday, Coleman Hawkins, et al.—had not yet registered on my sonar. Once they did, sometime in the mid-1970s, the range of my listening pleasure was immeasurably expanded.

I can't quite locate a particular experience that made me a lover of jazz. My conversion must have occurred slowly over a period of time and reached critical mass before I really knew how my life had been changed, but central to my sonic awakening were at least three concerts I attended in 1976—one in the unlikely Santa Cruz suburb of Capitola, one in New Orleans at the annual Jazz & Heritage Festival, and one at The Bottom Line in New York City. Elvin Jones, McCoy Tyner and Mingus, respectively, headed up groups in each of these venues that transformed my understanding of what music could be, opened my soul's receptors to the sense of discovery and revelation available to virtuoso improvisers pushing themselves and their collaborators into marvelous zones of unknowing, creating tones and rhythms and moods and emotions and lay-

ers of inner landscapes never to be experienced before or after but riding the present moment with a mixture of technical skill and melodic imagination and a certain uncanny intelligence that transcended anything I'd ever encountered in books.

Listening to records is undeniably a fine way to attune one's ear, but there's nothing quite like hearing music played live, and jazz, with its emphasis on the unwritten, on the individual expressive solo and collective improvisation, can be unspeakably thrilling to witness when the players are hot and in the process of discovering the outer limits of their accomplishment. To sit in a smallish concert hall or, better yet, some intimate club, and watch and listen to expert creative adventurers egg each other on to heights and depths of sonic exploration is exciting in a way that can't be touched by more scripted forms of performance. The sound of the music suffuses one's being— not just your ears but your whole body—so as to literally fill you with the art, even though those vibrations are ephemeral.

Yet somehow, within our cellular memory, something remains. Nearly a year ago, at Birdland in New York, I heard the Ron Carter Nonet—two basses, four cellos, piano, drums and percussion—burn through two sets of hybrid sounds, part downhome folk, part uptown bop, part Euroclassical, part intergalactic, whose unique and moving beauty, so daringly odd and difficult to describe or even remember as tunes or songs ("Wayfaring Stranger" was one), continues to echo in my consciousness. Carter is well known as a jazz master, and I don't know what else to call what his group was doing, but at that level of musical synthesis, genres and definitions are irrelevant. This experience, for me, epitomizes the genius of great jazz.

To the uninitiated, or even to a jazz fan hoping to hear something more easily familiar, Carter's show might have been too weird for comfort—I certainly found it disorienting—but that sense of testing the boundaries, of honoring traditions by recombining them in unpredictable ways, is in the richest spirit of the jazz ethos.

Like abstract art, it may require suspension of expectation and a learning how to look (or listen) with different eyes (or ears) than the ones we're accustomed to feasting on the figurative. But images and sounds that have become part of our common vocabulary—van Gogh's hallucinated landscapes, Jackson Pollock's dancerly drips and splatters, Monk's eccentric piano-poetry, Coltrane's soaring tenor and soprano solos—were once considered (maybe still are) too far out for polite society. Even now, one of Vincent's pictures is likely to leap off the museum wall and overpower the unsuspecting spectator, just as one of Coltrane's unmistakable epic riffs may erupt from the rush-hour dashboard and lift one's psyche far beyond mere traffic.

I doubt that anyone can really be taught to feel the force of any original art, but with the music known as jazz, receptive listening is a good place to begin.

Monk's Wake

[1982]

Thelonious Monk once appeared to me in a dream as some
kind of spiritual consultant. The wisdom of his sound com-
bined with his remarkable name must have suggested to my
subconscious that the man had something to say about the joys
of keyboards and keeping to oneself.

Indeed, from most reports Monk is rumored to have been a
very eccentric individual, reclusive and unpredictable even in
public. I've heard tales of Monk's eyes rolling up in his head as
he rose and walked zombiewise off stage in the middle of a set
at Shelley's Manne Hole in Los Angeles; tales of his playing an
entire performance with his elbows at some club whose man-
ager had made him mad. At San Francisco's Both/And club
in 1969—the night of the day I'd heard Buffy Sainte-Marie
sing a hair-raising version of "The Universal Soldier" at a mas-
sive demonstration in Golden Gate Park—I watched a Monk
whose mind seemed *elsewhere* nod his way through an evening
of extremely minimal music.

With people's passing it feels natural to resurrect what sto-
ries we have of them as a way of keeping them alive. When the

deceased is a great artist we have the additional opportunity to reconsider the record of an existence made manifest in its work. With the rise of recording technology recent musicians remain with us in a way that gives us instant access to sounds which otherwise would long since be lost in the air. So when Coltrane or Ellington or Mingus or Monk moves on for good we still have a chance to absorb their healing influence till turntables run out of revolutions and enlightened deejays give up the notion of bringing the music through radios. In Monk's wake, as in that of Mingus some years back, several conscientious jazz jockeys I've heard have brought forth a feast of the master's work more nourishing than words can say.

The compositions on which he performs solo are the ones where I hear Monk at his most awesome. There is a lonesome melodic simplicity, a pensive tone and measure to his playing, which are the highly refined notation of a veteran deep thinker. And there are unexpected funny edges everywhere, weird harmonies and rhythmic irregularities which make me laugh.

But listening to Monk one also feels like crying because that ironic humor crops up in response to vast existential questions. He plays piano like a philosopher who has realized that language can only begin to explore the ultimate mysteriousness of existence but that musical phrasing and timing and melodic invention may take us a little farther on the journey.

Somehow in the interstices of Monk's unique sonic syntax we can hear the silence of cosmic space. Like Samuel Beckett (whose writing Monk's music resembles in some ways), Monk implies through his art that our small and absurd sojourn in the universe is redeemed by acts of intense if ultimately hopeless awareness. This awareness shines in Beckett's most ludicrous

characters as it does in Monk's most casual performance of a corny standard. By consciously attending to essentials the artist shapes startling realizations available to anyone who stops to listen.

Monk's death draws our attention to his idiosyncratic yet readily accessible testimony of a life lived continually in search of fresh forms and means for expressing awe. This awe is audible on every record of his I've heard and it is almost always blended with a sense of play—that of the maestro not just playing his instrument but playing *with* it, as with a trusted lover, experimenting his way into realms of sensory revelation.

Here's one more person whose life we can refer to as a standard of excellence and integrity no amount of "normality" or well-adjustedness could usefully replace. Monk's years of marginal status in the music world are another instance of the mainstream being behind time while the pioneer is "out there" establishing the state of the art. The apparent strangeness of the man's personality might possibly be traced to his singular apprehension of the creative unknown in which he was known to move.

Once, in response to a standard "What's happening?" greeting, Monk is reported to have said: "Everything's happening all the time—every googleplexth of a second!" Wherever he may be traveling now (someplace out in the Thelonious Sphere, surely), the man is definitely happening—less on record really than inside each person who hears him out. Soaking up those sounds, actively tuning in to the endless subtleties of tone and tempo, one carries away reserves of renewable inspiration.

In that long-lost dream which found me in Monk's company it was not words or music he had to offer but a presence,

a calm if complex presence of mind. If everything is happening all the time, it's there for the play of the attuned senses and for fingertips' turning to song.

Exaltation at Zellerbach:
Sonny Rollins Rising

[2010]

Zellerbach Hall at UC Berkeley is one of the better concert venues I know. Large enough (2,200 seats) to accommodate world-renowned acts and their audiences, its elegant yet unsensational interior architecture gives a sense of spaciousness and intimacy at the same time, with good acoustics, so that even from the cheap seats you can see the stage clearly and hear the music with minimal distortion. With its airy, glass-walled lobby and comfortable, unpretentious café, its friendly staff and efficient ushers, Zellerbach seems to me an example of civilization on its best behavior, a place where secular culture takes on the low-key yet reverent atmosphere some people seek in churches, mosques and synagogues.

At a time when the University of California, due to its budget crisis, is slashing away at nearly every merely humanistic program under its brand, it's a relief to know that, at least for now, Cal Performances, with its great range of artists in music, dance, theater and world culture, is able to help the staggering university carry on as a link to the nonacademic world; Zellerbach is a place where anyone still solvent enough to spring for

a ticket can enjoy the benefits of any big city's best gathering place for entertainment. The auditorium is a sanctuary where, with luck, you may experience, on rare occasions, sensory and spiritual bliss.

That's what I look for in the arts, music especially, but at movies or art shows or poetry readings too—I want to be moved, inspired, amazed; I want to have something revealed to me that I never knew or expected. It doesn't happen often, but when it does you are reminded what art is for, what it can do, how it can touch and astonish. And it returns you to the outside world, if not transformed (though sometimes that as well), at least refreshed and revived and perhaps, even, better equipped to cope with the absurdities and indignities and stupidities of workaday existence, reassured that life's deepest delights can compensate for a lot of less-edifying nonsense.

I first heard Sonny Rollins live around 1981, when he was touring with McCoy Tyner and Ron Carter (with Al Foster on drums) as the Milestone Jazzstars and they played the Santa Monica Civic Auditorium and absolutely cooked, transcending the limitations of the venue with the sheer power and virtuosity of their playing. Tyner, a monstrous pianist in his combination of balletic agility and physical force on the keyboard, and Carter, one of the world's most eloquently melodic bass players, were suitably qualified to team up with Rollins, storied "Saxophone Colossus," widely considered the greatest improviser alive. It was a wondrous and memorable evening.

Next time I had the chance to hear Rollins was about 10 years later in New York City when he gave a free afternoon concert at South Street Seaport. Even from the back of the sunbaked multitudes that day I could hear the joy and lyricism

in his horn, could feel his rhythms infecting me with happy syncopation, even thought I could barely see him onstage or make out what melody he was playing due to the crappy outdoor acoustics.

So when I heard he was coming to Berkeley I bought tickets for his May 13 show in hopes that the master, one of the last of his generation's jazz geniuses still alive and touring, had some juice left; even without the physical power of his younger lungs, I figured he must still have the skill and wisdom to coax some beautiful things out of his instrument. Soon to be 80, he would surely bring the wealth of his vast experience—with Thelonious Monk and Miles Davis, Clifford Brown and Max Roach, brushes with John Coltrane and Coleman Hawkins, echoes of Charlie Parker ringing through his home turf of Harlem as far back as the 1940s—and carry those sounds and styles into fresh forms of expression.

I had no idea.

From the moment he took the stage with his quintet—a rhythm section consisting of Russell Malone on guitar, Bob Cranshaw on electric bass, Kobie Watkins on drums and Victor Y. See-Yuen on percussion—Sonny Rollins's spirit filled the hall. His wild white natural hair, an Albert Einstein (or Bride of Frankenstein) electrified Afro, his big Mosaic beard, loose tunic of a blazing Chinese red on his hulking frame, backed by his bandmates, their instruments gleaming against a black background, combined to give him the aura of a holy man whose very presence commanded one's full attention and respect. When he put the horn to his lips and started blowing, the house was vaulted into a zone of pure awe.

A prodigy since his teen years in New York, schooled on

everything from hard bop to folk songs, Western swing to calypso, schmaltzy pop tunes to unhinged free jazz, Rollins has an ear for catchy refrains, the kinds of songs whose main melodies you can whistle, and a rhythmic intensity that swings until it almost rocks—when the band gets into a groove your feet start moving, you can't keep still—without being "dance music," it animates you physically even in your seat.

I didn't recognize the opening number, but from the first notes it epitomized this thoroughly infectious quality of his music; the force of the sound was irresistible, if you weren't hooked you weren't paying attention—though how anyone could have escaped the fierce energy and drive and sweep of the sonic onslaught is beyond my comprehension.

From this smashing opener, which must have lasted 20 minutes though it blazed by in a flash, Rollins changed the pace by segueing into a standard ballad, the much-recorded (most memorably by Coltrane and Johnny Hartman) "My One and Only Love," the kind of song that in ordinary hands might come off as a series of clichés, a bit of low-budget romantic sentiment, but here was rendered sublime by the soloists' inventive variations on the familiar score, Rollins above all evoking a gorgeous yet sharp-edged lyricism with his crisp tone and melodic fluency, and Malone and Cranshaw rising on their respective instruments to meet his measure. Their version was a free translation that brought the composition to life with greater vividness than the original. Time was rendered irrelevant, but again the song soared for at least a quarter hour.

Their third selection was Rollins's original calypso "Global Warming," which he explained in his raspy voice, by way of introduction, implies individual responsibility, in other words,

"Pick up after yourself so somebody else won't have to. That's enough preaching," he concluded, and then things got hot. Calypso is the genre where Rollins really gets the syncopation going, and the band locked into a mesmerizing groove whose momentum suffused the room with high excitement, Malone sustaining a hypnotic drone on guitar, and drummer Watkins exuberantly and precisely driving the ensemble into an extended controlled frenzy of celebration.

During one of his recurrent retreats from public life, back in the 1960s, Rollins used to go out on the Williamsburg Bridge late at night and practice without inhibitions where he wouldn't disturb anyone. Later he went to Asia and stayed in a monastery for a while. These timeouts from performing are signs of his reflective character and also seem somehow to have deepened his creative reservoirs, enlarged his soul, so that when he gives himself wholly to a performance he's there not just to please the audience but to transfuse them and transcend himself with an overflow of praise, "a state of exaltation at existence," as he told an interviewer.

I've heard a lot of good music in my life, but I've never been in the presence of a more extraordinary performer.

There were just two more songs in the 100-minute show, which closed with another near-rocker, Rollins—moving haltingly around the stage, huge but slightly stooped, alternately hobbling and lurching as if he might fall over at any second—just blowing the bejesus out of his reed, the bell of his tenor belting out an unstoppable sound, the band so perfectly in sync as to resemble a single instrument—and at the end the audience on its feet applauding at length for an encore.

The five gentlemen came back out to take a bow, but that

was it, no encores, and no one could fairly complain they hadn't gotten their money's worth. As the house lights came up and we started to shuffle out, a murmur moved through the crowd, a low buzz of amazement and bemusement at the existence of such a musician, still able to put out such a powerful charge at an age when most mortals, those who are still alive, have geared down and retired to the golf course or to the recliners in front of their television sets.

"I am convinced that all art has the desire to leave the ordinary," Rollins said in the same interview. "But jazz, the world of improvisation, is perhaps the highest, because we do not have the opportunity to make changes."

This is why recorded music, beautiful and moving as it may be, can never have the one-time-only unfolding-before-your-eyes hear-it-now-then-it's-lost-in-the-air immediacy and wonder of a live performance, and why a performance like this one—gone now forever—can keep on resonating indefinitely, paradoxically present in the remembering cells even long after it's over.

The creators of such spontaneous mastery can't make changes, and yet the lucky witness may be changed.

Sympathy for the Stones

[1981]

The impending appearance of the Rolling Stones in San Francisco sets off millions of associations in my damaged memory. Like many another postwar baby, I came of age with the Stones on full blast in the background—it was enough to dent one's consciousness forever—and it's astounding to see them playing Destruction Derby with the minds of yet another generation.

And how poetically appropriate that *los Rolling* (as they are called in Spain) should be playing at Candlestick Park, where the concert stage is set up in center field. Willie Mays, arguably the greatest of all baseball players ever, used to roam that grass with the amazing grace of genius guiding his body: Mays caught long drives most other outfielders couldn't get close to. It wasn't that he was so fast on his feet but that his intuition had him moving to make the catch before the ball was hit.

Combined with this uncanny intuition was Mays' flamboyant *style* of playing ball: he played like someone who *loves* to play and *knows* how great he is. For a quarter of a century Mays terrorized pitchers and put opposing players in awe of his all-around powers. It's fitting for the Stones to be playing

Candlestick because Mick Jagger is the Willie Mays of rock and roll.

Legend has it that in the course of trying to avoid paying alimony Jagger once filled out a form indicating his occupation as "minstrel." It may sound funny in front of all that electricity, but that's exactly what he is—only more, because his poetry and showmanship are the standards of the trade and have been for years. Wonderful as the Beatles were, they stopped performing live at about the same time the Stones were hitting their stride. *Los Rolling* have not only stayed together over the decades but have sustained a consistently superb act.

While the early Stones were obviously the archetypal punks, their music has always been marked by virtuosity as well as brilliantly vicious lyrics and a relentless beat. Unlike the garage bands that blow the roof off for the sheer thrill of demolition, the Stones' musical artistry invariably transcends the brute force of their noise. Jagger's lyrics compare favorably with those of Shelley, who himself was a demonic and hotly controversial figure, always rousing the rabble and being hounded out of England.

Jagger's more immediate poetic progenitor is Chuck Berry, whose sound and rhythmic drive Mick and Keith Richards assimilated early (like lots of other white kids, including Lennon and McCartney) and took a little further by bending them into remarkably weird and evil-sounding electromagnetic warps. The fact that the Stones are still the best rock and roll band around after all this time testifies as much to the endurance of Berry as it does to the genius of Jagger, Richards, Watts and Wyman. Like the great blues and R&B masters, the Stones are still playing much the same music as ever—they haven't

exactly *changed* pop music, as perhaps Zappa or Morrison or Dylan changed it—they just do it better than anybody else.

Since about 1970 (post-Altamont and with the first new waves of militant feminism) the Stones have been criticized for the violence and sexism in their songs. As the foremost exponents of "cock rock," Jagger and the boys have come under fire from some feminists for degrading and abusing the numerous "girls" in their *oeuvre*. But to accuse the Stones of mere sexism is to miss the point completely: they deliberately project themselves as *bad*. And when you're *bad* you don't worry about being decent, much less politically correct.

Actually Jagger is beyond good and bad. On stage he is nothing less than *possessed*. He's an incredible dancer—a monkey jumping-jack—besides being the sexiest androgyne in show bizness. But he knows exactly what's happening around him and turns the apparent wickedness of his persona into something bordering on the angelic.

If rock and roll music is evil—which, at its best, it is—this may be related to its roots in the blues; that is to say, in slavery. African music is based on the drum. Black slaves in the United States, deprived of this essential means of communication, hollered and moaned to each other in the fields. From there to gospel and eventually to *a capella* street corner quartets was a natural progression. The blues are another branch of this original African-American music that gradually mutated into rock and roll. The rage and terror at the heart of Atomic Age folk music (as pioneered by the Stones) can be traced, I believe, to the historic sources of its tradition.

However commercially ripped-off black musicians have been by white guys like Jagger and Lennon and Dylan, neither

they nor any other honky superstar with integrity have ever ceased to acknowledge their debt to the originals. It's not white *musicians* who stole rhythm & blues but a racist society whose system of material competition has always been stacked against the black man.

The symbolic enigma of Meredith Hunter—the brother with the handgun who got stabbed in the back by a Hells Angel in front of the stage at Altamont while the Stones were playing "Under My Thumb"—is too much for me to begin unriddling. Did Hunter die for Jagger's sins? Was Hunter in the process of trying to assassinate Jagger (as it looked to me in the movie *Gimme Shelter*) when intercepted by biker "security" forces? Was the death of this young man a result of the Stones' spooky invocation of the most murderous energies in a drug-crazed culture?

From where I was at Altamont—way on the outskirts of the vast crowd, hunkered by a fire about a mile from the stage (it was December and getting dark by the time the Stones came on)—all you could tell was that something exceedingly weird was going on: the music kept starting and stopping, and since the stage wasn't visible from that distance and a violent mood had been established early in the day, for all I knew *Jagger* had been assassinated.

When his voice came bending over the dark hills, asking "Why are we fighting?" there was a gentle earnestness in his tone which seemed to me like the only thing between a quarter million people and some catastrophic stampede. The whole day had been eerie—partly perhaps due to my ingestion of a large purple capsule purchased on the street in Santa Cruz earlier that week; I had never seen so many people in one place

and the sight of the endless undulating masses of humans streaming over the hills in waves was enough to generate hallucinations, drugs or no drugs.

The calm in Jagger's voice at those critical moments of the killing was in clear contrast to Grace Slick's panicky pronouncement, "We've got to quit fuckin' up," as her bassist Marty Balin was beaten during the Jefferson Airplane's jittery set; Balin had attempted to physically intervene in a scuffle in front of the stage and had only made matters worse.

Whatever was happening up there, the soft and humane sound of the lead singer's plea for compassion was reassuring to various barbarians riding out a rough trip on the fringes of the tribe. Had Jagger been less judicious or less sure of himself as a presence, I'm convinced that a lot worse things would have happened that night. Were he really the street fighting man of his mask, hell could literally have broken loose.

It's almost a dozen years since Altamont and here come the Rolling Stones, more popular than ever because as hot as ever. Altamont occurred in 1969: there was a lot going on at the time, historically and culturally, which may have been more directly connected to the violence of that concert than any mumbo-jumbo a rock and roll band could cook up. Charles Manson, Richard Nixon and numerous other criminals were loose. The Vietnam War was in high gear. The country was in convulsions. Much of the Stones' appeal was in their translation of such distressing forces into the most powerful music many of us had ever heard.

Times may have changed since then and superficially settled down, but things are looking shakier than ever. Elvis is dead; Lennon, murdered. Countless others are also gone. Chuck

Berry has been in and out of the joint. Willie Mays is in public relations. And Ronald Reagan's in the White House.

The Rolling Stones are on tour for the lucre of it more than for the revolution, but the darkness of their vision is healthy for the culture in the same way that a bad dream is healthy for the psyche: they bring us face to face with our worst fears—cruelty and chaos—while transforming terrorism to luminous art by taking it out on their guitars.

The Integrated Man:
Harry Belafonte

[2003]

In the early 1950s, at the first sign of his commercial success as a recording artist, Harry Belafonte's mother took him aside. "Never sing a song you don't like," she advised, "because that's the one that may become your biggest hit, and you'll have to sing it *for the rest of your life.*"

Belafonte told this story last July during his concert at the Luther Burbank Center in Santa Rosa, before launching into his perennial "Banana Boat Song (Day-O)" for an adoring audience of mostly white, mostly middle-aged-to-elderly admirers. In the singalong parts of his best-known numbers, "women over 40," who in the fifties were seemingly nonexistent, sounded off with cheerful enthusiasm. The charm of the performer, still handsome at 76, was as seductive as ever even though the tight black mohair pants and plunging V-neck silk shirt of his prime had been traded for more conservative, looser-fitting but suitably stylish Afro-Caribbean garb. And while slightly less lithe and feline in his onstage moves, his grace and timing remained impeccable. The Belafonte magic was undiminished.

Few people *under* 40 have any idea how big Belafonte was

in his heyday. His *Calypso* album of 1956 was the first LP to sell more than a million records, his concerts sold out stadiums, and for a while neither Elvis nor Sinatra was as popular. Born in Harlem of a Jamaican mother and a seafaring father from Martinique, Belafonte was raised in both New York City and Jamaica and served in the US Navy before embarking on a career as an actor in the 1940s. Somehow he was sidetracked into trying his luck as a nightclub crooner, a jazz balladeer in the style of Billy Eckstine, but his heart wasn't in it; the material felt phony. Then he discovered folk music, and the rest is showbiz history in more ways than one might at first imagine.

Like other black entertainers in a still-segregated America, Belafonte suffered the usual indignities of institutional racism, performing in Las Vegas hotels where he couldn't stay as a guest, socially humiliated by ignorant bigots with no idea who he was, forced to endure the daily insults known by every "Negro" of his time. But more so than most of his peers in the business, Belafonte from the beginning was aggressive in his opposition to the prevailing apartheid mentality; he was angry and became active in the civil rights movement early on, eventually becoming a close friend and co-conspirator with Martin Luther King. As the most popular black performer of his day, he used what power and money he had not only to break barriers in the arts but to participate actively—as a marcher, as a speaker, as a funder—in the larger struggle for racial equality. Throughout his career he has worked continuously and persistently for civil and human rights both in the US and abroad. Much longer than most other "cause" celebrities, Belafonte has remained on the front lines in the fight for justice, freedom, dignity and peace.

Many folk-music purists who may admire Belafonte's political work nevertheless dismiss his music as much too smooth and formally arranged to qualify as "authentic." What such critics fail to recognize is that Belafonte never tried to pass himself off as a "folk singer" in any traditional sense but has been from the very beginning mainly a nightclub entertainer, then a stage and movie actor and (less visibly) a producer, always attempting to reach a mainstream audience with a culturally subversive message. He was one of the first popular artists to introduce world music—and the *idea* of an international folk tradition accessible to an American public—to otherwise clueless listeners in this country. It was through him that many people, myself included, first discovered a world of traditional music and then went deeper into its roots to find the earlier versions of many songs and the superb musicians who'd sung them. (Though it must be noted that many of Belafonte's best songs were original compositions with his collaborators Irving Burgie and William Attaway.) His concert and recording successes of the 1950s proved a gateway for many young kids of that era into the funkier folk and blues revival of the 1960s, which ironically (along with rock and roll) came to displace Belafonte's more stylized manner in the hip/pop consciousness.

Seeing Belafonte at the Greek Theater as a little boy in LA was probably the most exciting event of my summers. His show—with its range of spirituals, love ballads, traditional Anglo-Irish folk tunes, blues, work songs, a smattering of foreign-language material and a wealth of variations on Afro-Caribbean styles loosely describable as "calypso" (though not really the *real* calypso as practiced by the great improvisers of Trinidad)—was completely intoxicating, a heady mixture

of great singing, catchy melodies, memorable lyrics, synco-
pated rhythms, tight arrangements, cool choreography, witty
between-tunes discourse that even a 10-year-old could dig,
extraordinary physical beauty, and a truly inescapable sense of
style. While never an especially impressive dramatic actor, Bela-
fonte as an actor of *songs* is unsurpassed in the pop pantheon.
Even when doing pure *shtick* onstage, he gives a completely
persuasive impression of spontaneity; he's having fun and he's
fun to be with in the make-believe intimacy of a concert hall.

In Santa Rosa last summer he captivated the full-house
crowd despite the fact that many of us present had attended his
previous show at the same venue six years ago and had heard
many of the same songs then, and some of the same jokes.
Somehow Belafonte's genius as an entertainer transcended
the borderline hokeyness of his act, so that even jaded veter-
ans and natural-born critics such as this one surrendered our
skepticism, suspended disbelief and sang along on cue. With
his five-piece band and trio of backup singers—a multicultur-
al, multiethnic troupe of fresh young talent—the lead singer,
even while recycling the corniest or most sentimental material,
proved he hadn't lost his groove. He did signature favorites
like "Try to Remember" as if for the first time and retooled the
chain-gang holler "Another Man Done Gone" into a bluesily
haunting jazz vocal. The actor, the jazz singer, the comic, the
heartthrob, the sinuous dancer—all the original aspects of his
appeal—were still in evidence.

But if on the surface the show appeared to be pure enter-
tainment, at another level one could discern a more serious
agenda. As the evening wore on and the crowd loosened up,
the performer gradually introduced into his patter a not-so-

subtle pitch for peace and a strong if indirect critique of US foreign policy. Without ever pointing the finger, he made quite clear his conviction that "war solves nothing," and that by contrast "art not only reflects life as it is but shows what it should be." Belafonte has for many years worked as a volunteer with UNICEF and is an avid proponent of the United Nations, all of which he worked into his rap. It was a remarkably gentle blend of pleasure and polemic, nonthreatening yet dead-on. His show embodies the world-embracing values of the singer, so the performance itself is an act of humanitarian relief, providing (even here in the relative comfort of the first world) a temporary haven from the violence and chaos occurring elsewhere. It also provides an alternate vision of international harmony via humanity's entwined musical roots.

Like most entertainers, Belafonte no doubt thrives on the crowd's adoration, but he doesn't need the money so there must be other reasons for his continuing to tour in his eighth decade. My sense is that, beyond his international relief work and steadfast support of progressive causes, the artist sees his role as performer as an integral element in his long-term project to improve the world. His experience of the civil rights struggle, and of ongoing efforts to resist the corporate commodification and control of the planet, have no doubt instilled in him a sense of obligation to do whatever he can in the name of decency. Though his music is anything but cutting edge, its message of interconnectedness is subtly militant. Belafonte is integrated in the fullest sense, that of his own wholeness, an ability to bring together without contradiction the social transformer and the professional minstrel, the activist and the artist.

If on occasion he loses his cool and blows his diplomatic

cover—as earlier this year when, in an interview, he compared his friend Colin Powell to the "house Negro" of the antebellum South—he's neither your stereotypical Black Nationalist nor your guilt-ridden liberal living off the fat of his own success. In the poet Amiri Baraka's *Autobiography of LeRoi Jones* (the name he went by before he found both Islam and Maoism, a mixture that has proved noxious) there's a brief but telling anecdote about Baraka's effort, with some Newark homeboys, to Mau-Mau Belafonte into donating money to their Black Arts cultural project. Not intimidated by their amateur thuggery, Belafonte told them to get lost. In other words, he's his own man, proceeding according to his conscience and convictions, unmoved by ideological dogma. A veteran producer and entrepreneur in the high-stakes world of stage, film, television and records, not to mention politics (in the mid-1980s he was rumored to be considering a run for Senate in New York, but he came to his senses), Belafonte is, in the Yiddish lexicon, not just a *mensch* but a *macher*. He makes things happen.

One of Belafonte's pending projects, according to a *New Yorker* profile several years ago, is a collaboration with director Robert Altman on a film adaptation of the popular (and finally too-controversial in its racial stereotypes) all-black radio and television series *Amos 'n' Andy*. As yet there is no evidence of such a movie, but these things take time. Meanwhile, in 2001, without much public or critical fanfare, Belafonte produced— after a gestation period of nearly 50 years—what is arguably his magnum opus, a five-CD box set called *The Long Road to Freedom: An Anthology of Black Music*. Originally conceived in 1954 as a "Negro folk musical" for the stage, the project never got off the ground as a theatrical production; later, with the

crucial help of George Marek, head of RCA, Belafonte's record label, the concept was modified into a series of recordings. They started taping in 1961 and finished 10 years later, but it was three more decades before the product finally appeared.

The Long Road to Freedom is a phenomenal accomplishment, not only for the perseverance of Belafonte and his collaborators but for the ambition of its big idea and the fullness of its realization. On 180 tracks featuring more than 50 artists, accompanied by a beautifully illustrated (though poorly edited) 140-page book, Belafonte and his colleagues recapitulate a cultural history of African-American music from its roots in West African drumming and chant through the field hollers and spirituals of the slavery era to songs of the underground railroad, Civil War songs, folk ballads like "John Henry," children's game songs, street cries, city and country blues and gospel up to the 20th century. Rather than travel to make field recordings, Belafonte brought artists from various parts of the South and elsewhere to New York to record, with his typical meticulous staging, the traditional musics of black America.

In its monumental scope and historical reach, *Long Road* resembles a Ken Burns-style TV documentary, with all the strengths and weaknesses of that earnest intent to educate; but even for someone fairly familiar with 20th-century black music it is indeed educational to hear contemporary performers interpreting songs that pre-existed the recording studio. Equally interesting to me is the way these five discs embody Harry Belafonte's career-long resolve to serve as a medium for those traditions. Beyond its uplifting history lesson on the black experience in America, its production values are pure Belafonte, far cleaner and more highly stylized than the

"primitive" original material, but in the use of professionals to evoke folk art, paying elegant homage to its enduring power. The music *sounds* good, revealing its connection with historic circumstances and showing the continuities and branches in the range of its evolution. As a work of aural theater more than a record album, *The Long Road to Freedom* succeeds in realizing Belafonte's half-century-old vision of an epic "Negro folk musical."

Ironically, Belafonte's primary audience has never been the black community. Partly because he started out in nightclubs and never did the "chitlin' circuit," partly because of the slickness of his act, partly because he married a white woman and partly who knows why else, he's never connected with the black public in the way he has with whites. As a longtime fighter for integration, perhaps it's his fate to be a mixed metaphor, an old-school "race man" yet a singer even Republicans can love. Whatever exasperation that may cause him personally, and however much his fame on the national stage may have faded over the last four decades, his cultural contribution has been enormous and his graceful integrity under the terrible pressures of stardom, exemplary.

Lonesome Traveler:
Bob Dylan at 60

[2001]

"Never make your muse your mistress," the poet Kirby Doyle once counseled me. He meant, I've since learned, that when the one whose soul most closely rhymes with your own is near at hand, inspiring as her presence might be, that's nothing compared to the way her absence can move the imagination. As anyone knows who's ever written a love letter, distance amplifies inspiration. This is one of the cruelest paradoxes of creativity: the experience that comes closest to destroying you—say, the loss of your lover—is often the one that transports your art to its greatest depths and heights. Your loss proves, perversely, to be your gain. Given the choice, it's a twist of fate not everyone would bargain for.

When Bob Dylan's marriage was breaking apart in the mid-1970s, that devastating event occasioned one of his greatest albums, *Blood on the Tracks*, a record that seems to me an artistic turning point and a key to understanding much of his subsequent music. It would be stupid to assume that anything Dylan has written is strictly autobiographical—he is, after all, the most elusive and unreliable of narrators,

and even as heartfelt a work as that one is full of richly ambiguous invention. But the missing muse of his most recent disillusioned love songs bears an archetypal resemblance to the real-life mate he was losing back then. Just as the albums he recorded in the late 1960s and early 1970s, when he was settling down and starting a family—records like *John Wesley Harding*, *Nashville Skyline*, *New Morning*, *Planet Waves* and even parts of *Blonde on Blonde*—contain some of the lightest, happiest sounds he's ever made, the songs and albums since then have turned increasingly darker, heavier and more desperate.

Having listened pretty closely to most of his work for nearly 40 years, my intuitive sense is that only one person could have caused the pain he has chronicled recurrently over the last decade. It sounds to me like the same "shooting star" who left him tangled up in blue more than 25 years ago. Not that it really matters; the songs themselves have an independent existence. But only a loss of enormous proportions could inspire such consistently compelling and miserable yet somehow triumphant art. The indestructible minstrel appears to have taken his personal tragedy and wrung its neck.

Not that he's ever had any shortage of girlfriends—before, during or after his legendary marriage. As reported in *Down the Highway: The Life of Bob Dylan* (Grove Press), a new biography by Howard Sounes, the singer's personal magnetism has always been irresistible to women, and his desire for female companionship insatiable. A map of his love life would look like a Jackson Pollock painting. Yet there remains, in most of his music of the past 12 years or so, that nagging note of desolation, if not outright despair. How he turns such bitter feelings

into such extraordinary songs is a mystery, but there are clues for the attentive listener.

One philosophical instrument of this transformation is a deadly dark, no-nonsense irony. Even, or maybe especially, at his most gloomy, Dylan is funnier than most comedians. The black comedy of his best writing—abundantly evident in "Things Have Changed," his rocking, Oscar-winning dirge from *Wonder Boys*—manages to twist the grimmest revelations of woe and hopelessness ("Standin' on the gallows with my head in the noose") into a perverse form of affirmation. "All the truth in the world" may, as the singer grumbles, add up to "one big lie," but the recognition of this hard-to-stomach fact is curiously consoling when set to a biting lyric, a catchy tune and a driving beat that makes you feel like dancing.

Just as the musical beauty and imaginative richness of such classic bad trips as "Desolation Row" and "Visions of Johanna" somehow transcend the creepiness of what they depict, so "Things Have Changed" and most of the songs on the much-acclaimed 1997 album *Time Out of Mind* both sink the heart and lift it at the same time.

Bob Dylan turned 60 on May 24 and, aged as he obviously is—his latest face revealing the ravages of four decades of practically nonstop traveling—it's still not easy to believe he can be that old. That he's managed to last this long is an accomplishment not even an astrologer could explain. His astonishing rise in the early 1960s from scruffy coffeehouse folk singer to international rock-and-roll demigod between the ages of 19 and 25; the mysterious motorcycle spill that turned him into a phantom for a while; his tireless touring; his two (yes, two) divorces; tobacco and drug and alcohol abuse; relentless harassment by

deranged fans; legal struggles with various managers and exes and associates; an exotic cardiac infection that could have killed him; the grueling demands of a fame so monumental as to render him almost mythic—such an itinerary would be (and has been) enough to finish off many lesser mortals.

But Bob Dylan is nothing if not tough. He has tenaciously persisted, through his whole roller-coaster career (people have written him off at various stages as a sellout, a crackpot, a crank, a has-been and worse), in being unmistakably nobody but himself. He has, to paraphrase Faulkner's Nobel speech, not only endured but prevailed.

Using a voice that began as a nasally rasp and has deepened over the years into a sort of gravelly wheeze seasoned with the fatalistic wisdom of a million cigarettes smoked all alone as the sun goes down, the man has improbably made himself into one of the most soulful singers since Billie Holiday. Like Lady Day, he seldom sings the same song the same way twice—changing arrangements, styles, rhythms, melodies and even lyrics for the sake of keeping old material fresh—and through an uncanny sense of timing, phrasing and intonation is able to convey feelings and insights most of us could hardly bear to face without such consummate artistic intervention.

Dylan has often said that he doesn't really *write* his songs, he just kind of copies them down as dictated from some other source, most likely God. He has the musical instinct of a mockingbird, able to imitate and adapt for his own use practically anything he hears. He works on the fly and by ear—he neither reads nor writes music—often not even letting his backup musicians know in advance where a song is going. He's a strong and distinctive pianist, as can be heard on any number of songs

where the person pounding out those mournful chords could be no one else. He's also an expressive if technically primitive harmonica player. A first-rate folk and blues guitarist since the beginning (his debut album in 1962, *Bob Dylan*, displayed a driven energy whose intensity still startles), his skills as a musician have only increased over 40 years of practice.

On the old-school blues and folk albums he recorded in the early 1990s, *Good As I Been to You* and *World Gone Wrong*—both loaded with traditional songs from diverse sources recounting classic tales of lust, deceit, betrayal and murder—Dylan, unaccompanied, revisits his roots with a ferocity that has grown more powerful and resonant with age. He seems to be channeling ancient spirits as he takes the material and makes it, through the forceful personal truth of his playing and singing, both timeless and up to the minute.

That same connection with ancient forces has always suffused his original songs with a sense of history, hard experience and existential authority. My father, who had hustled his way into the upper middle class from the scrappy streets of Depression-era Seattle, was no fan of rock and roll, but one afternoon around 1967 when I was home from college he came into my room while I was playing *Highway 61 Revisited* (another contender for greatest Dylan album) and, after listening to a few verses of "Just Like Tom Thumb's Blues," declared, nodding toward the speakers, "He knows life."

It's strange the way you can reach at random into almost any period of Dylan's far-ranging career and find a song that seems to have been around forever as part of our common patrimony. The artist embodies what T. S. Eliot was talking about in his essay on "Tradition and the Individual Talent":

a profound immersion in the canonical repertory that proves to be an endless source of originality. From biblical hymns to carnival music, bordello boogie-woogie to baby lullabies, Hank Williams to Little Richard, Odetta to Buddy Holly, Stephen Foster to John Lee Hooker, Mississippi John Hurt to Bill Monroe, Chuck Berry to Jimmie Rodgers, Frank Sinatra to Robert Johnson, Elvis Presley to Woody Guthrie, Dylan's deep knowledge of virtually every American folk and pop tradition gives him an unmatched breadth of creative resources that have never ceased to feed his genius.

The "protest" singer of the early 1960s who broke through the innocuous complacency of the Top 40 to become some kind of cultural prophet and "voice of his generation" outgrew that role in a hurry and has been fleeing it ever since. As Sounes documents in his well-researched book, Dylan was never especially political, even though he caught the spirit of the anti-cold-war and civil rights movements in a few iconic songs. If you listen to an album like *The Times They Are a-Changin'* (1964), you find that the title song as well as others, like "When the Ship Comes In" and "The Lonesome Death of Hattie Carroll," may have been timely at the time but are still right up to date and universal.

Later, even such a topical song as "Hurricane," written explicitly to make a case for the exoneration of wrongly convicted boxer Rubin Carter, holds up because it's such a well-wrought piece of musical journalism. The operative word is musical; it's Dylan's lyric gifts and commitment to music rather than social reform that give his "political" songs their lasting power.

As Allen Ginsberg astutely observed in one of his late poems, "Dylan is about the Individual against the whole of

creation." He often writes and sings as if to himself, giving his songs an inwardness that speaks to others at an intimate level; that's why so many people feel they have a personal relationship with him.

Greil Marcus, another insightful Dylan commentator, noted in his book *Invisible Republic* that Dylan's crime against the folkies when he "went electric" at Newport in 1965 was not so much just plugging in but, what was more radical, having the nerve to speak for himself as an individual artist rather than for the collective. His refusal to be a "spokesman" was and is a mark of his integrity. Leadership was the last thing he was looking for—except perhaps in a creative sense, always trying to stay several steps ahead of the competition.

The fact is, his nastiest, most spiteful songs, from "Like a Rolling Stone" to "Idiot Wind," are equally if not more persuasive than those idealistic anthems that made him a poster boy for Justice.

And yet, true to his own contradictions, the man has always, even at his most surreal and nonsensical, remained some kind of moralist. In his search for spiritual truth he has found clear choices between right and wrong—or perhaps more accurately, between integrity and hypocrisy—or yet again, between clarity and muddleheadedness, which can lead one to be deceived by worldly appearances.

When he was at his most self-righteous, during the period of his conversion to Christianity, his music remained unscathed despite its evangelical intent. *Slow Train Coming* and *Shot of Love* are among his most underrated albums. Easily the best of his four concerts that I've attended was the all-gospel show he and his troupe performed at the Warfield Theater in San

Francisco in 1979. The band absolutely *rocked* in a way that, if you had faith or were looking for religion, might have put you over the top. If not, and if all you were listening for was a message, you might have found that concert extremely irritating. But Dylan has never been afraid to piss people off, and he's often at his best when most obnoxious.

Nearly 20 years later, long after his Christian phase had fizzled, there was the interesting spectacle of Bob Dylan opening for the pope on Youth Day at the Vatican, with the pontiff, after Bob's performance, riffing in his sermon on "Blowin' in the Wind" as a call for the world's young to embrace Catholicism. Surely that incident must have left even the most dedicated Dylanologists scratching their heads. My theory, more or less confirmed by Sounes in *Down the Highway*, is that Dylan did it for the money.

In any case it's been a long and twisted road from "Come gather 'round people… the times they are a changin'" to "I used to care but things have changed." The river connecting these very different psychic landscapes is change itself. (As the man says, "Lotta water under the bridge, lotta other stuff too.") Change, and the pesky specter of paradox: "The first one now will later be last," fair enough; but at a far more intimate and vexing level, "I'm in love with a woman that don't even appeal to me."

Or, worse yet: "I've been tryin' to get as far away from myself as I can."

Such gallows-Zen double-whammies are what charge Dylan's most recent work with its extraordinary philosophical zest despite its lugubrious undercurrents. The bitter lucidity of a song like "Not Dark Yet" (on *Time Out of Mind*) displays a

bleak wisdom as bracing in its honesty, as beautiful and spookily exhilarating as anything he's ever written.

The excellence of the music, as always, is instrumental in lifting the heaviness of both "Things Have Changed" and *Time Out of Mind* into a transcendent sphere, but without their intellectual engagement with an Ecclesiastes-like "vanity of vanities," the songs would never soar as they do. Dylan's willingness to wrestle in public with his own suffering—what he has called "the dread realities of life"—his courage in revealing the depths of his inner journey, is what continues to set him apart from other pop-culture stars and in the process endear him to his listeners.

One of the most notable aspects of his evolution as he proceeds to endure his fate as a public figure is the apparent emergence of a true humility even as his stature grows. Anyone alive in the 1960s remembers the cocky rock star of *Don't Look Back*, D. A. Pennebaker's great documentary, where the 24-year-old Dylan is exposed as so arrogantly brilliant that he appears to enjoy shredding the psyche of any Mr. Jones insufficiently hip to dig what's happening. Thirty-six years later he may still have no patience for fools, but he has learned to accept the official symptoms of respectability: the raft of honors and prizes, the Grammys, the Oscar, the Kennedy Center medal and numerous other lifetime achievement awards.

Graciously receiving such accolades, the artist, by now a grandfather, seems almost abashed, embarrassed by his success and as grateful for the recognition as any other mortal would be. In his slightly uneasy pleasure as an object of mass love, Dylan reveals a winning insecurity and a deep humanity that only makes him more likable—especially after the unhappy

endings that haunt so many of his songs.

Which brings us back to the blues, and that rhymes with muse. The lost lover, whether an actual person or an idealization of multiple romantic catastrophes, has implanted an ache in the singer's soul that literally keeps him going ("It doesn't matter where I go anymore, I just go"). The blues: bedrock of Bob Dylan's musical road; hard but self-sustaining way of life; consolation for the wounds of love; safety valve for the inconsolable grief that might otherwise smother the spirit; lifter of the heart that refuses to concede defeat.

A lonesome death awaits us all, but meanwhile the poet writes, the composer composes, the musician plays, the singer sings, the entertainer tours. "I'm mortified to be on the stage," he's said, "but then again, it's the only place where I'm happy."

Letters

American Colossus:
Henry Miller

1 In Life and on Paper
(1980)

My favorite photograph of Henry Miller shows him sitting at
a table, apparently after a meal, cigarette in hand, glancing off
camera with a roguish glow on his face; on the table remnants
of a feast have accumulated, cups and saucers and spoons, a
coffee pot, salt and pepper shakers, an open wine bottle, half-
empty glasses, and a candle tilting precariously in its holder
but burning bright. Henry is looking off to his right at some-
thing or someone whose presence clearly delights him, a gentle
grin on his face, and his eyes could light firecrackers. Over
his right shoulder is a crowded bookcase, above the bookcase
some photographs tacked to the wall; one is of the young Anaïs
Nin at her loveliest, another of Henry in the company of a mys-
teriously theatrical female, taken by the Parisian photographer
Brassai. Over his left shoulder is an open window, night out-
side; you can almost feel the cool air coming in.

This photo (photographer unidentified) appears to date
from the 1940s, the Beverly Glen or early Big Sur era of his

odyssey. I love the picture because it suggests in a single image so much of Henry's personality: the sensuous eater and drinker, the affable after-dinner raconteur, a man who knows how to laugh and to savor gladly the simplest experience. He is in his prime, relaxing at home with friends, a distinguished and execrated but as yet mostly unknown author of a half dozen monumental books—unknown because three of these books, the first three (*Tropic of Cancer*, *Black Spring* and *Tropic of Capricorn*) are banned in his own country, and the others (*The Colossus of Maroussi*, *The Air-Conditioned Nightmare* and *Remember to Remember*) seem strangely out of step and antipolitical and critical of the American status quo just when our national identity as the world's benevolent tough guys was at its peak.

Ironically, when Miller's most famous books were finally published in the United States a lot of people couldn't (and still cannot) see past the scandalously comic treatment of sex, the nitty-gritty burlesque of Henry's manic erotic humor. What many fail to understand, however, in their titillation or disgust, is that for Miller—particularly during a certain period in his life—sexual relations could also be deeply tragic, or worse yet, pathetic, a "rosy crucifixion" indeed, and only a relentless exposition of his own buffoonery could heal the scars of such priapic appetites. As he wrote to Lawrence Durrell about *Sexus*, by far his most phallic book, "There is a poverty and sterility I tried to capture which few men have known… That life of 'senseless activity,' which the sages have ever condemned as death—that was what I set out to record." Miller's skill and willingness to ridicule everything—not without an attendant compassion, coming to terms with human vulnerabilities—is never spared on himself.

Perhaps the congenial quality of his irony, even at its most irate and outrageous, is due to his late start finding his way as a writer. A total failure at forty, washed-up, busted, hungry and rootless, he passes through a spiritual zero, has a revelation and begins to write honestly for the first time the essence of what he's experiencing. *Tropic of Cancer* was a breakthrough not just for Miller but for every remotely "autobiographical" or "confessional" writer to follow: all is permitted, you can talk about anything in a book, as if you were speaking to a close friend in fullest confidence. In *Cancer*, as in many of the later works, Henry's courageous confrontation of the sickest realities festering underneath civilized appearances enables him to see corruption up close, to speak of it freely and thus transform it—and in the process, himself.

Shamelessly exploring his personal disasters in Paris and New York, the capitals of the West, Miller delivers prodigious testimony to human perseverance in the face of decay. He is a profoundly committed moralist who refuses to compromise with hypocrisy—and a kid with a curiosity that won't quit.

I say "is" because he's clearly still with us in more ways than just his books and paintings might suggest. Alongside Whitman and Neruda, Miller is for me among the greatest of inspirational resources, a writer whose exuberance and mystic playfulness of spirit consistently lift and liberate. A nourishing generosity radiates from such writers like sunlight. Celebrating the self is much more than just an ego indulgence because the "self" is everywhere, in everything: the individual and the surrounding world exist in dynamic interpenetration. To spill your particular music back into the universe in exchange for its miraculous reality bath is the least you can do in response to

the world's wonders. The incoherence and excessiveness one sometimes hears these guys accused of is a misplaced reference to their surplus of praise. They also share a heavy emphasis on friendship.

The process of spontaneous eruption in Miller's best writing gives it a sense of supreme joyfulness, even when addressing the most painful truths. The lusty delight he takes in language itself, in playing with improvisational possibilities, in extending boundaries and discovering the more intuitive than narrative or descriptive aspects of spoken experience, makes miles of his sentences shine in a manner more warm and luminous and casually natural than many a more elegant literary craftsman's most beautifully wrought lines. Still, for all his enthusiasm, Henry is more calm and disillusioned than most romantics, more sure of himself and philosophically grounded, less petulant, less desperate. I know few novelists whose range of ideas and feeling of ripe abundance can compare with Miller's.

And the so-called novels are only part of the picture, alongside the artless watercolors, the travelogues, the smoldering diatribes, the satirical and literary and philosophical essays, the wealth of affectionate tributes to friends and acquaintances famous and obscure, the merciless unmasking of the American Dream long before such skepticism was epidemic (these essays, many of them written in the thirties and forties, are as up-to-date as ever). Miller's writing is what reviewers like to call "uneven"—as mountain ranges and jungles are uneven. His imaginative unruliness and refusal to abide by conventional standards in art and life are useful clues to the riddle of how to outfox the crushing forces of the ordinary.

To pass on peacefully at 88 after a life of such creative realization seems worthy of the craftiest master. Henry the would-be Chinese hermit disappearing on a Tibetan mountaintop (or watching one last sunset from Partington Ridge) surely must have marveled at the mystery of spending his last years in the bourgeois enclave of Pacific Palisades, attended by friends and photographers and handsome handmaidens. His advice to the writer of his first biography on that difficult art and his own preference for books that are "purely poetical evocations, in which the facts don't matter in the slightest," could be a key to getting the drift of the myth he made of himself. "Why, you could even invent the facts. I'd prefer that. So long as you were interesting, I wouldn't care."

Or as he wrote to Durrell in 1937, revealing the kernel of his own ambition: "You see, writing you don't need to worry about. You are a writer—at present, almost too much of a one. You need only to become more and more yourself, in life and on paper."

2 *Philosopher Clown*
(2000)

Hard to believe it's been 20 years since Henry Miller left us. Miller at 88 lived out the final days of his extraordinary life in a big colonial house in Pacific Palisades, an unlikely last stop for his odyssey. He had started out on the streets of Brooklyn at the end of the 19th century, attempted unsuccessfully to "come of age" in New York City, escaped to the lower depths of sub-bohemian Paris where he belatedly found his voice as a writer and wrote his first three monumental books, left Paris for Greece on the eve of World War II, returned to the States

and traveled the country discovering why he'd fled in the first place, and eventually settled for several years, like some kind of Chinese sage, on a ridge above the Big Sur coast. The rigors of living so far from civilization in his advancing years, combined with the royalties from international sales of his many books, conspired to take him to the LA suburb where, by now a self-made legend, he enjoyed the luxuries of commercial success and disappeared into the sunset.

In 1991, his centennial year, scholars Mary Dearborn and Robert Ferguson published new biographies of Miller, novelist Erica Jong brought out a book-length personal appreciation and Philip Kaufman's film *Henry & June*, based on the journals of Anaïs Nin, temporarily reminded us of the writer's special place in the century's literary landscape, but since then he's pretty much vanished from the cultural radar. This is especially ironic in light of the rise of the personal memoir as one of the most popular literary forms and the recent apotheosis of Jack Kerouac as the great American rebel automythographer. It's hard to imagine either Kerouac or the memoir emerging as major forces in US publishing without the precedent of Miller's free-form taboo-smashing example. His first book, *Tropic of Cancer*, written in the author's early forties and published in Paris in 1934 (but banned in this country until 1961 on account of its alleged "obscenity"), begins with a prophetic epigraph from that most American of writers, Ralph Waldo Emerson: "These novels will give way, by and by, to diaries or autobiographies—captivating books, if only a man knew how to choose among what he calls his experiences that which is really his experience, and how to record truth truly."

Miller, even now, maintains his scandalous reputation,

known by most as a writer of "dirty books." But those who actually read his work in all its remarkable variousness may come to understand that, while he is a ribald and outrageous storyteller, he is also, like Emerson, a philosopher. *Tropic of Cancer* is a shocking book not just for its frankly sexual and scatological aspects but for its fearless confrontation with a civilization collapsing in a spasm of spectacular decadence. Just a few years before Hitler sends Europe into a cataclysmic war, Miller discerns, in the squalor of his immediate circle of degenerate friends and acquaintances, the symptoms of a more pervasive ailment, a moral cancer that he sets out to expose, sparing no one, least of all himself. That he is able to tell this degraded tale in a prose that, for all its darkness, is nothing less than exuberant, is some kind of miracle. Imagine Spengler's *The Decline of the West,* Eliot's *The Waste Land,* Sartre's *No Exit* and Dylan's "Desolation Row" combined and retold by the mutant manic offspring of Mae West and Groucho Marx, and you have some idea of the apocalyptic energy of Miller's breakthrough book. Obscene, perhaps, but only as a frighteningly and hilariously honest depiction of a world that's all too real.

In *Tropic of Cancer* Miller attempts to hasten the razing of this corrupt world while at the same time eradicating his personal catastrophe, which includes not only his abject failure to accomplish anything in 40 years of earthly existence but also his tormented erotic obsession—sometimes known as love— with the woman who was to be his lifelong muse and goad and inspiration, his second wife, June (aka Mona). The impoverished, directionless, hopeless yet comical account Miller's autobiographical narrator records could easily be considered nihilistic, but it's Miller's lyric genius, in the transcendental

spirit of Emerson, to lift his sordid material from the depths of its own depravity into something resembling redemption. Toward the end of this harrowing sustained exercise in creative rage, the author contemplates the crotch of a prostitute and launches into one of the most memorable riffs in literature, a 10-page diatribe against "a world tottering and crumbling, a world used up and polished like a leper's skull," a world that breeds, alongside the human race, "another race of beings, the inhuman ones, the race of artists who, goaded by unknown impulses, take the lifeless mass of humanity and by the fever and ferment with which they imbue it turn this soggy dough into bread and the bread into wine and the wine into song." Miller aligns himself with this race of artistic monsters and declares, in a paroxysm of exasperation that amounts to a manifesto, "A man who belongs to this race must stand up on a high place with gibberish in his mouth and rip out his entrails…. And anything that falls short of this frightening spectacle, anything less shuddering, less terrifying, less mad, less intoxicated, less contaminating, is not art…." This is a high standard for any artist to set for himself, but Miller at his most possessed and most inspired meets it, in this and many of the later books.

From the portrayal of his lowdown immediate surroundings in *Tropic of Cancer*, Miller turns a backward glance on his young manhood in New York in the equally scandalous and even funnier *Tropic of Capricorn,* whose first 100 pages relate his years of employment with the Cosmodemonic Telegraph Company, one of the most engrossing portraits of corporate bureaucracy ever consigned to paper. But *Capricorn*, as its goatish title suggests, is mostly about its horny narrator's

unquenchable thirst for sex and his simultaneous search for meaning in a world that seems no more nor less than maddeningly chaotic. More coherent as a narrative than *Cancer,* despite its many digressions and lack of a conventional "plot," *Tropic of Capricorn* is Miller's portrait of the artist as a young man who can't quite figure out how to be an artist. Despite his anguish and confusion and pain and despair, the antiheroic protagonist's story is once again told in such joyfully charged prose that it practically lifts you out of your seat as you read. This guy may be hurting but he's *alive* in a way that you can only hope to be—not necessarily by indulging your every forbidden appetite but by paying such close attention to your difficulties and to the details of your oppressive environment that even your failures become something to celebrate and thereby turn into evidence of an undefeated existence.

In the third and final book of this initial trilogy, *Black Spring*, Miller abandons the novelistic pretense of telling any single story and instead creates a kind of collage of sketches, portraits, vignettes, essays and poems-in-prose that once again combine to reveal the author in all his prodigious originality. This is the book, if the uninitiated reader can suspend the desire for conventional narrative and surrender to the spell of Miller's voice, that may be the best one-volume introduction to the author's work, as it represents multiple aspects of his literary persona. Perhaps the most marvelously disorienting section of *Black Spring* is "Into the Night Life... A Coney Island of the Mind," a 30-page dreamlike prose fantasia whose wild inventiveness, richness of imagination and gorgeous sentences are breathtaking. Here is Miller cut loose beyond the stench of rotten circumstance and the arbitrary limits of "making sense"

into a realm of ecstatic revelation, the writer as clown on a netless high wire performing for nothing so much as his own delight. The joy with which this acrobatic prose is infused is dangerously contagious. I say dangerous because, attempted with less virtuosity, this kind of writing, liberating as it may feel, is likely to result in an utterly unreadable mess.

But why not, Miller might answer, make a mess? Life itself is a mess, and isn't art obliged to be faithful to life?

Miller was also an accomplished amateur watercolorist, a selection of whose pictures appeared after his death in a book appropriately titled *Paint as You Like and Die Happy.* His writing—from the *Tropics* and *Black Spring* through the wonderful books of essays (*The Air-conditioned Nightmare, Remember to Remember, Stand Still Like the Hummingbird, The Cosmological Eye* and others) and the great book on his stay in Greece, *The Colossus of Maroussi,* to the excruciating *Rosy Crucifixion* trilogy (*Sexus, Plexus* and *Nexus,* the epic saga of his life with June)—is radical testimony to the artist's freedom to ignore existing rules and do it however he or she feels moved to make a singular statement. Not everyone can get away with such defiance of propriety—even Miller, at his worst, can be tiresome and sloppy—and not everyone has the nerve or courage or madness or whatever it takes to risk colossal failure by taking such a path. But his friend Lawrence Durrell, describing Miller as "one of those towering anomalies, like Blake or Whitman," places him in his proper context among the giants of literature, a source of consternation to some, consolation to others and inspiration to those who would find a form and style of expression true to their own experience.

3 Henry & Me
(2001)

By the time Henry Miller arrived in Big Sur in the early 1940s he was already a semi-legendary widely censored writer. Past 50, famous as a literary outlaw, his days as a sub-bohemian Parisian expatriate fading as World War II intensified, Miller's retreat to Partington Ridge marked a radical turn in his life and career. Like some Chinese sage of ancient lore, he was, it would seem, disappearing into the mountains with a certain serenity. He had already written a lot, including the scandalous *Tropic*s and *Black Spring* (published in Paris but still banned in the States) and to all appearances his greatest creative days were behind him.

But Miller still had a mission to accomplish: he had not yet told the story of the central event in his tumultuous life—his meeting and subsequent agonizing seven-year alliance with his second wife, main muse, nemesis, tormentor, supporter and object of sexual obsession, June. The resulting *Rosy Crucifixion* trilogy—*Sexus*, *Plexus* and *Nexus*, all written during the Big Sur years—is Miller's most ambitious, shamelessly self-revealing, hysterically funny, excruciatingly painful, perversely inspiring and largely misunderstood work. On the first page of *Sexus* he establishes the central theme that he will then attempt to excavate, explore, examine and exorcise in the 1,500 pages to follow: "To make absolute, unconditional surrender to the woman one loves is to break every bond save the desire not to lose her, which is the most terrible bond of all." The first volume closes some 600 pages later with the narrator reduced to a yapping lapdog.

When I first read *Sexus*, in the classic Grove Press Evergreen Black Cat pocket paperback edition with the plain red cover found, used, in its eleventh printing, in some secondhand bookshop, I had already been exposed to Miller's wild genius through the Paris books, most notably *Tropic of Capricorn*, which covers some of the same New-York-in-the-1920s territory. In my late twenties at the time, gloomily in love with my own muse and deeply troubled by the usual morass of existential questions that plague the oversensitive and excessively philosophical would-be artist as a young man, I had no idea I was about to encounter, in Miller's rollicking prose, a life-shaking literary experience. Henry's passionate energy, clownish self-mockery, astonishing honesty, priapic abandon and the remarkable skill and grace with which he strung sentences together eloquently, endlessly, with reckless disregard for tradition, convention or critical consequences dramatically demonstrated that life was not only well worth living but that it was possible to create an art uniquely and defiantly one's own.

Beyond their considerable inherent value as works of literature and regardless of their academic status—Miller is by now even more "politically incorrect" than he was "obscene" in the first place—it is, I think, the inspirational quality of his writings that endears Henry to his legions of grateful admirers. There will always be idiots who see in his amoral escapades a role model for outrageous behavior, but more thoughtful readers of his books understand that Miller is not recommending that we follow his example. Indeed, after his good friend Lawrence Durrell objected strenuously to the atrocious conduct chronicled in *Sexus* (Durrell's urgent 1949 telegram reads in its entirety: "SEXUS DISGRACEFULLY BAD AND WILL COM-

PLETELY RUIN REPUTATION UNLESS WITHDRAWN REVISED LARRY"). Henry replied in a lengthy response, "There is a poverty and sterility I tried to capture which few men have known." Miller's willingness, in the interest of setting down a true-to-life account of his experience, to expose himself in the worst possible light becomes, over the course of his story, an act of redemption. No matter how miserable or depraved we may have been, he seems to be saying, no matter how much we've suffered, that misery and depravity can be transformed through the miraculous alchemy of art.

The cultish following that Miller attracted during his lifetime, the endless parade of seekers and would-be acolytes that trudged up to Partington in search of some trace of the master's magic, the mystique (in part promoted by Henry himself in an absurdist spirit of self-parody) of Ping Pong games with naked voluptuous women, the feminist critiques of his alleged misogyny—all serve to obscure the profoundly spiritual essence of the author's effort to rescue himself, to achieve some belated wisdom and find some meaning, through the lonesome and rigorous practice of truthful writing. For those caught up in its mysterious spell, Miller's voice is druglike in its powers of mental intoxication. Like some drugs, his books have a way of deluding the reader into thinking himself capable of accomplishing the impossible. But they also have a way of altering perception, of opening new aspects of reality, of revealing what *is* possible if only we would pay attention, get in tune, open ourselves to the way things actually are.

The Miller library in Big Sur is a kind of shrine to this principle of limitless creativity that Miller embodied. I stopped there recently to breathe the atmosphere of his long-gone but

ever-present accomplishment. In the 20 years since his death, Miller has paradoxically both faded from popular consciousness and been revealed as the forerunner, for better or worse, of the seemingly unstoppable wave of memoirs that has engulfed the world of publishing. Before Jack Kerouac's autobiographical ramblings, before the countless confessions of dysfunctional comings-of-age, before the Oprahfication of self-helpful spiritual awakenings in print, Henry's epic automythographic riffs set a new standard for writers who dare to tell all. Or perhaps more accurately, he blasted away all standards, showing by example that one must establish one's own.

It was that example that moved me, I suppose, after my first book of poems was published in 1975, to make a pilgrimage not to Big Sur, which he had long since left, but to Miller's residence in Pacific Palisades, to leave my little volume as an offering of respect and gratitude. Affixed to the front door of the colonial house was an index card whose text, typed out in capital letters, said something to the effect of: THE GREATEST TRIBUTE YOU CAN PAY THE MASTER IS TO LEAVE HIM ALONE. Undeterred, I knocked. His housekeeper, a beautiful model named Twinka, answered the door in a terrycloth robe, as if she'd just climbed out of the swimming pool, or shower, or bed. She patiently explained to me that Mr. Miller (now in his mid-eighties) was not receiving visitors, so I signed my book and left it with her to deliver to him with my regards.

The next day I was driving down Santa Monica Boulevard adjacent to Century City, headed west. Stopped at the intersection of Avenue of the Stars, I noticed, out of the corner of my left eye, a car pull up beside me; it was a warm day and my window was down. I glanced to the side, then did a double take. In

the passenger seat of the adjacent car, his window also down, was a frail-looking elderly bald-headed man. This couldn't be happening—but, as in a dream, it was. "Mr. Miller?" I said, tentatively. The old man looked at me with a weary expression on his face, as if to say Oh well, this is the cost of fame, then nodded and gave a casual wave of the hand. "I left a book at your house yesterday."

That got his attention. "Oh," he said to me, "are you Kessler?"

Henry Miller had spoken my name—amazing. "Yes."

"I'm not a great reader of poetry, ya know."

"It doesn't matter," I assured him, "I just wanted you to have it as a gift."

"But it was good, what I read," he said. "Very good."

The light changed, his driver turned left, and I was left wondering what had just happened to me.

The Tolstoy of the Zulus:
Saul Bellow

[2005]

Saul Bellow, who died in April two months shy of 90, was the last of the *dominant* American novelists. Like Faulkner and, in the popular imagination, Hemingway through the first half of the 20th century, Bellow during most of the second half was the preeminent figure in US literature. With the decline of the novel as a cultural force in the face of so many other forms of popular entertainment and storytelling, and the vast diversification of the literary landscape—the sheer number and variety of writers publishing books—the kind of artistic prestige that Bellow enjoyed is probably obsolete. Even such big guns as Toni Morrison, Philip Roth, Joyce Carol Oates and John Updike will never be accorded the intellectual glamour and widespread respect earned by Bellow in his prime. This is partly due to changes in the culture, and partly to Bellow's genius as the greater writer.

How did a Canada-born, multilingual, culturally conservative Europhile like Saul Bellow turn out to be the most powerfully original American writer of his time? Surely all of these seemingly nonindigenous aspects of his character—

to say nothing of his deeply Jewish identity—contributed in a big way to the author's vision and voice. Often denounced in his later years by multiculturalists for his Eurocentric conservatism, Bellow himself was a walking, talking, thinking and writing embodiment of a multicultural sensibility. As a boy in Quebec (his family moved to Chicago when he was nine) Bellow remembered hearing and speaking so many different languages—Yiddish, French, Russian, English, Polish and Hebrew for starters—that he didn't realize they were indeed different. In his creative maturity his style was inflected with all these elements, and combined with what he picked up on the streets of Chicago (and later New York), synthesized into a uniquely American idiom.

It was of course in *The Adventures of Augie March* (1953) that Bellow broke out this richly polyglot yet native idiom, cutting loose with a freewheeling lyrical narrative that is to the American novel what, a century earlier, "Song of Myself" was to American poetry—a declaration not just of independence from previous literary models but of the delicious autonomy of the individual, a part of (yet apart from) everything and everyone he encounters. While these themes were not unprecedented in US fiction, Bellow had, like Whitman, dared to invent a new American language. Four years ahead of Kerouac's *On the Road* with its jazzy riffs and wild embrace of existential freedom, Bellow's *Augie* brought to its readers a phenomenal range of experience explored with a linguistically extravagant, zesty gusto seldom encountered before or since in our literature. It's a fairly shapeless book—the opposite of its author's first two tightly written, claustrophobic, gloomy novels, *Dangling Man* and *The Victim*—rambling in all directions for 536 pages

as it records the narrator/protagonist's unresolved pursuit of a worthwhile destiny—or as he puts it, "the refusal to lead a disappointed life"—and Augie himself, in his resistance to containment, is one of the book's most ill-defined characters. But the charged intensity and philosophical vigor of his rambunctious story prefigures the descriptive and intellectual power of Bellow's best novels to follow.

The small masterpiece *Seize the Day* (1956), another dark little "victim" tale, came next, as if to prove the author could rein in his raving muses, but if *Augie March* was his initial major creative statement, the heart and soul of Bellow's work are in the big novels of his middle period: *Henderson the Rain King* (1959), *Herzog* (1964), *Mr. Sammler's Planet* (1970) and *Humboldt's Gift* (1975). In each of these very different books the author's voice booms forth full-force and his protagonists—like Augie reflecting different facets of their creator but more fully realized as distinct individuals—come to embody the comedy, angst, intellectual preoccupations, philosophical questionings, revulsion with contemporary trends, ironic romanticism, and search for wisdom and transcendence that drive his narratives. The conventional notion of plot is incidental or beside the point entirely; Bellow's novels are *thought* driven: the story unfolds largely in the main character's mind as he struggles to negotiate the treacherous terrain of modern, mostly urban reality, a reality informed not only by the protagonist's acute sensory perception and the remarkable range of characters he encounters—each with his or her own angle on the game of life—but by the vast range of his reading. In the rolling seaswells of Bellovian consciousness books are bits of flotsam, something that may help keep you afloat and even save your

life, but never quite sufficient to carry you safely to a peaceful port. This tension between a reverence for the major works of the Western tradition and an awareness of their limits in helping to solve the problems of living creates the ironic cross-currents that give the author's enormous learning its playful quality; they keep it light even as he grapples with the heaviest questions—in short, as Eugene Henderson puts it: "What's the best way to live?"

Henderson, an American millionaire with a major midlife crisis—an insatiable desire for something he can't quite identify—takes off for Africa in search of his soul and finds a series of improbable adventures that culminate in a wrestling match and philosophical apprenticeship with an African tribal king, a dignified primitive or "noble savage," who is in turn a comic variation on an American archetype ranging from Fenimore Cooper through Twain to Hemingway. I think it was the critic Leslie Fiedler who noted the resemblance between the names Eugene Henderson and Ernest Hemingway and read *Henderson the Rain King*, at least in part, as a satirical take on Papa's macho African expeditions and a shot across the old man's bow announcing the arrival of a new contender for the crown of Fiction King.

At some point in his touchingly absurd journey Henderson has the revelation that "all travel is mental travel," and it is this principle that propels the inner wanderings of the protagonists of most of Bellow's subsequent novels, starting with his first great popular success, *Herzog*. His most nakedly personal and autobiographical narrative, and in my opinion his most perfectly realized work, this is the book that made the name of its author a household word and made him a wealthy man: it

was number one on the *New York Times* bestseller list for more than seven months—an astonishing fact when one considers that this was an extremely cerebral performance, packed with highbrow references and manic philosophical associations, a novel whose title character is a professor of intellectual history who is having a nervous breakdown while his wife is having an affair with his best friend. Moses Herzog's method of coping with his crisis is to fire off scores of letters in all directions, to friends, public figures, historical personages and obscure thinkers, exploring maddening conundrums of all kinds, from the erotic to the transcendental.

Herzog's dizzying erudition—the protagonist is plagued by, among other things, the weight of his unfinishable manuscript on *Romanticism and Christianity*, with all the oppressive historical and spiritual baggage its title implies—is shot through with vital anguish, big ideas, funky everyday annoyances, emotional confusion, inner reflection and outward observation in equally agitated measures. The author uses his extraordinary familiarity with the works of the great thinkers and writers of Western culture to throw into relief how useless this information is in relieving Herzog of his personal misery. Yet the thinking that drives the narrative—the whole book can be read as an extravagantly digressive internal monologue—is both over the heads of most of its readers and anchored in earthy sensory perception in a way that is totally engaging, captivating, exhilarating.

How could a book of such heady intellectual content become such a phenomenal popular success? I think that Bellow caught in *Herzog* the gathering torment of the decade not yet known as "the sixties"—not the clash of generations so much as the

increasing burden and speed of information and the impossibility of making sense of it all. Like Joyce in *Ulysses* with his stream-of-consciousness technique, Bellow recorded what felt more like a *sea* of consciousness, shapeless and stormy and vast and lonesome for the individual lost on its heaving waters, and faithfully reflected the chaotic feeling of an overstimulated mind tossed among its uncontrollable thoughts. Even well-adjusted people of normal intelligence could relate to what Bellow was revealing about a neurotic intellectual in acute psychic crisis; *Herzog* spoke in an intimate way that resonated with their deepest, most private experience, and readers responded with gratitude, recognizing in the author a kindred soul.

Neither seduced by commercial success nor distracted by critical acclaim (in addition to its huge sales, *Herzog*, like *Augie March* a decade earlier, won a National Book Award), Bellow maintained his singular independence and artistic integrity, dismaying many of his liberal admirers with his next book, *Mr. Sammler's Planet* (which made him the only three-time winner of the NBA). It was here that Bellow explicitly engaged the 1960s and the social and cultural conflict of those tumultuous years, using one of his most vividly imagined creations, Artur Sammler, a 70-plus-year-old Anglophilic Polish Holocaust survivor living in New York City, as the sensibility through which to witness the turbulence of the moment. *Sammler* was the novel that earned Bellow his reputation as a reactionary and a racist for its sour view of the counterculture, its stereotyping of black criminality and more general "sexual niggerhood," and its rejection of conventional wisdom about the dawn of a new age.

Oddly, in *Sammler* there is no mention of the war in Vietnam, which Bellow did not publicly oppose. But his vehement

denunciation (via Sammler) of the sexual revolution is remarkable not least for what it doesn't say about the author's own well-documented promiscuity. In his excellent *Bellow: A Biography*, James Atlas reports on his subject's countless liaisons during and between his five marriages, compulsively cheating not only on his wives but on his girlfriends too. But Bellow's personal libertinism was not a public movement and therefore presumably more acceptably unique than the uncorked eroticism of Sammler's sex-plagued world. (Bellow's misogyny, evident throughout his novels with their bitchy wives and greedy ex-wives and man-eating mistresses, is an interesting topic for another essay.)

While most of his contemporary artists and intellectuals were protesting against the war, rallying for civil rights, supporting sexual freedom and the dawning women's movement, and generally welcoming the convulsive changes of the period, Bellow, by way of Sammler, was irritably observing their barbaric, decadent, uncivilizing disturbances. The protagonist's recurrent worry—that things are getting so out of hand on Earth that escaping to the moon might be the only option—is brought home to him in countless ways by the eccentric people, many of them members of his own extended transplanted family, who surround him.

I confess that when I first read *Sammler* soon after publication it struck me as an incredibly cranky lament by a writer I had loved enough up to that point to have written my senior project on just a couple of years before. Why was my hero condemning the bearded, long-haired, drug-crazed, peace-loving, love-spreading, groovy likes of me? Reading it again more recently I recognized not only the brilliance of Bellow's

descriptions and characterizations—his sensory sharpness and psychological insight—but the invigorating quality of his thought and the courage it took for him to come out with a book and a vision so thoroughly at odds with the prevailing assumptions of the time.

Sammler is indeed a cranky *alter kocker* but his critique of the excesses and idiocies taken for enlightened thinking in the late sixties is bracing, even today. Through dark ironic humor, perceptual clarity, explicit complaint and the fascinatingly digressive inner monologue of his central character Bellow presents and defends an Old World detachment, dignity and stoicism besieged by the anarchy of what felt at the time like a revolution. To take a stand against such dramatic—and for some, welcome and exciting—change when it seemed inevitable showed the author as the radical nonconformist he was and remained throughout his career, refusing to align himself for long with any school of political thought, fiercely protecting his independence, whatever the consequences.

The book that won Bellow a Pulitzer and put him over the top for the Nobel Prize in the Bicentennial year of 1976 was *Humboldt's Gift*, the author's homage to his friend the poet Delmore Schwartz, a drug-addicted alcoholic genius who died, broke and demented, at 53. *Humboldt,* like the later *More Die of Heartbreak* and *Ravelstein*, and like a long line of other American novels, is a tale of male friendship, but more than that it is a "great poem of death" as Whitman called for, an argument against mortality, a resurrection in irrepressible prose of a lost unique human being. It's a rich portrait of an archetype, the cursed or tragic artist consumed by the fires raging in his soul and destroyed by a society indifferent to his art. It's also very

funny, like most of Bellow's best work.

While the Nobel may have marked his peak both as a creator and as a dominating figure of our literature, Bellow never rested on his laurels. In *The Dean's December* (1982) and *More Die of Heartbreak* (1987) he carries on his arguments with contemporary culture, but by now the narrative voice, though still energetic, begins to sound a little more, not just at odds but out of sync with the times, hard as it tries to engage itself. The author's reflections feel somehow reheated, resentful of their own irrelevance, irritable, quarreling with a world that doesn't really care what he thinks. You can sense the desperation of a major intellectual force beginning to sense that its time has past. It's still an interesting mind, but no longer quite so revelatory or original as it was.

Yet his last published novel, *Ravelstein* (2000), is fully alive with Bellow's souped-up sensibility, even at 85, smelling and noticing and complaining, thinking and questioning, settling scores, rescuing dead friends—in this case neoconservative scholar and author Allan Bloom (*The Closing of the American Mind)*—riffing on all things considerable and never just going through the motions.

Bellow's alliance with Bloom in the culture wars was epitomized by an infamous remark he made to an interviewer in the late 1980s when he was asked about multiculturalism and his preference for the dead white men of Europe as his literary heroes. Surely with the mischievous intent of provoking the politically correct, Bellow asked jokingly, "Who is the Tolstoy of the Zulus? The Proust of the Papuans? I'd be glad to read him." (This from a former anthropology major who'd once edited a magazine called *Noble Savage*.) If Americans, in Bel-

low's Sammleresque view, have regressed into ignoble savagery, permitting their culture to decline into a Babel of absolute relativity; if whatever's hip is the new orthodoxy and deconstruction the prevailing trend of intellectual analysis; if values are up for grabs and the old white guys are being boiled alive in postmodern mumbo-jumbo, maybe Saul Bellow himself had become the Tolstoy of our Zuluized zeitgeist, reaching back to his ancestors' Russia for the moral courage and epic inspiration to ask tough questions in books that refuse to settle into a complacent classicism.

For Bellow, even in his final years, was incorrigibly contemporary. Every one of his books is an inquiry into the vexations and contradictions of its historical moment. Refusing to fade away or sink into superannuity, he maintained his lifelong commitment and fidelity to what Whitman, even in the bitter disillusionment of his *Democratic Vistas*, called "the prophetic vision, the joy of being tossed in the brave turmoil of these times." My guess is that Bellow's time will come back around.

Lost Illusions:
Philip Roth

[1998]

It doesn't seem possible after the streak of knockout books he's published since 1990—*Patrimony*, *Operation Shylock*, *Sabbath's Theater* and *American Pastoral*, each of which was awarded one of the major US literary prizes—but Philip Roth may have outdone himself with his latest novel, *I Married a Communist*. With the stylistic precision of Flaubert and the psychic intensity of Dostoyevsky wedded to his own unique American Jewish vernacular, Roth has once again wrought a work of astonishing energy and intelligence, a book both profoundly personal and deeply historical, resonating with contemporary relevance. At 65, when he might be mellowing into a dignified maturity or, in another well-known tradition, have long since burnt himself out, Roth's transgressive creative powers continue to blaze red hot. You read this book at the risk of singeing your eyebrows.

The author is probably still best known to the general public for his fourth book, the bestselling *Portnoy's Complaint*, which made the Modern Library's much-disputed list of Top 100 novels of the century. It's true that *Portnoy*, a manic neu-

rotic monologue spoken in the persona of a sexually obsessed but otherwise nice Jewish boy from New Jersey, is one of the funniest books ever written. But it was published nearly 30 years ago, and in the intervening decades Roth's accomplishment has far surpassed that early explosion of comic genius. Through his alter-narrator, Nathan Zuckerman—protagonist of such remarkable works as *The Ghost Writer*, *Zuckerman Unbound*, *The Anatomy Lesson* and *The Counterlife*—he has constructed a many-mansioned funhouse of confused identities, constantly challenging the reader to distinguish between autobiography and imagination, between the "real" Philip Roth and his fictive counterselves. Well before postmodernism became an academic buzzword, Roth was taking the naturalistic tradition and wringing its neck in richly ambiguous ways.

In *I Married a Communist* we find the aging Zuckerman living reclusively in rural New England and looking back on his adolescence in Newark. The catalyst for this remembrance of things past is one Murray Ringold, his former high school English teacher, whom he encounters in the neighborhood attending a study retreat for senior citizens at a nearby college. Ringold, now 90 and seemingly undiminished in intellectual vigor, was one of the young Nathan's earliest mentors in the vital arts of reading, thinking, speaking and writing. Like Conrad's Marlow, Roth's Murray Ringold serves as the storyteller-within-a-story who, along with Zuckerman's interwoven memories, leads us into the heart of this book's darkness. In six long, martini-fueled, nonlinear conversations, the ancient Murray and the increasingly geezerly Nathan, fired up by their unexpected meeting and their shared nostalgia for lost time in a Newark that no longer exists, recreate the excruciating tale

of Murray's kid brother, Ira, another of Nathan's mentors and the Communist of the title.

A big, strong, blustering ideologue, World War II veteran and Abe Lincoln lookalike, Ira becomes a radio actor who goes by the stage name of Iron Rinn. He meets and marries a famous, much-divorced, past-her-prime actress named Eve Frame who, following their tumultuous and mostly horrible marriage, publishes an exposé of her husband's Communist associations, including the invented charge that he's a Soviet spy. This being the McCarthy era, the book effectively ruins Ira's life. In its most reductive and simpleminded reading, *I Married a Communist* (also the title of Eve Frame's book, ghost-written by a couple of right-wing gossip-columnist friends of hers) is a period piece about personal betrayal and political treachery in early 1950s America. For aficionados of more recent gossip it is also, in this shrink-wrapped reading, a fictional response by Philip Roth to his ex-wife Claire Bloom's 1996 memoir where she portrays him as a raving, enraged, sadistic, manipulative, mentally ill disaster of a man. As a work of revenge Roth's novel is a devastating imaginative counterattack to Bloom's more pedestrian effort, and as social history it is richly evocative of the horrific atmosphere of accusation, bad faith and ideological excess of its time.

But this being Roth, consummate creator of multidimensional fictive worlds-within-worlds, there's a lot more going on than the settling of scores, personal, historical or otherwise. For one thing, Roth's use of Iron Rinn as *nom de guerre* for his wild-man protagonist is clearly an echo of Robert Bly's mega-popular 1990 *Iron John*, "a book about men." Like Bly's archetypal fairy-tale figure, Roth's Ira appears from the mar-

gins of polite society to initiate young Nathan into the ugly and invigorating realities of adulthood, which in this case means political awareness. By introducing him to worker solidarity and the power dynamics of class struggle, Iron Rinn gives Nathan's dawning sociopolitical convictions an anchor in the outside world—a point of counter-reference to his New Deal Democrat, securely middle-class podiatrist father's home and its anti-Republican but not very radical orderliness. Seduced by the romance of the fight for justice, Nathan sees Iron/Ira as a heroic figure to be emulated—for a while anyway, until his harangues grow tedious and the aspiring writer develops, with the help of yet another mentor, a more esthetic attitude toward reality.

Via Murray's meandering narrative we discover that Nathan in turn was also Ira's teacher, a wholesome and inadvertently gentling influence on the older man's violent impulses; Nathan, in his relative innocence, served as a balm for the wounds of Ira's painfully troubled life, a mitigating presence in his otherwise rage-driven existence. Here Roth has turned the traditional initiation story on its head, working a variation on Wordsworth's insight that the child is the father to the man. Even the virtuous Murray, whose down-to-earth wisdom and mental clarity is the steadiest light in this kaleidoscopic book, turns out to have deceived himself about his own good sense in a twist that gives his story a heartbreaking poignancy no less tragic than his brother's. "Look," says Murray to Nathan toward the end of their marathon conversation, "there is no way out of this thing. When you loosen yourself, as I tried to, from all the obvious delusions—religion, ideology, Communism—you're still left with the myth of your own goodness.

Which is the final delusion." In a morally ambiguous world, unreliable because of its constantly shifting boundaries of right and wrong, good and evil, even the wisest individual is subject to self-deception. This may be a bleak view of the universe, but it's also a bracing corrective to self-righteousness.

As an investigation of male anger, an exploration of an especially ugly moment in US history, a novel of political perversion, a domestic tragedy of atrocious manners, an inquiry into post-World War II Jewish identity, a study of the bonds between brothers, a coming-of-age story of lost illusions, and a ferocious critique of the culture of gossip and celebrity at the dawn of the television age—a culture that now engulfs us more than ever—*I Married a Communist* is a phenomenal performance. With the possible exception of *Patrimony*, the 1991 memoir of his father's death, it is also Roth's most moving, philosophical and strangely tender work. For all the cruelty, rage, injustice and duplicity portrayed, its final pages reveal a writer coming to terms with the inevitable losses and profound disappointments inherent in human life, and facing those terrible truths with courage, and turning them into an all-but-transcendent art.

Humanstein:
Bellow and Roth

[2000]

Is it a conspiracy or just a coincidence that both Saul Bellow and Philip Roth have chosen for the protagonist of their latest novels an aging humanities scholar enamored of the ancient Greeks? Bellow's Abe Ravelstein, a philosophy professor famously modeled on the author's friend Allan Bloom, grounds his thinking in Plato and Aristotle; Roth's Coleman Silk, an African-American passing for Jewish who teaches classics, is devoted to Homer and the tragedians. Both men find in the works of these dead white males a combination of values, wisdom and insight into the human condition that transcends time and place.

The other thing these novels have in common is a first-person narrator who closely resembles the author and who functions in the story mainly as a witness. Bellow's Chick in *Ravelstein* is a moderately successful writer who has encouraged his friend to set down his educational ideas in a book that inexplicably becomes a bestseller and makes its author, Ravelstein, rich enough to afford the material luxuries he likes to lavish on himself. Chick holds Ravelstein in awe as a kind of

mentor—even though Ravelstein is the younger man—and is urged by the vain and bombastic Ravelstein (who, as it happens, is dying of AIDS) to write a memoir of him when he's gone.

Roth's familiar Nathan Zuckerman in *The Human Stain* is, like his creator, a well-known novelist who jealously guards his privacy yet whose life and work are disrupted by Silk, who entreats him to write the story of the disgraced professor's downfall after being unjustly accused of racism. Where Chick is a rather passive character, claiming merely to record "piecemeal" the larger-than-life antics of his pal Ravelstein, Zuckerman the irrepressible novelist is drawn so deeply into Silk's story that he becomes an investigator who imaginatively reconstructs events he could not have witnessed. Roth makes it clear to the reader that his book is fiction, which gives him license to excavate the imaginary facts in search of deeper truths.

By contrast, it's unclear whether the author of *Ravelstein* is fully aware of the unreliability of his own narrator. Chick/Bellow so adores and admires Ravelstein/Bloom that his affectionate account reveals not only a brilliant teacher and colorful individual but an obnoxious, slovenly, intellectually arrogant, cruel, overbearing, egomaniacal blowhard. More ironic still, as argued persuasively by Louis Menand in the *New York Review,* the real subject of Bellow's book may not be Bloom at all but the author's most recent former wife, a gorgeous Romanian mathematician portrayed here as a high-powered physicist named Vela, against whom he takes literary revenge with a scathingly nasty if superficial portrait.

Following that line of speculation I would go further to suggest that the wry equanimity of tone that pervades his prose is a reflection of Bellow's contentment with his fifth and latest

wife—named Rosamund in *Ravelstein*—a bright but blandly angelic young woman less than half his age who, in the novel as in life, is devoted to taking care of him in his twilight years. It's as if Bellow, having survived into his mid-eighties with his stylistic and intellectual gifts intact, can't quite believe how lucky he is to be living his final chapters in such sweet company.

Roth, on the other hand, at 67 a generation younger than Bellow, shows no sign of mellowing with age. If anything, his fierce engagement with the issues of our time, and of all time—freedom, identity, justice, betrayal, hypocrisy, integrity, family—is more intense than ever in *The Human Stain.* The creator of the comic masterpiece *Portnoy's Complaint* has in recent years taken that manic energy and turned it toward the darker reaches of contemporary history for the sake of exploring, in maximalist terms, profoundly vexing questions: What is the nature of the human soul? Why must the good suffer? How do the most intelligent people still manage to deceive themselves? How does history inevitably invade and change our supposedly private lives? Roth's vision may be tragic, but the passion, anger, exasperation, wit and curiosity that fuel his sentences make this latest book, like the five that preceded it in the 1990s, yet another invigorating and consciousness-shaking performance.

In a recent interview, Roth cited Bellow's great 1953 novel *The Adventures of Augie March* as one of his early inspirational examples of "verbal freedom, imaginative freedom," a liberating model of the individual voice that every writer aspires to. In *The Human Stain* the theme of freedom, of creative individuality, also occupies a central place: Coleman Silk, a physically and intellectually gifted light-skinned black man, decides, like

so many Americans before him in fact and fiction, to reinvent himself. Having ruthlessly rejected his own mother, Silk sets out on the Nietzschean/Emersonian path to *become* what he is, and succeeds, only to be brought down, some 50 years on, by "the stranglehold of history that is one's own time." Like the ruined king in *Oedipus at Colonus*, Silk's dignity and heroism reside (as Zuckerman imagines it) in the *consciousness* of his conduct amid "the terrifyingly provisional nature of everything" that conspires to destroy him. Roth offers no catharsis, no resolution, no "closure," only a pained awareness of ambiguity and grief.

By inventing his own rather than accepting a received identity, Silk takes on a lifelong secret that is a private burden, but a burden that empowers him to move freely in a society otherwise closed to most individuals of his "group." In unraveling Silk's story Zuckerman/Roth reveals the slipperiness of fixed notions of identity and at the same time explores not only Silk's secret but the shadowy zones in the souls of his other main characters as well—especially Coleman's much younger lover, Faunia Farley, a supposedly illiterate, much-abused, long-suffering, hard-luck, tough-minded woman who, despite her dreadful life, forcefully rejects the role of victim.

In the probing portrayal of Faunia we see the dramatic difference between Roth's and Bellow's respective interest in women: where Bellow is content to describe from a bemused distance his female characters in *Ravelstein,* Roth in *The Human Stain* attempts to enter the minds of his—even the unsympathetic academic villain, Delphine Roux—and examine the workings of their psyches from their own point of view. Faunia is a complex and compelling character with a power

and wholeness one might not expect from an external description of her situation. Roth brings her alive in all her contradictory subjectivity.

The human stain is itself a resonant metaphor, first cited by Faunia in reference to a tamed crow. It alludes to the taint that people leave on everything they touch, and to the indelible marks of identity we bear despite our every effort to erase them, and to the imperfections of our messy lives that may have their roots in the biblical curse of the knowledge of good and evil, and finally to the incriminating spots on Monica Lewinsky's dress, "the smoking come" of a president whose human weakness and public persecution provide the atmospheric backdrop for the terrible tale of Coleman Silk.

As in his previous novel, *I Married a Communist*, Roth is indicting the moral corruption of a social order that, in its hypocritical piety, demands the ritual sacrifice of anyone who won't abide the tyranny of mass thought. He resists all ideology, struggling instead with human unknowableness—another kind of stain—the enduring mystery of who we are and what makes us act as we do. Roth is no optimist and is therefore long-shot Nobel Prize material: his work unsettles more than it uplifts. But like Bellow, who won that honor in 1976 and is the acknowledged dean of American letters, Roth is a monster among fiction writers who may in time cast an even longer shadow.

Nonprophets:
Roth and Dylan

[2004]

One morning a couple of years ago—to be historically accurate, it was April 1, 2002—while visiting New York City, I was walking up Broadway on the Upper West Side, just above 77th Street, when I noticed coming toward me along the sidewalk a tall man who was unmistakably Philip Roth. Such celebrity sightings are not all that uncommon in Manhattan—in the past I'd crossed paths with Woody Allen, Peter Jennings, the actress Julia Stiles and other identifiable cultural personages—but running into Roth seemed to me especially serendipitous, akin to my encounter with Henry Miller in Los Angeles in 1975 when his car pulled up next to mine at a stoplight and we exchanged a few friendly words before the light turned green.

Roth, by critical consensus the top American novelist alive, is a personal favorite of mine in spite of that. He's one of the few contemporaries whose mind is consistently interesting, his sentences ablaze with concentrated intelligence, his characters and ideas unsettling and compelling. Within the previous year I'd sent him clippings of two reviews I'd written of his books, and I also enclosed a copy of my poetry book *After Modigliani*

(2000) because the year after its appearance he published a novella called *The Dying Animal* which also had a Modigliani nude on the cover. So when I saw him and our eyes met I must have had such a dopey grin on my face that he walked right up to me, stopped, and shook my hand with a curious look as if to say, Where do I know you from?

I said, "You're Philip Roth." He nodded. "I wrote to you last year," I said.

"Did I answer?"

"No."

"I get so much mail."

I assured him I understood and remarked on the coincidence of our Modigliani cover art.

"Yes, that was strange." He sounded as if he remembered seeing my book.

"Not half as strange as meeting you on the street."

After a minute or two of talk, in which I felt the intensity of his focus, the power of his attention, he excused himself and ducked into a nearby pharmacy. My eyes followed him, and after standing there stunned for a few seconds (was this some kind of April Fool's joke?), I continued north on Broadway, soon enough regretting that I hadn't had the presence of mind to invite him out for a coffee and a more extended conversation. It was just six months or so since September 11, 2001, and I thought he might have some insight into what was going on, where history was headed, how politics was changing, what to expect. Of course in retrospect it's ridiculous to have imagined him to have any more of a clue than anyone else about the meaning of the historic nightmare then unfolding, but it's not uncommon to believe that great artists—precisely because they

do so in their work—can also articulate in ordinary talk their visionary understanding of the times.

Just look at what happened to Bob Dylan. In a few quick years, from the early to middle 1960s, Dylan went from being a scrappy little folksinger in obscure Greenwich Village coffeehouses to rock-and-roll messiah on the world stage just because he'd written and recorded a few dozen extraordinary songs. His keen ear for the folk tradition combined with an uncanny gift for memorable lyrics and a charged style of performance evolved into a musically irresistible series of albums that seemed to echo and magically transform the agitated energies in the atmosphere. Because of these musical accomplishments some people thought Dylan knew something they didn't. Like for example where "it" was *at*. Reading deep meanings into Bob Dylan's records—not to mention his cryptic utterances in published interviews—became an industry that, while it has faded a bit over the years, continues to this day.

According to his recent memoir, by the late sixties Dylan just wanted to be left in peace with his wife and kids, but obsessed fans cum stalkers made his private life impossible. The fame he'd sought as a young folkie turned out to be far more trouble than he'd bargained for. It took innumerable evasive maneuvers, several changes of style, a terrible divorce, a couple of religious conversions and a long artistic slump before he more or less evaded his legions of idolatrous pursuers. (More recently he's returned to the circuit better than ever, an itinerant legend with a remarkably tight band and an inexhaustible repertory making the rounds of venues large and small.)

Like Dylan's *Chronicles: Volume One*, Roth's new book, *The Plot Against America*, shot straight up the bestseller

charts soon after its October publication, with a huge boost from a blizzard of critical attention and literary-political buzz that has yet to abate. A counterhistorical fiction of large ambition and considerable nerve, Roth's novel dares to imagine an early-1940s United States taken over by the reactionary Republican administration of President Charles Lindbergh, who, except for the pilot's outfit, bears little resemblance to George W. Bush. For one thing, Lindbergh is an isolationist trying to keep the country *out of* foreign wars, not an evangelist for "peace and democracy" who goes around starting them; for another, his demonized minority is not Muslims but Jews, whose fate during that specific historical period is one of Roth's central concerns. But it is precisely this nonresemblance to actual events—or more accurately, an imagined or yearned-for resemblance—that has made the book such a sensation. Surely a great many readers hoped that Roth, whose portrayals of American life are nothing if not pungent, would have something revelatory to say about our current predicament.

Too bad. Roth himself has disclaimed any correlation between the historical fantasy of his *Plot* and the present crisis of American democracy. At most his book provides a retrospective faux-prophecy of a very different kind of right-wing government from the fictional one of his Lindbergh. It is in the intimate details of Roth's family portrait that *The Plot Against America* is most vivid and moving, in part because he uses his real family as his protagonists, narrating their terror from the point of view of little nine-year-old Philip. Terror—there's one parallel between the imagined then and the real now, a creeping dread of the next nauseating turn of events, events so unprecedented and scarcely comprehensible that children

and adults alike suffer a common feeling of disorientation and helplessness.

In 1969, around the time of his scandalous bestselling fourth book, *Portnoy's Complaint,* Roth famously remarked that contemporary American reality was far more incredible than anything a novelist could invent. The cultural turmoil of the moment was such that fiction writers couldn't keep up with actual events except by writing journalism. Norman Mailer's novelistic report of the 1967 March on the Pentagon, *The Armies of the Night*, was perhaps the most successful attempt to catch in prose the epic upheaval of that era. Roth's *Portnoy* operated on a more intimate level, exploring through one very neurotic narrator the sexual obsessiveness of the time. It is from the eccentric intimacy of this personal (though not necessarily autobiographical) story that the novel derives its great comic power.

As Dylan might have warned him, the fame that came with *Portnoy's Complaint* and its huge commercial success created large disturbances in the life of its author, disturbances Roth artfully converted to fiction in his 1981 novel *Zuckerman Unbound*, which chronicles the fallout of bestsellerdom and celebrity in the life of Roth's alter-author Nathan Zuckerman. (Editors at *The New York Times Book Review* wittily headlined its review of Dylan's memoir "Zimmerman Unbound," making a sly connection between these two middle-class Jewish boys who rose to the peaks of their respective professions.)

In several of Roth's novels of the 1990s—*Sabbath's Theater, American Pastoral, I Married a Communist* and *The Human Stain*—the big picture of US history is the background that informs but doesn't overshadow the specific dramas of particu-

lar individuals. *The Plot Against America*, on the other hand, in its newsreel exposition of large-scale fictional history, loses that close-up focus on its characters and thereby fails to sustain its persuasiveness. It's not that what's described couldn't have happened but that it didn't and we know it, and the author is never quite able to bring us completely into his alternate world. As a picture of the Newark neighborhood of his childhood, yes; but as an evocation of an America gone fascist, not quite. Even today's dire situation has not devolved into racist pogroms—though some Arab-Americans might dispute that—and besides, Roth's *Plot* has a happy ending: Lindbergh vanishes, Roosevelt is restored to the White House, the Allies go on to defeat Hitler, Philip grows up to become a famous writer.

Roth has called his novel a "false Memoir." Dylan calls his memoir *Chronicles*, but its five chapters (as in the Five Books of Moses) are wildly digressive in the richest sense and goofily erratic in the poorest—one senses, as so often with this artist, that he's taking the reader on a shaggy-dog hunt down a crooked trail crossed with countless red herrings. His eagerness to ditch his overbearing fans of the late sixties, which he describes rather sourly, is carried over into much of this book as he coyly avoids discussing whole decades and major episodes of his life and career. Presumably, various left-out parts will be taken up in future volumes.

Meanwhile what comes most completely alive in Volume One are the sections of the book—nearly half, as it turns out—that recollect his first winter in New York City. The kid is 19 or 20 and on fire with the fervor of folk music. In recounting his meetings with near-mythic figures of the downtown

music scene and beyond; his readings in the libraries of friends who let the homeless minstrel sleep on their spare couches; his listenings to the records in their collections; his breathless efforts to break through in the clubs and cafés of the Village; his appreciation of a great range of fellow performers from Harry Belafonte to Neil Sedaka; and most of all in his love for traditional American music of all kinds—in all these sketches and evocations and anecdotes Dylan conveys his passionate enthusiasm, then and now, for the wonders of a particular cultural tradition and of his own creative awakening.

Among the many fleeting and telling scenes he brings to life, perhaps my favorite is the young singer's meeting with Thelonious Monk one afternoon while the jazz giant is practicing in the Blue Note. "I...told him that I played folk music up the street. 'We all play folk music,' he said."

On the next-to-last page of these *Chronicles* Dylan lists a roster of heavy hitters from Minnesota—Roger Maris, who was just then breaking Babe Ruth's home run record; novelists Sinclair Lewis and Scott Fitzgerald; and aviator (and Philip Roth's imaginary president) Charles Lindbergh—noting his North Country kinship with these forerunners, each of whom, he writes, "would have understood what my inarticulate dreams were about. I felt like I was one of them or all of them put together." Home run king, satiric storyteller, romantic fabulist, solo flyer, Dylan sees aspects of his own aspirations and eventual accomplishments wherever he looks. If his memoir is evasive in its omission of great swaths of experience, it's faithful in its portrait of the artist as a force of nature on the make. The great irony is that when he catches up with fame—or it with him—it's so much more catastrophic than he expected.

The confluence of history with Dylan's emergence as a singer and songwriter accounts in part for his calamitous collision with stardom. His genius just happened to come into its own at a time when a war was ripping the country apart and social and political turbulence was in the air. He was perceived as leading a revolution because he caught in his music something of the moment's hallucinatory reality.

He also notes that, at the time, his favorite politician was Barry Goldwater because the Arizona senator reminded him of movie cowboy Tom Mix. Whether Dylan is putting us on or not is an open question (especially in light of his memorable lines "I'm liberal but to a degree, I want everyone to be free, but if you think I'll let Barry Goldwater move in next door or marry my daughter, you must think I'm crazy") but the truth, as revealed in this book, is that Bob Dylan is deeply conservative—in his profession of "family values," in his fascination with history, but most of all in his reverence for and active conservation and renewal of American musical traditions. He hears in the songs of the old folk, country, blues and jazz artists a reservoir of inexhaustible wisdom to which he pledges permanent allegiance. His fidelity to that commitment can be heard as clearly as ever in his latest work.

Roth too, in reaching back to his childhood and the small world of his family invaded by the shadows of war, is attempting to revive a lost time, a time before history intruded to wreck everything. Registering his disbelief at the terrible developments he's witnessing, young Philip's father asks: "How can this be happening in America? How can people like these be in charge of our country? If I didn't see it with my own eyes, I'd think I was having a hallucination." It's the kind of question

that feels eerily familiar in the aftermath of the 2004 election. But as Roth's narrator notes with the dismay of a child whose illusions of safety have been shattered, "Lindbergh's election couldn't have made clearer to me [that] the unfolding of the unforeseen was everything. Turned wrong way around, the relentless unforeseen was what we schoolchildren studied as 'History,' harmless history, where everything unexpected in its own time is chronicled on the page as inevitable. The terror of the unforeseen is what the science of history hides, turning a disaster into an epic." He should know; that's what he's doing in the art of his fiction. And as the unforeseen unfolds before us, we look in vain to writers like Roth—as I did on that April Fool's morning—to tell us what to expect.

The most dynamic chapter of Dylan's memoir is called "The Lost Land," invoking a time and an innocence he'll never know again, a time of optimism and discovery while President Kennedy was still alive and the civil rights movement was gaining momentum and Vietnam, much less Iraq, was not yet a household word. Roth's book recalls a lost paradise of familial security smashed by historical forces beyond anyone's control. In both cases the artist's only viable response to cataclysmic events is to retreat strategically into creative imagination and forge from the most traditional forms and materials—timeless songs, the historical (or antihistorical) novel—a voice of individual defiance, an artifact of human integrity, a record of hope in the ruins of the Republic.

Three Bad Dudes:
Jerome Washington,
Pete Hamill, Marlon Brando

[1994]

Memoirs can take many forms: reportage, confession, apology, self-justification, revenge, nostalgia, evasion or, most often, some combination of these. Nobody can be trusted to get the facts of their own life straight enough to tell the whole story in a truly credible manner, but various kinds of truths come across regardless of the veracity of the testimony. The natural inclination of most memoir writers is to put themselves in the best light, to make themselves look, if not good, then at least less bad than they may have been at the time. We are shown their version of events, and it's this very subjectivity that gives the stories their flavor and lends them a certain intimacy.

Marlon Brando, Jerome Washington and Pete Hamill come at the genre from radically distinct angles while sharing some common themes. Brando's *Brando* offers a breezy tour/performance of his life story in a very readable conversational style (thanks in part to his own way of speaking and in part to the skill of ghostwriter Robert Lindsey); Washington's *Iron House* records his account of 17 years of everyday life behind bars; and Hamill recounts in *A Drinking Life* what could be called

a portrait of the artist as a young drunk. All share a sensitive tough-guy persona and all have resided in a kind of prison: Brando the prison of fame, Washington the joint itself, and Hamill the psycho-physiological prison of alcoholism. All three books are gripping in their way, and all are tinged with deep shades of sadness.

Brando admits he became an actor not out of any deep artistic ambition but because it was the only thing he was naturally adept at besides playing practical jokes. The most interesting parts of his book, to me, are not the accounts of those jokes (though they're amusing) nor the reports of going to bed with Marilyn Monroe and countless lesser sex goddesses (though they're good gossip) but his reflections on the craft and art of acting, and on celebrity as a most undesirable way of life. He speaks frankly and un-self-righteously about his political activism, acknowledging his naïveté as well as his ideals; he explains the appeal of his Tahitian retreat, talks about his new-agey health experiments, his legendary promiscuity, his neglectful screwed-up parents, but he also confesses to being a con man and a manipulator so you can't be sure he's not just running a scam as he pours out his seemingly candid tale.

It's when discussing acting itself that you feel the truth of his voice and get a sense of the nature of his genius: Brando remembering how as a young stage actor he'd sit in a phone booth at Broadway and 42nd Street and study the faces of the passersby, "the way they carried their heads and swung their arms; I tried to absorb who they were—their history, their job, whether they were married, troubled or in love. The face is an extraordinarily subtle instrument; I believe it has 155 muscles in it. The interaction of those muscles can hide a great deal,

and people are always concealing emotions." This study of human expression combined with an intuitive access to his own emotions, developed into a technique under the tutelage of acting teacher Stella Adler, suggests at least part of the essence of his art.

Brando claims that the classic scene in the taxicab with Rod Steiger in *On the Waterfront* was improvised because he found the script implausible and asked director Elia Kazan if they could wing it. The result was his "I coulda been a contender" speech, a masterpiece of dramatic alchemy. Due to the daring inventiveness of his acting the film for a moment is more real than "real life." It's this uncanny ability to *be* the character, to inhabit the role from within, rather than just play it, that first set Brando apart from other actors. Certainly his great early performances—in *A Streetcar Named Desire*, *The Wild One* and *Waterfront*—radiate some primal quality that's partly sex appeal but much more besides: a *style* of acting previously unseen. Even much later, in *The Godfather*, Brando the movie star disappears into Vito Corleone the character.

The swamp of fame, which Brando likens to "muck," "manure" and "sewage," is for him an unfortunate by-product of his talent that he has to live with despite his contempt for the entire apparatus of celebrity. Hollywood, he says, is simply a place where he and others know how to make a living, "like a mill town in New England or an oil field in Texas." He laments that all his personal relations have been warped and falsified by his fame. Even strangers, especially strangers, compulsively fabricate myths about him and he's helpless to disillusion them. And the "carrion press" doesn't help any as it "resorts to inventing stories about you because it is part of a culture whose most

pressing moral imperative is that anything is acceptable if it makes money." Not that he's so different. "I'm not an innocent: I do things for money too. I've made stupid movies because I wanted the money. I'm writing this book for money…"

And so while *Brando* is compelling in its way because of the author's larger-than-life persona, it's mostly just another celebrity memoir, a highly selective backward glance whose main value is the light it sheds on its subject's professional claim to fame. Brando is honest enough to admit he's nothing more than an actor (albeit a singularly gifted one) and evasive enough to avoid any mention of his several wives or children—presumably the most intimate relations in his adult life—preferring to relate many lighter, less consequential encounters. For dirtier gossip the reader will have to go to Peter Manso's 1,000-page biography, also recently out. But if you want to hear Brando's voice in all its interestingly down-to-earth banality, his memoir is an easy enough read.

Whatever else you can say about Jerome Washington's *Iron House,* his narrative collage of prison life, an easy read it's not. The early pages feel especially oppressive, the sketches of various inmates—all colorful enough characters—and their purgatorial circumstances suffocatingly claustrophobic, soul-crushing in their hopeless mood of confinement. But as you continue reading you gradually feel the redemptive power of the writing, Washington's humane transcendence of his predicament through facing its hard reality with his eyes wide open. The writer rescues not just his own but his fellow prisoners' humanity, faithfully recording small ordinary incidents that reveal these bad guys as individuals and add up to a much

bigger picture. *Iron House* is both a convincing document of prison life and a work of personal transformation.

The narrator's voice is matter-of-fact, unsentimental, understated, almost impersonal. The grief and anger just beneath the surface are tempered by a wry perspective that enables him to see the awful yet often comic facts of life inside: "Cryin' Shame was the ugliest of the ugly sissies who pranced the prison yard. Razor scars from gut-bucket barroom fights lined his pockmarked face like strings on a gypsy's guitar, and when he grinned his snaggle-tooth mouth issued a breath as funky as ten-day-old mustard greens on a hot summer night. Cryin' Shame was so ugly, it was rumored, that when the judge sentenced him to life in prison, he was given an extra year for violating the Environmental Protection Act."

Washington's reportorial approach, rather than instructing the reader in how he or she is supposed to feel about what the writer's presenting, leaves us free to experience our own emotions. He isn't looking for a correct response but trying to convey in all their ambiguity the low-down truths of long-term incarceration. For all the book's implicit politics, it is refreshingly free of the political analysis or rhetoric of other works of its kind. Eldridge Cleaver's *Soul On Ice* and George Jackson's *Soledad Brother* come to mind as examples of powerful prison writing from a political or polemical standpoint that lack the subtlety of Washington's more experiential literary method. He dramatizes, to great effect, the commonplace interactions, the personalities, the power dynamics, the hustles and frustrations of just trying to get by. What emerges is not an overt argument (though the underlying themes of cruelty and injustice are unmistakable) but, as the subtitle says, *stories*, with all the

human complexity that word at its richest implies.

One of the most touching, and most personal, vignettes is the author's first-person account of a hospital stay during which he is permitted to eat a banana for the first time in years. His description of the banana and his reaction to it, its smell, its feel, its taste, his emotions as he eats it, is incredibly moving. Washington is a precise and perceptive writer with a musical, sensory style, and when (as in the banana episode) he exposes his own feelings as well as the look and feel of his surroundings he is extraordinarily persuasive. Wisely perhaps, he keeps this kind of open self-revelation contained, relying instead on "objective" observation to get his vision across. The humor, pathos, compassion, pity and terror are implicit. Inmates wheel and deal, jockey for status, fantasize, invent outside lives, plan escapes, fight, flirt, fuck, kill each other, kill themselves, or one way or another manage to endure their degradation. Washington dutifully records what he hears and sees, framing each fragment as carefully as a photographer.

Iron House is an indictment of a dehumanizing system, but it is also, and more originally, a testimony to the survival strategies of flawed humans driven to the bottom of society by both circumstances and their own bad choices. The author doesn't judge, nor does he glorify or romanticize his "characters," but presents them in all their quirky fallibility. He doesn't argue his own case, nor even reveal what he was in for, let alone make excuses or complain. He simply casts a cool eye and ear on a world he knows painfully well from the inside out.

As Washington observes once he returns to the public streets, people inhabit many kinds of prisons. One of the most insidi-

ous and destructive—that of alcohol abuse—is the subject of Pete Hamill's memoir. Hamill, a well-known columnist for the *New York Post* and author of several novels, explores in *A Drinking Life* not so much the details of his 20-odd-year career as a serious drinker but the family and social culture in which the seeds of his habit found fertile ground. The oldest son of a working-class Irish father whose own drinking largely created the atmosphere in which the boy grew up, Hamill lovingly recreates the Brooklyn environment of his 1940s childhood where his father toiled and drank, and his mother persevered, and the author spent his formative years on the street, observing and absorbing the theater of life before television (and later heroin) changed everything.

By far the most evocative parts of *A Drinking Life* are his detailed descriptions of his native neighborhood as seen through a small boy's eyes: a world both intimate and expansive, a universe contained in a few square blocks. In the saloon where his father is a regular, young Pete is introduced and eventually inducted into the male ritual of drink, along with its attendant loosening of inhibitions, big displays of emotion, bruising fistfights, bravado and humiliation. "Drinking was a part of being a man," he writes. "Drinking was an integral part of sexuality, easing entrance into its dark and mysterious treasure chambers. Drinking was the sacramental binder of friendships. Drinking was reward for work, the fuel of celebration, the consolation for death or defeat. Drinking gave me strength, confidence, ease, laughter; it made me believe that dreams really could come true."

Inevitably the booze-fueled dreams become the predictable alcoholic nightmares and after a couple of decades on the juice,

having wrecked one marriage and staggered through one too many revolting situations, the author calls it quits. It would be too simple to blame alcohol for Hamill's varieties of dislikable conduct—the mindless brawling and macho posturing, the various cruelties and dishonesties—but alcohol is inextricably interwoven with his relations with his father and therefore a major part of a larger pattern in which he grows increasingly lost. This is a coming-of-age tale, or more accurately a failure-to-grow-up tale, in which a smart and sensitive kid with the desire to be a cartoonist, maybe even a fine artist, discovers he lacks the talent or dedication and winds up (to his great good luck) as a reporter and eventually a journalistic celebrity who hobnobs with the stars and has an extended affair with Shirley MacLaine.

Riding the crest of success, aged 36 and guzzling to match his status as a minor media object, he looks at the scene around him and is suddenly disgusted by what he sees—and what he's become. He finishes his last drink one New Year's Eve and that's that. It seems like a smart decision, but it's hard to tell whether Hamill's more obnoxious traits—his violence, egotism, machismo—will be so easily eradicated. In any event, the "cure" of his affliction is only an incidental aspect of this book. It's really a resurrection of a lost time he looks back on with lyric nostalgia through the golden glow of a beer glass, a time when men were men and women were girls, and bad little Catholic boys could be forgiven their transgressions simply by confessing everything, as the grown ex-Catholic writer attempts to do.

Hamill's prose is lucid; he describes events with the clarity of a skilled reporter, bringing vividly to life his developing

awareness of the world. The remembered dialogue rings true, though obviously distilled in retrospect. But at key moments he pulls back, suppressing details that might reveal more of the shadows he barely acknowledges—crucial encounters, especially with women, that would, if honestly told, expose a much fuller truth about himself. Instead he summarizes ("There were tears and scenes. I behaved badly.") just when he could be opening up and examining exactly *how* he behaved. It is this avoidance of the most painful and perhaps humbling material that gives his book its sense of unplumbed depths. The recovered drinker in writing this confession appears to be in search of absolution, but in order to earn that inner peace he needs to go deeper into his darker side. Maybe this is impossible in a memoir. It might require fiction's more freely unconscious act of imagining.

Tough Guy Tells All:
Charles Bukowski

1 The Lover
(1979)

A reclusive aging poet faced with a little fame and the facts of his fear and loneliness discovers himself in demand among several lovers. In the course of embracing these women one after another, the writer finds fresh evidence of his humanity, his selfishness, his soulfulness and of course his human buffoonery.

The Buddhistic illumination—a radiant acceptance of the fool within—resulting from such worldly experience is, as far as I'm concerned, the true subject of Charles Bukowski's superb new novel, *Women*.

Women is an extraordinarily well-sustained narrative tracing the adventures of Bukowski's alter-author Henry Chinaski as he jumps for the charms of a series of females—each portrayed with an irreverent compassion which encompasses flesh and personality while sparing no one the cold-eyed clarity which cuts through to our common folly.

Chinaski's insensitivity and/or ignorance when it comes to

pleasing his erotic partner is equaled only by his fine ironic view of himself in the light of such dumb-blindness. Able to look at his own acts with the passionate detachment of a horse-player, Chinaski/Bukowski achieves remarkable insights by way of an extremely clean understated prose style consistently attuned to the telling detail:

"I took out my hanky and wiped my mouth. The hanky came away smeared with red. I was finally getting everything the boys in high school had gotten, the rich pretty well-dressed golden boys with their new automobiles, and me with my sloppy old clothes and broken down bicycle."

Each simple specific notation of the mundane is registered to reveal depths of humor and suggestiveness rarely reached by more literary novelists and unknown altogether to popular purveyors of escapism.

Beyond the "personal" aspect of Bukowski's unabashedly autobiographical odyssey, there's a consciousness at work in his writing that brings out his native cityscape—Los Angeles, land of the future—with a wonderful comic subtlety. Cars—particularly Chinaski's beloved 67 Volkswagen ("I would never kill a man who took my woman; I might kill a man who took my car.")—and airports provide Bukowski with limitless material for disemboweling the idiocy of the city person's dependence upon mechanical aids to communication, transport and survival.

The scene where Chinaski is lost in the wilds of Utah is a fantastic satirical treatment of back-to-the-land romanticism as well as a skewer through his own pretenses to toughness, stripped of his dear liquor stores and telephones and taxicabs.

The automobiles in this book take on preternatural powers

to affect Chinaski's psychic stability—just as cars do in many of our lives, although few "humanistic" writers are willing to face such facts. Bukowski is perfectly satisfied to portray himself as a jerk at the mercy of such machinery while dismissing any sense of victimization. He accepts his limits as a city man and establishes affectionate symbiotic relations with the devices that keep him alive while killing him.

One such device—and besides sex the major motif of *Women*—is alcohol. An unbelievable amount of drinking occurs in this book, yet it's never glorified as any kind of virtue or salvation. Rather, the bottle or beer can is clearly a crutch of a terrified individual up against a discouragingly absurd destiny. The lush is obviously responsible for his own pathos but Bukowski seems to imply that the alternatives—in terms of a more respectable literary or corporate or factory career and their respective automatisms—are even more dehumanizing.

By placing his fragment of faith in his relations with other equally desperate humans, and in his own ability to transform his sordid days through writing them down, Bukowski escapes the "artistic"/esthetic trap and breaks through to a level of understanding any intelligent parking lot attendant can appreciate.

The writing in *Women* is so lucid, so absolutely accessible, as to appear at first glance effortless—a linear account of a sequence of mere experiences. But any careful reading will disclose a style that could only have been arrived at across years and years of persistent discipline. The prolific imbalanced output of poems and stories Bukowski has poured forth over the last couple of decades has led, in *Women*, to a rich realization of straightforward fiction-making powers rarely achieved in current literature.

A man with few illusions left about himself, willing to spill his insecurities and trusts before a public which tends to grasp only the sensational or obscene aspects of his masks and his work, Bukowski continues his pitiless pursuit of truth through portrayal and exaggeration of his most intimate idiosyncrasies and those of the people whose paths intersect his.

Anyone with the courage to recognize him- or herself in this writer's terribly human characters may discover the satisfaction and release to be had at the hands of hardcore art—an art which refuses to fold in the face of an otherwise losing life.

"*Women:* I liked the colors of their clothing; the way they walked; the cruelty in some faces; now and then the almost pure beauty in another face, totally and enchantingly female. They had it over us; they planned much better and were better organized. While men were watching professional football or drinking beer or bowling, they, the women, were thinking about us, concentrating, studying, deciding—whether to accept us, discard us, exchange us, kill us or whether simply to leave us. In the end it hardly mattered; no matter what they did, we ended up lonely and insane."

2 The Son
(1982)

Since the mid-1960s, when his stories were appearing as newspaper columns in Los Angeles underground weeklies and his poems were turning up all over the country in hundreds of little magazines, Charles Bukowski has emerged as a highly respected if controversial presence in American letters. Despite the extensive critical ignorance of Bukowski's importance as a literary force, he has become a popular author on his own

power. Working in a disarmingly straightforward style, turning out thousands of pages of reportage on the daily doings and undoings of his life, Bukowski has tuned his language over the years into a remarkably tight and communicative instrument.

One of Bukowski's central themes is human violence, domestic and otherwise—a violence with roots in his own brutalized childhood. His pitilessly honest treatment of this reality has provoked hostile reactions from genteel and politically rigid sectors of the public. As a lifelong tough guy and terminal alcoholic, Bukowski's persona—both in his writings and live readings—has always had a calmly murderous assertiveness. Hecklers go crazy trying to shake his composure onstage. The "dirty old man" has known hell most of his life, however, so nothing fazes him. (Now that he's living comfortably off the sales of his books, he doesn't give readings anymore.)

Anyone who takes the trouble to read Bukowski closely can see that his persona is just that: a mask to cover his "big, soft baby's ass" of a heart. He is a soulful poet whose art is an ongoing testimony to perseverance. It's not the drinking and fucking and gambling and fighting and shitting that make his books valuable but the meticulous attention to the most mundane experience, the crusty compassion for his fellow losers, the implicit conviction that by frankly telling the unglamorous facts of hopelessness some stamina and courage can be cultivated.

Without trying to make himself look good, much less heroic, Bukowski writes with a nothing-to-lose truthfulness that sets him apart from most other "autobiographical" novelists and poets. Hemingway's romantic relationship with his own machismo looks strained compared to Bukowski's stoicism; Henry Miller's moralistic/philosophical attack on

social and literary conventions seems transcendentally naïve beside Bukowski's below-good-and-evil outlook. Firmly in the American tradition of the maverick, Bukowski writes with no apologies from the frayed edge of society, beyond or beneath respectability, revealing nasty and alarming underviews.

Civilization, as Bukowski knows it, is a lost cause; politics is an absurd charade; work is a cruel joke. People are basically undependable; most writers are insufferably pretentious. Drinking, listening to classical music, typing and playing the horses are somewhat helpful treatments for rampant misery.

This picture would be grim if it weren't for the humor and depth of his perception. "The problem was," he writes in his new novel *Ham on Rye*, a relentless account of coming up in the Depression, "you had to keep choosing between one evil and another, and no matter what you chose, they sliced a little bit more off you until there was nothing left. At the age of 25 most people were finished. A whole god-damned nation of assholes driving automobiles, eating, having babies, doing everything in the worst way possible, like voting for the presidential candidate who reminded them most of themselves."

While as a work of fiction *Ham on Rye* may not have quite the richness of character or sustained narrative drive of his 1978 masterpiece, *Women*, it's an essential document for understanding the origins of Bukowski/Chinaski's world view. "The first thing I remember is being under something"—an opening line with a resonance that won't quit because all his life (until his recent international acclaim) that's exactly where he's been.

Beaten repeatedly with a razor strop by a frustrated, usually unemployed father; stuck outside the social mainstream from

elementary school on; cursed with a bewilderingly atrocious case of boils as an adolescent, Henry Chinaski's incomprehension is limitless. Duking it out with his peers, fantasizing about unapproachable females, reading novels in the public library, Chinaski somehow makes it to 21 battered but still unbroken.

The fistfights that punctuate *Ham on Rye* (like Holden Caulfield's pathetic phone calls in *The Catcher in the Rye*, the echo of whose title I'm sure is no coincidence) are Henry's main means of communicating with his contemporaries. The kid's father is so inexpressibly brutal, so totally lost in his own pathological unhappiness, it's a miracle the child survives at all. Bukowski the writer has kept the child Chinaski alive and has grown old and wise enough by now, his bitterness drained away, not only to resurrect and absolve the pain of that formative period but to dedicate his book to "all the fathers."

A desperately miserable person tormented by his own mediocrity and taking it out on his son, Chinaski's old man must have plenty in common not only with other ordinary slobs who suffered through the Depression but with innumerable men today who find themselves "under something." By writing this terrible tale in a tone of understated but unmistakable mercy— a forgiveness of "all the fathers" who've lost control—Bukowski makes peace with his hateful forebear as well as with their common predicament: poverty, or at least poverty of spirit.

For all the sadness and sordidness of his story, Bukowski gives us a courageous account of a human heart keeping itself responsive against all odds. Without ever suggesting that he's "right" about anything, his clarity of vision, the clean evocative simplicity of his prose, his resilience in the face of fear and suffering all make him singularly readable and real compared to

numerous lesser authors of greater repute among the literati.

Hard to stomach as what he has to say may be, Bukowski is living proof of the healing and redemptive powers of art. His books are read, his style is imitated, his voice is listened to because he has something important to offer: it has to do with endurance. "Words weren't dull, words were things that could make your mind hum. If you read them and let yourself feel the magic, you could live without pain, with hope, no matter what happened to you."

Salinger's Masterpiece: Fifty Years of Silence

[2010]

Holden Caulfield is a sensitive, sympathetic young man, and *The Catcher in the Rye* is, according to critical consensus, among the more perfectly made works in American literature. When I read it, some 45 years ago, I was already out of high school but not what I'd call a mature reader, so while I could tell there was something different about this book—about the voice of the narrator and the author's use of language—I can't say I was all that captivated by it. I would probably appreciate it much more now as an extraordinary piece of writing, but as an 18- or 19-year-old aspiring poet I confess I didn't connect with Holden Caulfield.

Salinger's protagonist, with his New York City Upper East Side prep school neurotic insights into the difficulties of growing up, is akin to Woody Allen's later series of lovable *schlemiels*, put-upon whiners who speak for that part of us all. I don't care for that aspect of Woody Allen, and even at 18 I didn't especially relate to Holden's problems. If I'd read the book in high school, maybe it would have spoken to me more meaningfully, but I was so clueless at Holden's age that his

monologue would more likely have gone totally over my head.

The fictional characters I took to in those formative literary years were people like Joyce's Stephen Dedalus in *A Portrait of the Artist as a Young Man* and Thomas Wolfe's Eugene Gant in *Look Homeward, Angel* and Saul Bellow's Augie March and even Jack Kerouac's pill-popping pot-smoking beer-swilling bipolar Sal Paradise of *On the Road*—though I myself was a rather conservative lad still living with my parents in Beverly Hills. I wasn't really that interested in complaining about how "phony" adults were or how soulless high school had been. What inspired me were lyrical expressions of the romantic spirit and visions of adventure and travels in the magic of the English language.

Here, at the level of language, is where I remember Salinger speaking to me in a way that was compelling. In the talky American vernacular of Holden Caulfield's voice (the rough equivalent of a Valley Girl's today) and in the mysterious rhythms and stylistic precision of the author's other fictions, several of which I read in part out of curiosity about what made this writer such a subject of public interest, I could sense something slightly beyond my grasp as a reader but engaging nonetheless—a feeling there was something going on in Salinger's sentences beneath the surface of the narrative, some subterranean sensibility, an eccentric, interesting way of perceiving the world.

Critical response to the later books was mixed, and according to some recent commentators the author was so sensitive to negative criticism that he retreated permanently to his New Hampshire hideaway and was never heard from again. Apparently, according to several stories in the days following

his death, Salinger was no recluse but a regular presence in his small out-of-the-way community, using the public library, attending church suppers, shopping for groceries and generally enjoying the anonymity of the average citizen (whatever and whoever that might be). But his neighbors respected and protected his privacy, and he not only refused interviews and avoided photographers (like the West Coast writer to whom he is sometimes compared in this regard, the elusive Thomas Pynchon) but ceased completely to write for publication. This, to me, is the most fascinating thing about J. D. Salinger. Because however exceptional his fiction may be, his renunciation of a writing "career" is even farther off the charts.

Most writers, amateur or professional, fiction or nonfiction, published or unpublished, are motivated in part by the desire to communicate with others and to be recognized for their accomplishments. Surely Salinger too started out this way— why else would he have published all those stories in *The New Yorker?* And I would guess that he enjoyed the success of *The Catcher in the Rye* and the cultural prestige that came with it—at least for a while. But evidently fame, as so many accidental or incidental celebrities have learned, was more than the writer had bargained for; was in fact a major pain in the ass, and so, when the critical tide began turning against him, and his readers asked him to please repeat himself and give them more of what he'd done already, he decided he'd had enough and he disappeared.

Most writers don't have such strength of character. Most popular artists—with significant exceptions—are taken by the siren song of their fans' praise and strive to please those clamoring multitudes whose repeat business is paying their bills. Many

artists discover at some point that this is a losing game, that an adoring public can easily turn into one that devours its objects of adoration and revels in their destruction. The famous are craved for what they give us, the thrill of their talent, the beauty of their art, but when they fall the masses take perverse pleasure in the spectacle, reassured that the gifted and the brilliant and the lucky and the loved are punished for their achievement and are really no different from the rest of us. An exceptional artist, a popular artist, an artist who in some way enchants us, we often find a way, through the very intensity of our attention, to tear to pieces, as the maenads did to poor Orpheus.

Surely Salinger could see this coming. Philip Roth, in *Zuckerman Unbound*, the novel that chronicles in fictive form the repercussions in the author's life from the phenomenal success of *Portnoy's Complaint*, exposes the social ordeal and psychic cost of sudden fame. Bob Dylan, in the first volume of his *Chronicles*, tells of the incredible inconveniences and frightening invasions of privacy attendant to stardom. Both Roth and Dylan *wanted* to be famous and have somehow, despite the hassles of their renown, gone on heroically to evade their admirers and continue to create through the power of their own genius, setting their own artistic agenda and letting people take it or leave it. But not everyone has such inner resources. Perhaps Salinger felt that he couldn't withstand the insanity and absurdity and just plain stress of being a popular icon.

Think of Greta Garbo's retreat into quiet privacy. Or Marlon Brando's refusal of the role of movie star, trading his gorgeous young body and glamorous persona for the fat-armored carapace of an aging troglodyte. Even Arthur Rimbaud, who famously renounced poetry at age 19 (before he was ever

famous), had the good sense to die in Africa before he was 40 rather than stay around Paris to be treated as the cultural property of France and its intellectual elite.

The strange thing about Salinger, as far as we know, is that he continued writing but refused to publish. He is said to have explained that, having abandoned the marketplace, he wrote for his own pleasure. If readers were eager to see what he would do next as a writer, too bad for them. Able to live comfortably thanks to the royalties from *Catcher*, he cut himself off from the life now aspired to by most contemporary writers: the life of public appearances, book signings, interviews, jacket photos, award ceremonies, publishing deals, appreciative readers, star-struck fans, movie deals, audio books, video books, Internet books, literary festivals, creative-writing programs, writers' conferences, writerly rivalries—everything but writing—all the excitements of the public stage. Like other wounded yet tough-minded creators (Emily Dickinson, Robinson Jeffers), he declined to be an entertainer and went his own way into a welcoming and welcome obscurity.

When Salinger died in January, I was struck by the extent of the coverage, as if all the pent-up curiosity about him had suddenly been released in an orgy of overdue celebrity-lust. National Public Radio's flagship program, *All Things Considered*, made his death the top story on their 5 o'clock newscast and devoted a whole 15-minute segment to the author and his work and people's memory of and commentary on them. I can't think of any other writer in my lifetime—not Norman Mailer, not Saul Bellow, not John Updike (I wasn't paying attention to such things in 1961 when Hemingway blew his brains out)—whose death provoked such a media frenzy.

Of course it was mostly *The Catcher in the Rye* that everyone rushed to remember, how that book had been a milestone in their lives or at least in their reading experience. But does anyone really believe that such a fuss would have been made over the author's death if he had continued to publish for the last 50 years? Would the mystique of his genius have been enhanced or diminished by a series of variously acclaimed, variously popular books? Or would he, like so many other big-name writers—even the best of them—have simply become part of our cultural landscape or ambient media noise like, say, Joyce Carol Oates, to be acknowledged, even praised and celebrated and awarded, but not seen as any sort of extraordinary character?

Silence, it turns out, was Salinger's most brilliant career move and most interesting creation. However exquisitely written his books may be, there are other comparable accomplishments in American literature that never received this kind of attention. Whatever may turn up in his unpublished papers—and I'm certain the predators of the literary-industrial complex are on the hunt for anything they can find and market—Salinger succeeded, through his very invisibility, in making himself an almost monumental literary figure. Offered the job of professional author, Salinger, like Melville's Bartleby the Scrivener, preferred not to, maintaining an integrity of reticence that's hard for most of us to comprehend. And that, I would argue, more than anything he wrote, is what made his death such a big deal.

Beyond Good and Evil:
Thomas Keneally

[1993]

Thanks to Steven Spielberg's smash-hit Hollywoodization of the Holocaust, you probably know by now that Oskar Schindler was an opportunistic German entrepreneur who saved some 1,300 people from extermination in the Nazi death camps by employing them in his factory in Poland during the Second World War. Spielberg's movie is based on a book by Australian writer Thomas Keneally originally published in 1982 and now resurrected as a trade paperback. Using the traditional techniques of fiction to tell this extraordinary story, Keneally calls his book a novel, but it's a novel in name only. Based on extensive interviews with 50 "Schindler Jews" now living in seven countries, it is a documentary narrative that attempts to recreate as faithfully as possible the actual events that transformed a rather unsavory if charismatic character into some kind of secular savior.

Oskar Schindler, what a guy. Drinking, gambling, wenching, wheeling and dealing during the Nazis' rise to power; moving in for the financial kill in the wake of the German blitzkrieg into Poland in September 1939; setting up business with Jewish

slave labor; working the black market for all its worth. Bribing his way into the hateful hearts of occupying-army officials, he positions himself to clean up as the Third Reich is goosestepping its way across Europe slaughtering everything—especially anything Jewish—that happens to be in its way. A basically apolitical operator with libertarian instincts, Schindler at first doesn't think too much about the incipient genocide he's witnessing, but apparently his conscience isn't compromised by the excesses of his decadent lifestyle. At some point he simply cannot ignore the surrounding horror, and that's when he turns his considerable talents to undermining the system he's trying to exploit. Within months of his arrival in Cracow to set up shop—as the Jewish population is humiliated, rounded up, shipped off to certain death or murdered in the streets—Schindler begins his private campaign to shelter as many Polish Jews as he can find use for in his enamelware factory. Most of these people make it through the war.

The tales of these individuals, woven through the book, are good stories in themselves: rabbis who turn themselves into metalworkers, children who cannily negotiate their way through unimaginable ordeals, women who outwit the Gestapo by assuming false identities, all the terrible life-or-death encounters with power-drunk Nazi punks. The survivors' multiple perspectives lend Schindler's saga personal dimensions. It is through their eyes that we see their protector grow increasingly larger-than-life with his astounding knack for getting what he wants out of the system. Anybody who can't be bribed can't be trusted, he must believe, as he ingratiates himself to military bureaucrats through a combination of charm, cash, cognac, cigarettes, sausage, housewares and a wealth of

other black-market merchandise the conquering heroes can't get enough of.

Schindler's contempt for the people he's manipulating—the borderline-psychopath commandant Amon Goeth and the various big and little shots of the Reich hierarchy—is just one intriguing aspect of his complex personality. Faithless in his marriage and in his original Catholic religion, dissolute in his habits yet physically able to endure them with a seemingly indestructible constitution, an amoral sensualist with an almost endearing innocence about his licentiousness, Schindler, when the really ugly shit hits the fan, experiences an ethical awakening. Far from changing his ways, he cultivates them to great effect for the newfound purpose of keeping his workers alive.

I was hoping that the book, unlike the movie, would reveal much more of this inner transformation, get inside the character Schindler and use the novelist's intuitive understanding to show who he really is. Yet while we get a vivid picture of Schindler's impressive deeds, we never quite penetrate his deeper self; he remains an enigma. As with some great actors, great salesmen and great hustlers, the performance is everything; maybe there's not that much behind the mask.

So as a character Schindler is interesting in part because he's such a plausible mixture of strengths and weaknesses, not purely "good" by any conventional measure, effectively opposing evil because he's a little evil himself—wicked may be a more accurate word—fiendishly clever, daring, inventive, ruthless as well as compassionate. If he seems heroic, as in Spielberg's feel-good version, that notion is undercut in the aftermath of the war as he fails at one business after another and comes to depend on the generosity of the previously

victimized prisoners whose lives he saved, many of whom have grown prosperous in the meantime. By the time he dies in 1974 Schindler is a rather pathetic figure, and this too adds to his humanity. His great moral deed is not rewarded materially; in the relative normalcy of postwar commerce he can't quite get it together. Which leads us to suspect that without the crisis of the Final Solution the man might never have realized his potential as "a just Goy." He may not even have been a successful capitalist.

By the end of Keneally's novel the compound ironies and tragedies of the story are impossible to escape. Most interesting to me is how the most atrocious historic events can turn otherwise unremarkable individuals into heroes through no intention of their own. Schindler the cynical profiteer accidentally backs into a noble destiny. It's so diabolically ironic that it could almost make a nonreligious person believe in some sick-humored God—the kind of God who could allow a Holocaust.

While lacking the first-person immediacy of other eyewitness testimonies—the books of Anne Frank, Elie Wiesel, Primo Levi, Etty Hillesum, Viktor Frankl, Tadeusz Borowski, Jerzy Kosinski and others—*Schindler's List* is one more vital fragment in the historic mosaic whose original builders are gradually disappearing. Every such account, including those of the survivors in Keneally's book, is a deathless testament to human depravity and endurance.

Nietzsche's Headshrinker:
Irvin Yalom

Poor Nietzsche. The guy gets a pretty bad rap. If people aren't blaming him for the rise of nihilism or holding him responsible for the Nazis, they're quoting out of context little morsels from his multifarious writings in order to make some simpleminded point. Precisely because his work is not reducible to thought-bites—which isn't to say it is without its wealth of memorable one-liners—Nietzsche is a contradictory, funny, combative, out-rageous, wildly original, inexhaustible thinker. And that's why his work is so endlessly usable by anyone with whatever ax to grind. Like the Bible, Shakespeare, Walt Whitman, Bob Dylan, *et al.*, you can make him say pretty much anything you want.

That hasn't stopped scholars from trying to unriddle the "real" Nietzsche nor artists from attempting to divine his psyche. One of the latest to weigh in is Irvin Yalom, a Stanford psychiatrist whose 1992 novel, *When Nietzsche Wept*, is recently out in paperback. Yalom may be remembered by some as the bestselling author of *Love's Executioner*, nonfiction tales of his practice as a shrink. He's a proponent of what he calls existen-tial psychotherapy, which begins from the premise "that death

will come, and that from it there is no escape," and therefore individuals are fundamentally alone facing an existence that may be meaningless. What redeems this seemingly bleak vision is freedom: human beings are free "to make our lives as we will."

Nietzsche's famous and much-abused phrase "the will to power" refers to this kind of will: the will to change, the power to create yourself, to "become who you are." Yalom acknowledges the master several times in *Love's Executioner*, but in the novel he indulges his imagination and invents a fictive Nietzsche (grounded in known facts) whose multiple physical ailments and migraine headaches drive him to seek medical treatment from Dr. Josef Breuer, preeminent Vienna physician and mentor to upstart med student Sigmund Freud. Yalom has turned to fiction for an artistic synthesis of the themes in his earlier work on the existential dynamics of psychotherapy. He engages in the intriguing historical speculation of what might have happened had Breuer and Nietzsche met and together invented psychoanalysis. At the same time—and this may be what makes *When Nietzsche Wept* such compelling reading— Yalom appears to be wrestling with his own soul.

The story is set in motion by Lou Salomé, legendary muse/ friend/sidekick to Nietzsche, Rilke, Freud and other turn-of-the-century dead-white-European-males of note. Salomé boldly arranges with Breuer for Nietzsche's treatment, unbeknownst to the patient. What follows is an encounter between two *serious* high-powered middle-aged men—giants of their times brought low, we learn, by their obsessive desire for beautiful young women—men on the verge of a nervous breakdown. Yalom explores their respective obsessions, their angst, their midlife crises, their ideas and their efforts to heal each other

through conversation and, ultimately, friendship.

While Nietzsche gets top billing as the world-historical superstar of the tale, it is Breuer who is the more engrossing character. Yalom has evidently put a lot of himself into the Viennese doctor, so that while it may be a stretch to call the character autobiographical, one reason Breuer is so humanly convincing is that the author has penetrated the facade of his (Breuer's/Yalom's?) worldly success to reveal a person riddled with doubts and second thoughts and what-ifs, a man burdened by hollow achievements and haunted by despair. Ironically it is the arrival of his overwrought, aphorism-spouting patient that triggers Breuer's crisis: it takes an individual of Nietzsche's gravity to plumb the doctor's psyche, to provoke its collapse in order to help it recover.

Yalom develops the two men's relationship slowly, subtly yet inexorably, until their respective roles as healer and patient are reversed. It is a Nietzschean twist on the myths of his own profession, where traditionally the therapist/priest is the authority figure loftily dispensing insight for the benefit of the neurotic. By proposing that this hierarchical dynamic be replaced by an interpenetrating dialogue of peers, the author stands conventional wisdom on its head—much as Nietzsche scrambled the assumptions of European philosophy by arguing for a "transvaluation of all values." Intellectual honesty demands the recognition that social structures and received understandings (including those of the psychotherapeutic relationship) are often arbitrary obstacles to individual insight and self-realization, and that real creators must demolish such false understandings if they are ever to arrive at anything approaching truth.

One psychological truth that Yalom unearths is how pro-

foundly some men are bamboozled by their vulnerability to female beauty. In the case of both Nietzsche and Breuer, a primary source of anguish is the unfulfilled fantasy each entertains of possessing, sexually and spiritually, a particularly powerful and handsome woman approximately half his age. Idealizing this unattainable creature, projecting all sorts of misplaced emotions onto the object of desire, each drives himself to distraction and beyond with a volatile combination of longing, jealousy, remorse, self-pity and vanity. One of Yalom's notable accomplishments in this double portrait of tormented men is his ability to make them both sympathetic in their respective dreams and delusions. The reader may recognize the foolishness of their fixations, yet the characters feel so poignantly real that she may grasp the agony of their plight even if she doesn't share their hang-ups.

For anyone who's ever done psychotherapy, or engaged in intensive talks with a friend to try to resolve some crisis, *When Nietzsche Wept* is an inspiration because it suggests that if you're willing to confront with courage and honesty your deepest weaknesses and self-deceptions you may actually take control of your own life. In the novel Nietzsche isn't exactly "cured," but he achieves a catharsis that enables him to carry on with his work. Breuer the bourgeois doctor and pillar of allegedly sane society feels the bottom fall out of his own shaky foundation and realizes finally that he too can proceed to create the destiny he's chosen.

Author Yalom, by splitting himself into these two imaginary minds and letting them go at it, has not only tackled some life-and-death ideas but in the process obliquely exposed a few of his own worst fears and foibles. He's also told a hell of a good story.

Never Believe What You Think:
Carlos Fuentes

[1994]

The hottest-selling condom in Mexico at the moment, Carlos Fuentes was saying the other night over a plate of ravioli, has on its package the image of Zapatista rebel leader *Subcomandante* Marcos, the wisecracking guerrilla who since the Chiapas New Year's rebellion has become a national folk hero. The condom is called *El Levantamiento*—The Uprising.

Fuentes was in Santa Cruz for Viva Zapata 3, a festival of Latino culture sponsored by the El Andar Foundation, a nonprofit outgrowth of Santa Cruz County's bilingual monthly *El Andar*. It was a cultural coup for the paper, now five years old, to bring an international intellectual celebrity of his stature to town as the keynote speaker for its annual celebration of *Indio*-Afro-Hispanic identity. Here was Fuentes, one of the big boppers of world literature, award-winning novelist, essayist, historian, diplomat and human rights activist, having dinner with four of the event's organizers—*El Andar* publisher Jorge Chino, festival coordinator David Bone, Cabrillo College teacher Laura Kliewer, art restorer and designated driver Alejandro Reyes—and me, recruited as a nonviolent bodyguard. Enjoying

the attention despite the fatigue of a jet-lagged day of transcontinental travel, our guest was riffing in Spanish and English on various profound and gossipy topics, much to the delight of his hosts. This was the first phase of a fast-paced 30 hours during which he was scheduled for five public appearances.

The condom comment was one of several private asides that seemed to me as illuminating as any of his weightier remarks to the press and public. In his pundit capacity Fuentes praised the Chiapas uprising as a democratic revolution by people demanding the right to elect their own leaders. The Zapatistas, he said more than once, have awakened Mexico from its sense of self-congratulation, galvanized the country's consciousness and thrown into relief the contradictions of its one-party so-called democracy. The assassination in March of Institutional Revolutionary Party (PRI) presidential candidate Luis Donaldo Colosio, a reformer who appeared to be moving the ruling party in a more democratic direction, has plunged the country's politics into even deeper turmoil and confusion. If the August elections aren't clean, he warned, more violence could erupt. As things stand, according to Fuentes, the current candidates are so uninspiring as to be "almost an invitation to abstention."

In the car between engagements Fuentes noted that the Colosio assassination was clearly a conspiracy, but as yet nobody can say for sure by whom. It's a murky time in Mexico, he said, probably the most uncertain moment since the Revolution of the 1910s. As the country joins the world economy by way of NAFTA (which Fuentes favored) and becomes more and more intimately related with the United States via transborder migration and the increasing intercourse of the two

hybrid cultures, this scholar of history doesn't claim to have a clue as to what may be about to happen.

One thing Fuentes did seem certain of, which he stressed again and again in different ways, is that the world's accelerating multiculturalism "is a process of inclusion, never exclusion," and that cultures do not exist in isolation—least of all those of the Americas. Though California senators Barbara Boxer and Dianne Feinstein are calling for "a new Berlin Wall" at the border, US–Mexican intimacy is an accomplished fact that goes back to the days when what is now California was Spanish territory. "We are all the result of a fusion of cultures"—indigenous, European, African, Asian—"and that is the health of any society."

Brimming with charisma, energy and enthusiasm, Fuentes was at his best, I felt, in his encounter at Cabrillo College with about 40 bilingual writing students and teachers. With extemporaneous eloquence and passionate conviction he invoked the power of the literary imagination as a translator of reality. He said the greatest hoax of the information age is the idea that people are well informed: "We are swamped by pseudo-information, ersatz trash" masquerading as knowledge. Any library, he reminded his rapt audience, has more than 500 channels. He expounded on the life-enriching value of reading and the tremendous creative potential of youth, which makes up in passion what it lacks in experience. "If I had the passion of when I was 17 combined with what I know now, Shakespeare would be my..." he searched for the word... *"busboy."*

I'll take Fuentes and some of his friends over the Big Shake any day. The "Boom" generation of Latin American writers who came to prominence in the 1960s—Jorge Luis Borges,

Alejo Capentier, Julio Cortázar, Gabriel García Márquez, Mario Vargas Llosa, Fuentes and a few others—liberated their literature from preexisting notions of the novel. The experimental inventiveness of these writers has not kept their work from being read and relished by vast numbers of people in the Spanish-speaking world and well beyond. Their books have been both intellectually challenging and immensely popular—even on the streets of Santa Cruz strangers stopped to salute the famous author—and as citizens the artists have been activists.

Ten years ago, when news of the much-beloved Cortázar's death reached him, Fuentes telephoned García Márquez to commiserate over the loss of their friend. "It's not true," García Márquez angrily retorted, "Cortázar is alive. Don't believe everything you read!" Fuentes used this anecdote to illustrate how deeply doubt informs the greatest imaginations. "Doubt and imagination go together," he told the student writers. "Never believe what you think."

That night at the Civic Auditorium, when he lectured at length to a crowd of 2,000 on the cycles of Mexican history and their continuity with current US-Mexico relations, I doubted this was the real story Fuentes had to tell. Deeper and truer may be the inexplicable mixture of history, legend, myth, psychology, poetry, politics, social satire, linguistic daring, transcultural consciousness and consummate fabulation in his novels.

Marriage of True Minds: Page and Eloise Smith

[1995]

"I've always felt that any real education should be related to the real life of the community, of the outside," Page Smith was saying, "and in retrospect it would seem to me that if we were going to start the campus again the way to do it would have been to find empty buildings and structures in the city and the county that we could inhabit and that way we'd be from the very beginning right in the middle of things."

Smith was the ideal interview subject, I learned in that first meeting in 1980. All you had to do was ask him a question and he would unroll an eloquent response in waves of rhythmic sentences you thought he might never find his way out of yet which somehow always came back around to a lucid resolution. Relaxed in denim overalls and laceless shoes next to the woodstove in the vaulted barn of his library, Smith spoke that morning of "passionate rational speech" and its decline in American life since the nation was "talked into existence" by its founders in the Age of Enlightenment.

It's a cliché, when a prominent person dies, to speak of the end of an era, but no one else in the last 30 years better rep-

resented the highest ideals of Santa Cruz's civic and intellectual life than Page Smith. Practically the inventor of the UCSC campus, serving as provost of Cowell College under Chancellor Dean McHenry from 1965 to 1970, Smith was never able to achieve the full integration of the city on the hill with the city in town that he originally envisioned, but in living his idea of passionate rational speech, in teaching both professionally and informally on and off campus, in encouraging conversation wherever he was, he remained very much in the middle of things. Despite the frustration he felt with the institutional obstacles that had thwarted his utopian ambitions for UCSC, he succeeded brilliantly, in partnership with his artist wife Eloise Pickard, in making his life a consummate creative act.

Friend and fellow academic renegade Norman O. Brown compares Eloise and Page to Baucis and Philemon, the kindly old couple in Greek and Roman mythology who for their goodness were blessed by the gods to die at the same time, becoming trees whose branches intertwined. "He was always very beautiful about his wife," says Brown, "and they were always very beautiful together."

Only to a thinker of Brown's transworld erudition would it also occur to compare Page Smith with Jerry Garcia, but both embodied in their lives and work a sixties-vintage ideal of joyful community and universal enlightenment which, quaint as it may seem in the jaded nineties, never stopped reaching deeply into other people's lives. As longtime friend and colleague Mary Holmes observes of Smith, "Anybody who talked to him couldn't help but be affected by him."

What was it about Page Smith that made him such an imposing yet congenial presence? He had an unusual

combination of authority and humility that charmed rather than intimidated. He was a great listener as well as a vigorous speaker, physically large and powerful (he'd been a wrestler in college) yet gentle, a man sure enough of himself and his ideas that he welcomed opposition. "He enjoyed a fight," says Brown. And fellow historian and former student John Dizikes remembers, "He was always interested in the other side."

Maybe that's because Smith himself was a many-sided person. He railed against the publish-or-perish imperative, claiming that "research" and publishing bore no relation to teaching, yet he himself was a prodigious scholar and prolific author of books. "He always wrote about things he cared about," says Holmes, and this personal involvement with his material gave it a feeling of urgency, of necessity, of inevitability. Dizikes recalls Smith telling him, when the younger professor felt uninspired by the prevailing conventions of intellectual discourse, "Write about what you love."

Love, according to all accounts, is what informed the totality of his being. Former colleague J. Herman Blake recounts a recent telephone conversation when Smith was telling him of Eloise's illness: "He was sobbing as we spoke," says Blake. Mary Holmes explains simply, "He was a whole person, a complete person, a man of intellect, a man of passion. His love for Eloise was one of the big things in his life." The Smiths' 53-year marriage could hardly have been more exemplary, a model of mutual respect and support and devotion, each of them highly accomplished and successful in their respective professions yet also attentive to their children and grandchildren, active in their community, crusading for their convictions in the world at large—Page for humane social values and liberal

education, Eloise for the role of art in saving people's lives, taking her creative campaign into California prisons. Page helped establish projects for the homeless in Santa Cruz. They were both gracious hosts in their Bonny Doon home, Eloise famed for her gourmet cooking and flair for interior design, and Page for his affably rangy conversation.

The key to his genius as a historian may have been his natural gift as a storyteller. Smith often spoke of history as "tragic drama," and in his monumental eight-volume narrative *A People's History of the United States* he painted in epic strokes a panoramic mural of the nation's chaotic development, finding a kind of symphonic order in the seething masses of detail he had unearthed in the humblest places, mining the diaries and letters of unknown citizens to construct a personalized ground-level view of the action while never losing sight of the big picture. He disdained the academic tendency toward specialization, remaining a generalist who could write as easily and with as much engagement about the lives of chickens as about the political intrigues among the founders of the Republic.

A great man who was also a good guy, Smith was totally approachable. I remember seeing him downtown throughout the seventies, sitting on a bench on the Mall or standing in front of the Cooper House on a sunny afternoon engaged in lively dialogue with one person or another, often as not a good-looking younger woman. When he resigned his position at the university as a matter of principle in protest over the denial of tenure to his friend, philosopher Paul Lee, he and Lee and Holmes proceeded to found the Penny University in a downtown café, an open forum for discussion of big ideas that has continued every Monday afternoon for 21 years.

And from outside the university he continued to wage a war of words against the reigning assumptions of academia, going so far in his 1990 book *Killing the Spirit* as to question the ideological wisdom of women's studies programs, a critique that earned him no affection among academic feminists despite his earlier pathbreaking work on women in US history, *Daughters of the Promised Land*. No simpleminded espouser of received or trendy acceptable ideas, Smith had the courage and independence to say what he thought and let the brickbats fall where they might. *Democracy on Trial*, his recently published study of the internment of Japanese-Americans during World War II, dares to suggest that in the context of that historical moment there may have been some justification for American paranoia about internal security. For a certified liberal even to raise this issue was an astonishing act of intellectual nerve, and one that could be pulled off only by a scholar of rock-solid self-confidence.

This sense of confidence and determination, when he was still inside the university, was at times seen by some of his colleagues as "obstinacy, stubbornness, intransigence," says Dizikes. According to Holmes, "He never wavered in anything," he was a natural leader who "always had the power to make people feel that he could be responsible." Like one of his heroes, William James, he believed in belief, his own or others', and respected principled argument even when he rejected it. And despite his aristocratic origins as the son of a prominent East Coast colonial family, "he liked the goofiness, the openness of California," notes Dizikes, who first met Smith in 1955 as a student in his class at UCLA. "He liked the bizarre, he felt at home in the sixties" with its atmosphere of rampant experimentation.

The Smiths, says Holmes, practiced an ecumenical Christian charity with no trace of pretentiousness. "Eloise condemned pretention," and Page always had "the kindest interpretation of human action," generously forgiving people's follies and flaws. Perhaps this generosity of spirit flowed from the wholeness of his own experience, the seamless integration of diverse elements—writing and raising animals, family and social activism, political conviction and personal compassion, physical vitality and intellectual energy, pleasure and duty, passion and reason—which, combined with the powerful love alliance with Eloise, gave him an expansive sense of serenity.

"His personal flare," declares Nobby Brown, "will be written across the sky." For however prominent he was in public life, as much as he championed collective action and community, as hard as he fought to reform education at the institutional level, it will be finally as an inspired and inspiring individual that Page Smith is remembered by those who knew him. His life, right down to the last day, leaving this world in concert with the death of his true love, was a masterpiece of personal history, a story lived with the grace of the greatest art.

California Realist:
James D. Houston

[2009]

One afternoon about 30 years ago I was browsing in Logos, the great used-book store in Santa Cruz, when I bumped into novelist James D. Houston. Houston, known as Jim to friends and acquaintances, was easily the best-known writer in town, and had been since my arrival in 1968 to attend graduate school at UCSC. At that time he had already published a couple of novels and was placing stories in big-time national magazines like *Playboy*; he was, in his mid-30s, a model for aspiring younger writers like me who had dreams of one day being authentic authors with books of our own. By the time of our encounter in Logos, Jim had several more titles to his credit, both fiction and nonfiction, and as we exchanged greetings and inquired about each other's latest projects, he cheerfully reported that he'd just turned in a manuscript to his publisher.

I don't recall exactly how the conversation came around to the protocol of working with editors, but on that topic Houston told me he always included a number of minor errors in his manuscript so the editor would feel that he had something useful to do—and would be distracted from more meddlesome

and substantive changes to the author's prose style.

When Jim Houston died, at 75, in April, I thought of this anecdote as emblematic of his consummate professionalism, from his meticulous attention to every sentence in his writing to his feeling for the subtleties of the publishing business. He was a working writer, consistently attuned to the art, the craft and the business of his profession, moving easily from fiction to nonfiction and back, steadily dreaming up new projects and completing them, all the while staying true to his personal vision of his job as a chronicler of the life and culture and history of his native region of the Pacific Coast, and of the Pacific Rim. His intimate knowledge and cultivated study of all things Californian, especially Central and Northern Californian; his literate immersion in the surfing, historical and musical universes of his beloved Hawaii; and his difficult but ultimately liberating investigation, with his wife, Jeanne Wakatsuki Houston, of her family's experience in a Japanese-American internment camp during World War II, in their co-authored book, *Farewell to Manzanar*, all add up to a body of work with regional roots but national and international reach.

Santa Cruz poet Morton Marcus, Houston's close friend since their days together in the early 1960s as graduate students at Stanford, told me that back then, at the start of their writing careers, he and Jim would have intense and endless conversations about what they were reading, and that Nathanael West's short 1939 novel *The Day of the Locust* struck Houston "like a bolt of lightning." West's caustic take on Hollywood is one of the earliest classic California narratives, and Houston was evidently captivated by its cultural and regional specificity. It took him several years to sort it out, but by his

third novel, *A Native Son of the Golden West*, Houston had found his subject, and in subsequent books like *Continental Drift, Gasoline, Love Life, The Last Paradise, Snow Mountain Passage, Bird of Another Heaven*, and such nonfiction works as *Californians: Searching for the Golden State, In the Ring of Fire: A Pacific Basin Journey*, and *Hawaiian Son: The Life and Music of Eddie Kamae*, he ceaselessly explored the subtleties and intricacies of what it meant to be rooted in such a watery and geologically volatile yet gorgeous and seductive realm.

His last book, *Where Light Takes Its Color from the Sea*, a gathering of essays and short fiction written over the last 45 years, is a fitting coda to his career and a good introduction for those unfamiliar with his work. In this volume, published last year by Berkeley's Heyday Books, the reader will find examples of Houston's journalistic skills, his fine eye as a portraitist, his ear for many styles of vernacular speech, his strength as a descriptive writer, flights of lyricism, wry wit, grounded spirituality and deep understanding of the California ethos. He reaches back to his Scottish and North Carolinian ancestors, and to his father's migration from Texas to San Francisco (where Jim was born), to show how even the most Western of writers in his case is connected by blood and history to far-flung parts of the planet. Add to this his half-century-long marriage to Jeanne, whose parents were Japanese immigrants, and their three multicultural California kids, and you have a picture of the worldly scope that informed Houston's grasp of the local.

Another 1939 California classic, John Steinbeck's *The Grapes of Wrath*, as well as other Steinbeck books set in the Salinas Valley and Monterey, provided a model for Houston's

blend of reportorial and imaginative narratives of the West. Steinbeck, along with Robinson Jeffers, Wallace Stegner, Jaime de Angulo and William Everson, are all cited by Houston as setting the standards of regional insight and artistry he sought to emulate.

Yet even the success of *Manzanar*, and the internationalization of his and Jeanne's fame that came with that book's translation into many languages and its canonization as required reading in schools and colleges (not to mention the couple's adaptation of it into a television movie seen by millions), never seemed to have any effect on his down-to-earth, regular-guy personality. Big as he was (both physically, at six-foot-three, and in terms of literary accomplishment), it never went to his head. In his supreme self-confidence he was able also to be truly humble, never taking his local stardom too seriously, always content to be just one among many in the lively and varied community of Santa Cruz writers.

When my book of poems *After Modigliani* came out in 2000 and I gave a reading from it at Bookshop Santa Cruz, Jim and Jeanne were in the audience. I read a poem called "Strangers in a Strange Night," an account of a rather sordid sexual episode that begins in a bar on the east side of town and whose opening line is "What was the name of that dive near the beach on Seabright..." Out of the shocked or bemused or disgusted silence following the poem, Jim's deep voice could be heard to say: "Brady's." Of course—"that dive" was just across the harbor from the historic house where he and his family had lived since 1962, and true to his sense of historical accuracy combined with knowledge of the neighborhood, he was naturally moved to offer the name of the bar.

Houston's memorial event at a large public venue in Santa Cruz drew, by my estimate, at least 700 people, many of them family or friends or associates or former students (he had taught writing, on and off, over the years at UCSC), but others, I expect, had been casual acquaintances or admiring readers or simply locals with a feel for the momentous import of his death. There were Scottish bagpipes and Hawaiian singers and testimony by such stars of California literature as Maxine Hong Kingston and Al Young. The recurrent theme of everyone's remembrances was what a dream of a great life Jim had led, rich not only with prolific and successful writing but with surfing and music (he was an accomplished guitarist and standup bass player, not to mention the ukulele) and family and friends; his warm voice, sparkly eyes and resonant laugh were repeatedly invoked. The wealth of sincere and affectionate tributes reminded me not only of how well he was loved but how well he had lived, and with what integrity. The reception that followed, with plenty of food and drink and a Hawaiian string band, was a festive reunion of longtime veterans of local cultural history, with Houston himself about the only missing dignitary.

As I moved toward the exit of the sunny courtyard after a couple of beers, I paused to survey a display of photos: Jim as a boy, as a young sailor, as radiant groom with his beautiful bride, as a dad with his growing family, as a celebrated author in his signature white suit. We'd never been close friends, just casually friendly as fellow writers and denizens of a shared habitat. Yet somehow those pictures really got to me, and suddenly I felt his loss as acutely personal. Surely this had to do, more than anything else, with his quality as a person.

An Amazing Man: Morton Marcus

[2009]

Morton Marcus, whose outsize presence animated and at times dominated Santa Cruz County's literary culture for most of the last 40 years, died peacefully at home after a long illness early in the morning of October 28. He was 73, and seemed both younger and older—younger because his attitude toward everything was one of boyish enthusiasm, and older because the amount of living he jammed into his years would have taken several lifetimes for anyone less charged with creative energy.

To fellow writers, Marcus was best known as a poet, but in a far more capacious sense of that word than simply someone who writes poetry. In his case being a poet meant being part rabbi, part shaman, part entrepreneur, part teacher, part movie critic and television personality, part radio host and interviewer, part political organizer, part journalist, raconteur, bon vivant and, oh yes, writer of lots of poems and books of poetry—verse poems, prose poems, lyrical poems, surrealistic fables, family narratives, nature poems, urban poems, short poems, long poems, skinny poems and fat poems. At times didactic or philosophical, at other times comic or fantastic, often stretching

beyond any signature style or comfort zone, his writings defied easy categories and roamed wherever his imagination led.

Even long after his retirement from teaching literature, creative writing, and film history for three decades at Cabrillo College, Morton was an irrepressible teacher. "This is a guy," said his friend the poet and printer Gary Young, "who would lecture the birds in the park." Indeed, given the opportunity, which he frequently had at his various microphones in diverse venues and circumstances, Mort would unpack an impromptu discourse on just about any subject that came up, from the history of the novel to the Japanese tea ceremony. And in a more intimate setting, in private conversation, as Gary noted, "he was a spellbinding storyteller."

I first met Mort in 1968, soon after we'd both arrived in Santa Cruz. In our occasional dinners together over the years I was struck each time by his voracious intellectual appetite (not to mention his appetite for food): he was, as he said to me last year, "absolutely intensely engaged in everything" and could draw on his vast reading and picaresque personal history—having been farmed out by his much-married mother to a series of boarding schools and fending for himself throughout his youth—to talk as well as eat you under the table.

A conversation with Mort would typically range from poetry and poets to sports and athletes (he'd been a boxer and a street fighter, a high school basketball star and later a coach), from Eastern philosophy to movie trivia, from international politics to his familial and personal odyssey starting in the shtetls of Eastern Europe and migrating through New York City to Northern California and eventually Santa Cruz, which he considered his only true home.

These lively dialogues were always genial but frequently heated and contentious, informed by his passionately held opinions on whatever topic. His longtime close friend, fellow poet and Cabrillo colleague Joe Stroud told me, "The wonderful thing about Mort was that you could have huge disagreements about everything—poetry, politics—but the friendship was bottom-line solid. He didn't want agreement; he loved engagement."

But unlike most other blowhards, know-it-alls and egomaniacs—whom he could match huff for puff, if necessary—Morton was also an attentive listener, a sensitive reader and a generous champion of others' work if he found anything in it worth admiring. Being interviewed by him on *The Poetry Show* on KUSP radio, where I was his guest a number of times, was to discover in your own poems, by way of his strikingly insightful questions and observations, aspects of your writing of which you were previously unaware. I always enjoyed these on-air discussions, not least because with Mort as my interlocutor I was sure to learn something.

Of all his contributions to local culture, I'm personally most grateful for his organizing, in the early to middle 1970s, a series of weekly readings at downtown restaurants that virtually created a Santa Cruz literary community. Morton's organizational energies and skills with publicity brought together a vastly diverse assortment of writers to hear one another's work, and these well-attended gatherings generated friendships and collegial relations many of which continue to this day. For young writers looking for like-minded souls with whom to interact and compete and sometimes seduce, and for an audience to witness our performances, the Marcus touch as

social director, carnival barker and ringmaster set a standard I have never seen surpassed.

As Joe Stroud said to me, choking back tears, "I think Mort is going to be someone we're going to miss more and more. Beyond the boombast [*sic!*] and the bullshit, he was an amazing man."

It was Jim and Jeanne Houston who first cajoled Mort and his family into moving to Santa Cruz. Houston and Marcus had been graduate students together at Stanford in the early 1960s, and their friendship then evolved into a lifelong personal and literary alliance as they became twin towers of accomplishment in their respective disciplines, Jim in prose and Mort in poetry. Their illnesses and deaths within six months of each other this year are a devastating double blow to local culture. Both in their early 70s, both still working right up to the end (Mort completed his final book two days before he died), they represent the passing of an irreplaceable generation.

And yet, their example serves as a continuing inspiration to all the other writers they befriended here. And other artists too, like Mort's friend Futzie Nutzle, learned from and were inspired by his vision. "He had some kind of ability to point things out to us," Nutzle told me. "I think he pointed out the beauty... but it took him a while because he was so tough."

That toughness, that scrappy street-fighter tenacity, surely accounts for the fact that it took the kidney cancer he was diagnosed with two years ago—a cancer that would have been swiftly fatal for most people—so long to finish him off. Morton simply did not give up, even when he knew the cause was lost.

I remember a conversation we had over sushi and sake one night in the 1990s, when he admitted to me that he felt he had

not measured up to his original ambition to be a truly great and famous writer. As with most of us who begin with such lofty goals and dreams, those illusions had given way to a more realistic assessment of his achievement. But he realized that was no small thing, and that all the books he'd published, the magazines and anthologies in which his work had appeared, all the readings and lectures he'd given and classes he'd taught and articles he'd written and friendships he'd cultivated and events he'd organized added up to a lasting contribution to his community—both the local one and the larger immortal fellowship of literature with which he felt forever affiliated.

Morton Marcus left his mark on Santa Cruz, and on each of us who had the singular luck to know him. As Nutzle said, "It's hard to believe that somebody of his magnitude is somewhere else now."

Bard under the Radar:
Greg Hall

[2009]

When someone close to you dies, it's always strange, even if they were old and in poor health and you knew it was coming. When the deceased is a longtime friend, an exact contemporary and a peer in your shared obscure line of work, someone you spoke with over the phone the day before and who was no drunker than usual and otherwise in good health as far as you knew—when he is suddenly found dead in his San José cottage, apparently of a heart attack, at 62, disbelief is added to your grief.

Greg Hall, at one time the most prodigiously gifted poet in Santa Cruz, unexpectedly left this world last Tuesday, June 23. He had phoned me Monday and we'd spoken for maybe a half hour, about everything and nothing—that is, mostly about poetry in one manifestation or another, about the small miracle that we and a few friends were still doing it after all this time, about the curious consolation it is to devote one's life to such a marginal yet essential creative practice.

In the 1970s, when Santa Cruz was experiencing a poetic renaissance, Greg Hall was a star, alternately inspiring and

exasperating fellow poets with his brilliant imagination, his gentleness, his humility and his wit. I was certainly one who wondered, in the competitive way of poets, how I might ever write poems so brimming with reality and a seemingly effortless way of making the wildest connections and juxtapositions—as in "the left foot of Juan Marichal sinks over the Golden Gate," an image of the high-kicking delivery of the great Giants pitcher as an event as cosmic as the setting sun—seem completely natural and inevitable.

Working in those days on a series of manual portable typewriters, later on one computer or another, Greg Hall went through periods of self-doubt or spiritual conversion often enough to discard writings that he no longer believed in, and surely threw away more excellent original poems than most poets write in a lifetime. He was not attached to the material world, his own works included. He was constantly recycling his books and music, living in tiny cottages in Santa Cruz or Capitola, or in spare apartments in San José or Campbell, working in hospitals or nursing homes as an orderly, a technician, an administrator, and on his own time constantly reading a vast range of books—poetry, history, philosophy, fiction, biography—and writing, writing, writing.

He was one of those rare poets not only totally authentic in his devotion to the art, but even rarer, utterly indifferent to public recognition. He had no ambition to publish—in 40 years he put out just two small collections from small presses (*Flame People* from Santa Cruz's Green Horse Press and *Inamorata* from Tollbooth Press in Redwood City), and his work hardly ever appeared in magazines (exceptions include Silicon Valley's *Montserrat Review* and my own *Redwood Coast Review*

and *Alcatraz*). His only ambition was to serve his muses: poetry, music, art, alcohol and cigarettes.

That he lived as long as he did under the circumstances is an accomplishment in itself.

That he lived uncorrupted by the culture of publishing yet generously and successfully shared his work with a diverse circle of friends and colleagues, and that the work itself sustained over four decades, through all its changes and variations, a uniquely integral expression of his mystery-smitten spirit, is even more worthy of admiration.

Poetry has lost one of its truest souls, and hardly anyone will ever know.

An Unknown Writer:
Richard P. Brickner

[2006]

Except for a brief obituary in the Metro section of the *Times* and a private Manhattan memorial service six weeks later, the death in May of New York writer Richard Brickner went mostly unnoticed by the world at large. Brickner was what the publishing industry calls a "mid-list" author, that is, someone whose books don't sell enough copies to make promoting (or even publishing) them worthwhile. During his lifetime he published four well-wrought novels of no great notice or distinction— *The Broken Year, Bringing Down the House, Tickets* and *After She Left*—and in this he was fairly typical of the vast majority of writers who achieve the dream of publication. But he also published an extraordinary memoir called *My Second Twenty Years*, which chronicles the long and ongoing aftermath of an automobile crash at age 20 that broke his neck and left him permanently paralyzed from the chest down. In a wheelchair from then on, he took his paraplegic destiny and ran with it.

In the fall of 1990, while living in New York City, I embarked on the daunting project of writing a novel. Since this was my first attempt at the form, and feeling I could use

some professional guidance, I enrolled in Brickner's "Free-style Writing Workshop" at The New School, a course he'd been teaching for many years with open enrollment for people working at any level in any form—fiction, nonfiction, poetry, essay or drama. It was a big class for a workshop, about 40 students, and at first it was hard to imagine how it would work; so many writers of varying degrees of skill working in different genres could easily be a recipe for chaos. But from that first night when he wheeled himself into the room with as much physical as intellectual confidence, gliding up to the table in front, getting settled and introducing himself, it was clear that the instructor had things under control.

Each week each student was invited to submit up to 20 pages of material, which Brickner would meticulously critique in his distinctive scrawl and return to the writer the following week to do with as he or she would. He would select a couple of texts to read aloud to the class (the author would remain anonymous) and invite discussion, including finally his own remarks, which were insightful, sympathetic yet not falsely enthusiastic, frank in their eye for weaknesses yet still encouraging. An anecdote he shared as a guideline for how to deal with criticism, how seriously to take other people's comments on one's work, was the advice his mother had given him some 40 years earlier when he was a budding bon vivant and the drinking age in New York State was 18: "If three people tell you you're drunk, lie down."

He also spoke of the time some years before when he was teaching this class and at the first session invoked, as a way of encouraging student writers to dig deep in their own experience, the Socratic dictum that "the unexamined life is not

worth living." In response to this wisdom a young woman at the back of the room piped up, "How do you know?" Brickner had clearly been amused by the ironic profundity of this remark; his openness to the unexpected, his appreciation of such intuitive if off-the-wall insight, had the effect of increasing my sense of his authority.

Despite my lack of experience in the novel, the evident accomplishment of my writing led Brickner to take a particular interest in me, and over the next several years we became friends, even after I had returned to California. We exchanged letters, poems, stories, jokes, gossip and the occasional phone call, but the heart of our friendship from the beginning until 2001 when he fell out of his chair and broke his leg and in the course of recovery from that event was too immobile and depressed to want to socialize, were our dinners in his East Side neighborhood. I'd show up at his apartment building, the doorman would ring him to announce my arrival, and soon he'd come rolling through the elevator doors, ready for an evening out.

Dick Brickner had no shortage of dinner partners. Having lived in Manhattan all his adult life and cultivated both a rugged independence and an extensive circle of friends—which was constantly expanding to include new former students, usually female, to whom he'd become attached in one way or another—he had an extremely active social life. He regularly hit the streets on his own power, hailing a taxi, instructing the driver how to fold his chair and stash it in the trunk and help him into the back seat, going to the theater or the opera or the movies, having dinner with friends in their homes or out in restaurants, and generally taking advantage of the city's

vast cultural resources. He hired strapping young men to lift him into and out of bed, but otherwise his physical limitations seemed to be an annoying but not insurmountable obstacle to doing pretty much whatever he wanted to. With his direction I learned to push his chair down the sidewalk with sufficient technique to keep him from being jolted when going over bumps and cracks in the pavement, negotiating curbs, crossing streets and avoiding running over other pedestrians.

Typically we'd roll up to a restaurant where we were expected (Dick was a regular at several neighborhood places and was always on the lookout for new ones), the hostess or maitre d' would swing the door open, if there was a step a couple of waiters would lift the chair over it, people would greet "Mr. Brickner" by name, someone would move a chair or two out of the way to accommodate him and he'd maneuver into position at the table. We'd start by ordering drinks—wine would come later, with the meal—peruse the menu, make our selection, and get down to discussion of all things considerable. Coming from a family of psychiatrists (both his parents had been shrinks), he was a good listener as well as talker, had an analytic mind and a taste for the intrigue and torment of romance. He was the confidant of numerous friends, often with regard to their marriages or love lives, and with women more than once became their love interest, "the other man" to whom they would go for solace, intimacy, sexual companionship or intellectual intercourse. *The Other Man* is the title of the second volume of his memoirs, as yet unpublished.

In any event, he was a lusty eater and drinker, forking it in and slugging it down with gusto, his dining pleasure punctuated by pointed opinion or observation, or hearty laughter

involving considerable physical effort, shifting his weight in his wheelchair, grimacing as he adjusted his position, finding some level of comfort within the inconvenience of his condition. Like most people I've known with severe disabilities, he had no use for niceties or nonsense, wasting no time in getting down to whatever really mattered. I relished those conversations, ranging as they did from literature and politics and love and sex to movies and music and sports. His interests were wide, his curiosity deep and his wit acute.

Among his favorite authors were Vladimir Nabokov for his elegant style, Isaac Babel for his ruthless realism, and Henry James for his layered psychological insight. He also appreciated many contemporaries and often recommended new books and writers he'd recently discovered. More than anything he loved the opera, where he found an art form equal in expressiveness to the dramatic intensity of his own emotional life, which was tumultuous and faithfully recorded with great detail and precision in *My Second Twenty Years* and *The Other Man*.

Handsome, intelligent, sensitive and charming, Brickner was a magnet for women, and his handicap in some ways made him all the more seductive. He was sexually nonthreatening and his needs aroused in some a mothering instinct, yet he was also iron willed and strongly erotic with a keen imagination and a passionate desire for physical intimacy. For him, one gathers from his writing, the greatest misfortune of his injury was not so much the inability to walk as the difficulty to achieve a successful fuck. The memoirs are an exceptionally candid and often heartbreaking account of a young man's (and then an older man's) search for love in all its emotional and sexual complexity, and for the satisfaction of a lasting romantic

alliance that both includes and transcends the holy grail of the orgasm, male and female. If sexual love is a minefield for most people under the best of circumstances, imagine what it must be for someone who has to overcome such physical as well as psychic obstacles. Brickner's rigorous, honest, powerful, wrenching and thoroughly engrossing narrative of his epic and ultimately winning effort to live a fulfilling life—through writing, through teaching, through love, through friendship, with all their disappointments and complications—is the soul of his literary accomplishment.

Like some Beckett character—a highly conscious head perched atop a body that's not much more than a pile of shit—who refuses to submit to the pathetic absurdity of his situation and insists on nothing less than an operatic destiny, with romance and passion and all their attendant exaltations and disasters, Brickner transformed the dark joke of his life into artistic drama of the highest order. As in his beloved operas, the stage may be strewn with corpses at the end, but catharsis has been achieved, and the witnessing reader, shaken to the core, is given the strength to proceed with his her or own self-made destiny, drunk on the elixir of the author's language yet sobered by his unflinching confrontation with a resistant reality.

My Second Twenty Years, for all its power, and even for its commercial potential as an inspirational work of "crip lit"—paralytic writer deals successfully with disability, though without any phony philosophical bromides or feel-good resolution—is out of print. Its sequel, *The Other Man*, has thus far been unable to find a publisher. The fate of these excellent books in the current marketplace, glutted as it is with super-

ficial effluvia, speaks volumes about the state of the publishing industry. I don't pretend to know how many readers such books would be likely to reach in our present sorry circumstances, but it's not just my too-brief friendship with the author that convinces me of their enduring value. His readers, few as they may be thus far, will know what I'm talking about.

In time perhaps Dick Brickner's memoirs will find a second life. For now I'm grateful to have read them, and to have had a firsthand glimpse of where they originated.

George Hitchcock,
Jorge-of-all-trades

[2010]

When I was an undergraduate and aspiring poet at school
in upstate New York in the mid-1960s I started reading the
small-circulation independent literary journals known as little
magazines. It was a volatile historical moment when cultural
life was starting to erupt in all sorts of unpredictable forms, and
one of those forms was this suddenly dynamic proliferation of
creative periodicals run by eccentric individuals with a taste
for poetry and some esthetic agenda or political viewpoint to
promulgate, and read by a self-selected bohemian elite. One
such journal was the San Francisco quarterly *kayak*, a remark-
ably lively magazine launched in 1964 and publishing some of
the best poets, both famed and unknown, then writing in the
United States. The editor and publisher of *kayak* was someone
named George Hitchcock.

Like pretty much every other anti-establishment poet in the
country, I wanted to be in *kayak*, so I started submitting my
poems—and promptly receiving them back along with shock-
ingly irreverent rejection slips with deadpan regrets from the
editor accompanied by a comical collage or illustration clipped

from some 19th-century picture book featuring a man falling into a hole or being devoured by wolves or shot by a firing squad or suffering some other unfortunate fate. These rejections, in addition to being amazingly quick and thus sparing you the agony of suspense, had a lighthearted "tough luck" in the subtext—none of those "we-found-much-to-admire-in-your-work-but-due-to-the-large-volume-of-submissions… and-good-luck-placing-it-elsewhere" notes more typical of today's creative-writing-program-based reviews. No niceness or phony encouragement tainted *kayak*'s forthright rejections with insincerity.

When I returned to California for graduate school at UC Santa Cruz in 1968 I met George Hitchcock at a small gathering at the home of poet Morton Marcus, who had also moved there that year to teach at Cabrillo College. As destiny would have it, Hitchcock moved to Santa Cruz the following year to teach writing and theater at UCSC's new College V, whose academic theme was to be the arts. While continuing to collect rejections from *kayak* I gradually, in the course of occasional encounters, began to get to know its humorously grumpy editor. Near the end of my career in grad school, before flipping out and dropping out, I took George's poetry workshop, and when the term was over he invited me to serve as his teaching assistant next quarter in improvisational acting. This seemed to me very strange, as I had zero experience in theater, but evidently the teacher detected something in my poems or personality that he thought would enable me to improvise the role of his TA.

Instead I continued my graduate studies in various madhouses up and down the state, returning to Santa Cruz the

following year unsure whether to resume pursuit of the PhD or take a leap into the unknown and try to be a writer. One night George's friend Kenneth Rexroth was giving a reading on campus and I happened to run into George on the way to the hall. I told him I was thinking about going back to graduate school but wasn't sure if I should. He asked, "Do you need the money?" I had a fellowship but also some family income, enough to live on. "Not really," I answered. He said, "Don't do it."

It was the best advice I ever received.

In those days before the MFA industry and Garrison Keillor made poetry a respectable occupation, to decide you wanted to be a poet was not a plausible career move. You were dooming yourself to a life at the edge of everything, with neither a guaranteed income nor any sign of societal acceptance. Hitchcock, with his own anti-academic history and a brief career in progress as an accidental professor, apparently had concluded that, at least for someone like me, unemployability was a better bet than professorhood.

Eventually my poems made it into the pages of *kayak*, and in 1975 George published my first book. The *kayak* imprint was a great endorsement, and though the book received mixed reviews, it did get reviewed, and at the premature age of 28 I was launched as an author. Hitchcock, in his gruff and subtle way, had given my so-called career a supportive shove. I wasn't the only poet, young or mature, for whom George had played such a role. Over the next several years I would meet many of them in the community that grew out of *kayak*, both in its pages and in the legendary collating parties where the magazine was physically put together.

Three or four times a year, on a Sunday afternoon, dozens of poets and friends of *kayak* would gather at George's house in Santa Cruz to collate, staple, stuff, stamp and send out the latest issue. George—a skilled printer, among his other crafts and arts—by then had printed the pages himself on a press in the shop on his property, and the issue would be assembled by his crew of helpers, whom he and his partner, Marjorie Simon, would supply with platters of cold cuts and plenty of beverages. It made for delightful social life—many good friendships and collegial acquaintances were initiated—and efficiently accomplished the mission of putting out the magazine. George was the director of this operation, positioning people on the assembly line and instructing them on procedures (if this was their first time) but otherwise assuming as low a profile as his leonine 6-foot-4 physique would allow. He ran things in a way that enabled his helpers to run themselves.

His poetry workshops worked much the same way. George rarely commented on students' writing, rather allowing participants to read and remark on one another's efforts. He didn't assert authority or try to push the poets in one direction or another, instead just listening attentively, sometimes making a brief comment, or starting an exercise with some object he would pass around the room—in his apartment at College V in the workshop I took with him in 1969, later in his living room in Bonny Doon or in the big Victorian on Ocean View in Santa Cruz—and turning the writers loose to riff associatively, giving free rein to their imaginations.

It was imagination that he valued above all—not autobiography or sentiment or ideas or noble thoughts or "spirituality"—but a sense of invention, discovery, astonishment and wit. In

criticism, intellectual honesty was paramount. *kayak* ran from 1964 to 1984, a total of 64 issues, and that was that. George, as self-described "dictator" of the enterprise, was ready to move on to other things—more of his own writing, visual art, teaching, acting, directing, traveling. He'd been a merchant seaman, a journalist, a labor organizer, a gardener, a playwright, an actor, an investor (municipal bonds, he once counseled me, were the best place to put your money), a poet, someone you couldn't easily pin down with a limiting definition. After the earthquake of 1989 he and Marjorie left Santa Cruz and returned to his native Oregon, where he continued with his various activities, spending winters in La Paz, at the tip of Baja, where George, as "Jorge Hitchcock," frequently showed his whimsical, surrealish, sophisticated, mordant, quasi-primitive paintings and collages in local galleries.

George Hitchcock died at his home in Eugene on the night of August 27. He was 96 years old and had lived an extraordinarily creative and fully realized life. He was an influential teacher, more by example than direct instruction, to many other writers and editors, including this one, and a legendary figure in the literary culture of the sixties through the eighties—a model of independence, ethics and integrity—without ever making a spectacle of himself or trying to play the role of anyone's guru. He didn't like to be the center of attention but enjoyed providing a setting for others to interact and flourish. *kayak* was both a highly individual vehicle, a "one-man boat" piloted by the editor's singular vision, and a community effort created at his famous Sunday get-togethers.

At a time when the academic formalist model was fading as a viable style for contemporary poetry, and the New York School

and Black Mountain poets and the Beat movement were on the rise, George took *kayak* in its own unique direction, cultivating an imagistic, surrealist, non-doctrinaire, irreverent, often political, sometimes polemical sensibility, and publishing a range of poets from W. S. Merwin and Raymond Carver and Anne Sexton to Robert Bly and Gary Snyder and Philip Levine, as well as many lesser-known bards like me. The magazine also printed letters and George's collage illustrations—always provocative and amusing—and had a section for criticism where I published my first book reviews. It was easily one of the most vital publications of that or any era in American poetry.

But his post-*kayak* years were at least as fertile, with a prolific output of art and a continuing creative evolution as an all-around man of culture who proceeded on his own path while also encouraging others—for example, endowing a poetry fund at UCSC for nurturing the art and its writers through readings and other programs.

His personal style, in the years I knew him, tended to tweed jackets, sometimes a cape, paisley ascots, rakish hats (often with a feather in the hatband), a pipe, a walking stick—a somewhat Oscar Wildean figure of anachronistic fashion—and a resonant tenor voice that bespoke his stage experience. He liked to dress up in a scary costume on Halloween and give the trick-or-treaters the fright of their night. The Day of the Dead, with its dancing skeletons and festive celebrations of the departed, was a holiday suited to his darkly comic temperament.

He hitched his kayak to a star and blazed a long bright streak across the sky.

All the Fictions
Fit to Print

[2003]

More than one reader has asked me whether the poems by Diana O'Hehir in the spring issue of *The Redwood Coast Review* were "real" or "made up." It's an interesting question to ask about any poems, but these, in case you missed them, were written in the voices of various prison inmates speaking about their lives and the conditions of their incarceration. O'Hehir is a retired professor of English and creative writing and, as far as I know, has no criminal record, but like many poets, she imagined her way into the mind of another person (or in this case persons) and acted as a medium for their stories in the tradition of the dramatic monologue. Fiction writers do this all the time, inventing characters and letting those people speak through a kind of reverse ventriloquism, the writer serving as dummy for his or her creation. Is Huck Finn real? Well, not exactly, and yet he has long outlived his actual author. In literature, facts need not get in the way of truth.

Journalism is another story. This past spring the venerable *New York Times* suffered an embarrassing blow to its credibility (which cost the two top editors their jobs) when one of its

young reporters was discovered to have plagiarized, invented quotes, misrepresented where he had been and what he'd seen and whom he'd spoken with in scores of articles over several years before he was finally busted for his transgressions. The *Times*'s motto, "All the News That's Fit to Print," evidently does not extend to the fictional fabrications of its writers. The paper prides itself on a scrupulous respect for facts, and even though truth may be another matter, reliability of reported information is one of its most valuable assets.

But journalism is also storytelling, and one of the things that makes *The New York Times* a great newspaper is its wealth of expert storytellers. To turn a mass of disorderly information into a coherent narrative is an art in itself, and to do so on a tight deadline in a clear and lively style that is informative and readable requires both reportorial skill and a special kind of creativity. Working on longer deadlines, biographers and historians face similarly daunting challenges: how to select the most telling facts—once one has dug them up—and weave them into a tale that will rivet the reader's attention. Much as I admire the *Times*, I think the revelation of its recent problems is instructive not just for editors but for readers of newspapers everywhere to heed the cliché *Don't believe everything you read*. In other words, even when (especially when) considering nonfiction, it's a good idea to maintain a healthy skepticism. Serious news hogs always get their information from several sources, just as responsible reporters do, and sophisticated readers of history know never to trust just one historian's version of events. And memoirs, those supposedly candid accounts of people's lives as told by themselves, are notoriously unreliable tales, far less believable than the best fiction.

One of the finest American novelists, E. L. Doctorow, is known for integrating historical figures into his imaginary stories. In his most recent book, a collection of cultural and personal essays called *Reporting the Universe*, Doctorow tells a revealing anecdote about his beginnings as a writer. In a high school journalism class in his native New York City, the young Doctorow was assigned to do an interview and chose as his subject a stage doorman at Carnegie Hall. The interview was so well done that his teacher wanted to publish the story in the school newspaper; she would assign a photographer to take the doorman's picture as an illustration. There was only one problem, Doctorow reports: he had invented the doorman. He flunked the assignment but had discovered irrefutable evidence of his vocation as a fiction writer. When I read books like *Ragtime* or *Loon Lake* or *Billy Bathgate* or *City of God* I'm grateful for Doctorow's early failure as a journalist.

Here in Mendocino County one of our most gifted and energetic writers is the kind of journalist who could get away with what he does only in the pages of his own newspaper. Bruce Anderson, editor and publisher of the feared and revered *Anderson Valley Advertiser,* never lets mere facts interfere with a good diatribe. The AVA does investigative stories and reports on the local school board, publishes what is one of the liveliest and looniest letters pages anywhere—a bulletin board for the seriously agitated—and prints the columns of the razor-fanged Alexander Cockburn, but Anderson sets the tone and does much of his paper's most wickedly delicious writing. His ruthless attacks on liberals, feminists, Democrats, timber barons, county supervisors, Volvo drivers, latte sippers, tourists, sheriffs, district attorneys, the Disneyfication of Mendocino

and other personal and political aggravations are legendary far beyond his local turf of greater metropolitan Boonville. His invective is alternately dead-on and off the wall, but accuracy is not the issue. Anderson's intention is to stir things up, and that he has done with remarkable success week after week for nearly 20 years. Is the AVA journalism? You bet. But whether or not it's "real" is another question.

The Peruvian novelist and one-time presidential candidate Mario Vargas Llosa has a book of essays on the novel called *La verdad de las mentiras* (The Truth of Lies) in which he argues, as I have here, that the imagination is a far more trustworthy instrument than facts are for revealing the heart of human experience. In American literature the novelists Thomas Wolfe and Tom Wolfe are interestingly opposite illustrations of this idea. Thomas Wolfe, the North Carolina romantic who wrote essentially autobiographical narratives with a rhapsodic lyricism that prefigures the jazzier dithyrambs of Jack Kerouac, is subjectivity personified: though he projects himself into the third-person persona of his protagonist Eugene Gant in *Look Homeward, Angel* and *Of Time and the River*, and later George Webber in *The Web and the Rock* and *You Can't Go Home Again*, there's no question that he's writing about himself and his own journey. His fiction is unmistakably personal in a way that, for better or worse, puts his actual self on the line in all its glorious narcissism. A star in his brief lifetime (1900–1938), he is seldom mentioned anymore as the phenomenon he was for a while in US culture.

Tom Wolfe, our contemporary, a journalist from Virginia whose literary skills were honed as a feature writer for the *New York Herald Tribune* and *Esquire* magazine in the 1960s,

evolved his own theory of the novel based on the 19th-century model of such masters as Dickens and Balzac: the novel as social documentary or panoramic portrait of contemporary life meticulously researched and reported, then objectively set down in a naturalistic narrative. Wolfe's bestselling novels *The Bonfire of the Vanities* and *A Man in Full* dissect American society and its emblematic characters (at least as one might find them in New York City of the 1980s and Atlanta of the 1990s) while seeming to leave the author—except for his trademark Wolfean style—completely out of the picture. Unlike his namesake and predecessor, Tom Wolfe keeps his cool and remains above the fray he's committed to describing, fastidiously omniscient, as if it would be in poor taste to dirty his white suit with more intimate involvement. Are his characters convincing as credible people, or are they merely two-dimensional types intended to illustrate his thoroughly documented findings about American life in these times? Are his novels more or less "real" than his earlier journalism?

These two Wolfes—not to mention Virginia Woolf, a writer so deeply subjective in her explorations that she taps into some universal psyche—suggest in their very different storytelling strategies the vast range of ways that truths and fictions get mixed up in any text. How true or real a given work may finally turn out to be is a matter of dispute that only time will settle. "Poetry," said Ezra Pound, "is news that stays news." Marianne Moore wrote of poets as "literalists of the imagination," able to produce "imaginary gardens with real toads in them." A newspaper is a compendium of stories, narratives that may not *stay* news, and certainly never tell the whole truth, but nonetheless provide a running and often compelling account of what's hap-

pening in the world. For the passionate reader, all these forms are a feast for the inquiring consciousness nourished by words. More real than "reality" TV, more true than facts, the universe of the active imagination made manifest in print is infinitely revealing and inexhaustible.

A Note on the Author

Stephen Kessler is the author of eight previous books and chapbooks of original poetry, fourteen books of literary translation, a collection of essays, *Moving Targets*, and a novel, *The Mental Traveler*. He was a founding editor of the independent literary publishers Green Horse Press and Alcatraz Editions, the international journal *Alcatraz*, and the newsweeklies the *Santa Cruz Express* and *The Sun*. Since 1999 he has edited the award-winning literary newspaper *The Redwood Coast Review*. He is also the editor and principal translator of *The Sonnets* by Jorge Luis Borges. His translations of Luis Cernuda, *Written in Water* and *Desolation of the Chimera,* have received a Lambda Literary Award and the Harold Morton Landon Translation Award from the Academy of American Poets, respectively. For more about Stephen Kessler, visit www.stephenkessler.com.